Victorian & Edwardian
Fashions for Women
1840 to 1919

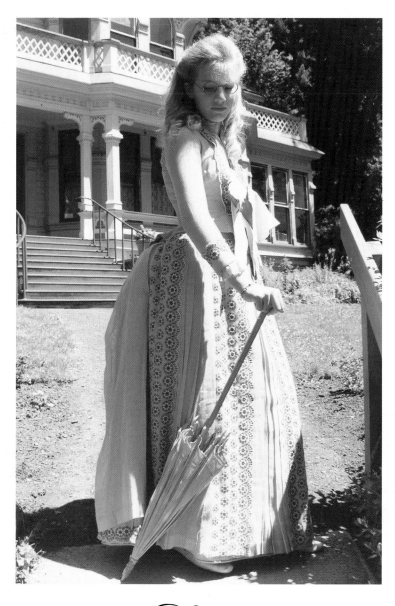

Kristina Harris

Schiffer Publishing Ltd
77 Lower Valley Road, Atglen, PA 19310

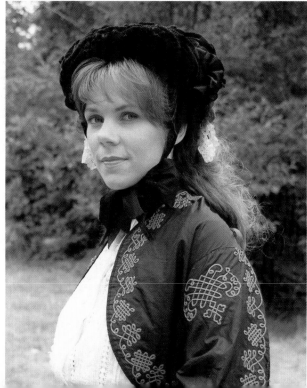

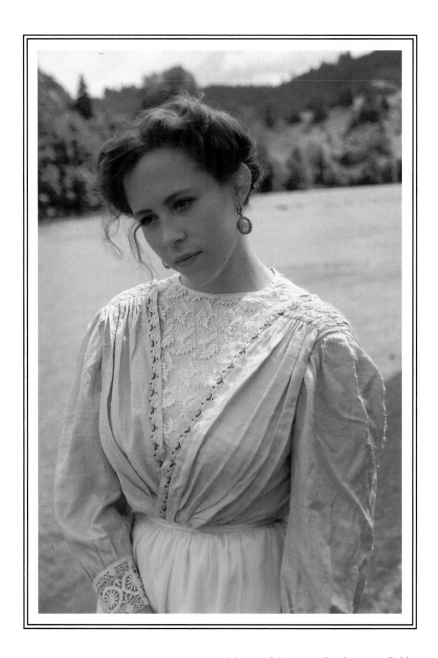

Printed in Hong Kong
ISBN: 0-88740-842-7

We are interested in hearing from authors
 with book ideas on related topics.

Published by Schiffer Publishing Ltd.
77 Lower Valley Road
Atglen, PA 19310
Please write for a free catalog.
This book may be purchased from the publisher.
Please include $2.95 postage.
Try your bookstore first.

Library of Congress Cataloging-in-Publication Data

Harris, Kristina.
 Victorian & Edwardian fashions for women / by Kristina Harris.
 p. cm.
 Includes bibliographical references and index.
 ISBN: 0-88740-842-7 (pbk.)
 1. Costume–History–19th century. 2. Costume–History–20th
century. 3. Costume–Collectors and collecting–United States.
I. Title. II. Title: Victorian and Edwardian fashions for women.
GT595.H37 1995
391'.2'09034–dc20 95-11839
 CIP

Contents

of clothing squeezed onto any person. No garment was worn by any model unless proper, protective undergarments were worn beneath the garment. All models were instructed about the fragile state of all garments photographed before every photo shoot. No surroundings (indoor or outdoor) were allowed to stain, rip, or harm the garments photographed in any way; garments were always carefully protected.

In fact, because the garments were only modeled for a few minutes, the garments modeled for this book were probably in less danger of harm than garments mounted on mannequins and displayed for an exhibition.

Finally, for those who are reading this *Note* and wondering what all this fuss is about, please be sure to read *Chapter One* for more information.

Kristina Harris
Springfield, Oregon
November, 1994

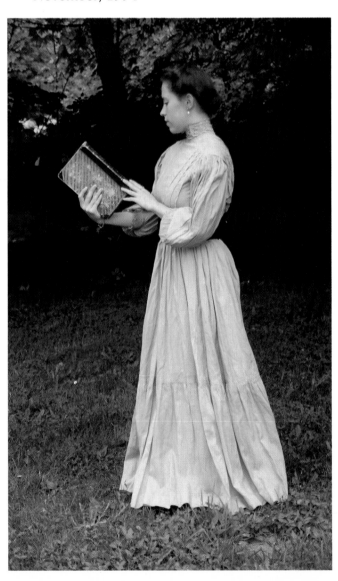

Author's Note

As I prepare to send this book off to the publishers, already I know that some people in the antique clothing world will have a concern about the manner in which numerous garments in the book were photographed. Like many thoughtful people in the antique clothing field, I believe in the conservation of clothing as artifacts. However, as with any artifact, clothing is best appreciated if it is well presented. Rarely do we see antique furniture presented in a museum under a glass case, solitary from other furniture and decor. And just as a Rococo settee seems less influential without a decorated room as its companion, so clothing somehow seems less adequate hung on a wall or set atop a mannequin.

There is no better way to appreciate the value, craftsmanship, and beauty of antique clothing than to view it as it was intended to be seen—on a live figure.

But for those, like me, who are concerned that placing antique clothing on a live model can be hazardous to the clothing's health, let me ease your concerns. No article of clothing was worn by any model if it was in an extremely fragile state, nor was any piece

Acknowledgments

It is truly amazing how many people it takes to make a book possible. I happily thank everyone who has cooperated.

Thank you, Mother, for all your support whenever I undertake any project; your time, energy, and helping hand has been greatly appreciated during the making of this book, in particular.

Another big thank you is due to the Schiffers, who have been a great joy to work with. From the first inklings of an idea for this book, to our meeting in person, to this book's final stages, you couldn't have been more positive and enthusiastic. Do you realize how much this means to a writer? Thank you!

Thanks to my father, also, who—though he's gotten much too picky to find things in antique shops for himself—somehow managed to surprise me with several pieces of antique clothing which he thought I'd like to include in the book. They were good additions, Dad!

I also thank the entire board of Eugene, Oregon's Very Little Theatre for allowing me to borrow and photograph a large number of antique clothes from their marvelous collection. Thank you Mary Mason for putting me in touch with the costume department. Special thanks is also due to Lucy and Darwin Sullivan for putting up with my many visits that always lasted longer than anticipated because I always discovered yet another treasure. You often performed above and beyond the call of duty—thank you.

My gratitude is also extended to the people who graciously allowed me to borrow items from their collections in order to photograph them; a big thanks to: Joanne Haug of Reflections Of The Past in Bay Village, Ohio; Rosetta Hurley of Persona Vintage Clothing in Astoria, Oregon; Priscilla Washco of The Victorian Lady, in Waxhaw, North Carolina; and Nancy Fishkoff of Reincarnation in Pacific Grove, California.

Appreciation also goes to Jan Alberg and Eugene, Oregon's historic Shelton–McMurphy–Johnson House Board for allowing me to photograph on location.

I also thank all the models, who couldn't have been more enthusiastic if they had wistfully sighed even once more "I wish we could dress like *this* today." The book wouldn't have been the same without you! Thank you: Andrea Bush, Brianna Rose Cole, Anna Kristine Crivello, Clinton McKay Crivello, Lisa Ann Crivello, Jocelyn Jones, Darcie Jones, Stephanie Jones, Krystyn Kuntz, and Alicia Wray. I offer additional thanks to Jocelyn Jones for enthusiastically uncovering many models for me.

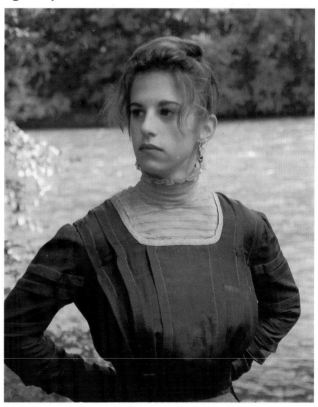

Introduction

I'll never forget the first Victorian dress I met in person.

My parents were ardent antique lovers, and my mother owned a small antique shop. And though, at the presumptuous age of eleven, I vehemently proclaimed that I'd never clutter *my* house with "old stuff," I sneakily visited my mother's shop on a regular basis in order to feed my secret antique passion. I'd spy gorgeous cut glass, exquisite engravings, and velvet covered settees—always with a bored look in case anyone noticed me.

Then one day, I casually entered my mother's shop only to be struck absolutely dumb by a magnificent turn-of-the-century gown hanging on the wall—a soft peach silk dress, trimmed with delicate coral *fleur de lis* braid, the tiniest of pink buttons, and fluid ecru lace. My heart fluttered with love at first sight.

After a few visits where I did little more than swoon over the gorgeous gown, I persuaded my mother into letting me take the dress home. There, I held it up to myself. Immediately I was taken back to all the movies I'd seen with beautiful ladies costumed in rustling, flowing Victorian gowns. Suddenly I was Judy Garland in *Meet Me In St. Louis*, and Ava Gardner in *Show Boat*.

Most every collector has a similar story. That rushing, exhilarating feeling you get when you spot the melon sleeve of an 1890s dress poking out from the racks of a vintage clothing shop (or your grandmother's attic trunk) has no comparison. And as you collect, the experience of collecting grows.

Personally, I love not only the look and feel of antique clothing; I also love the history behind it—what it tells me about our ancestors. I like imagining myself in their place (usually without all the tough parts of their life, like unbearably bumpy coach rides and unsanitary outhouses). I love the idea that a woman—an individual—chose to make or buy a certain dress, and that it was probably special to her, since it managed to survive all these years.

But the reasons for collecting are as varied as collectors are. Whatever your reasons, you have picked up this book—and I hope that it will enhance your collecting experience.

I have tried to make the book an interesting read-through, in addition to organizing it for easy reference. I have combined the Victorian and Edwardian eras for a single reason: they are so heavily intertwined. The general looks, style, and feeling behind clothing remained much the same when Queen Victoria took her throne in 1839 as when her son King Edward took her place in 1901.

I have also tried to make the book as practical as possible by picturing garments within the average collector's arm-reach. This being a collector's guide and not specifically a tour of fashion history, I felt it important to concern this book primarily with garments that the average collector can both *find* and *afford*. Every garment pictured is from a private collection or is readily available to collectors through dealers. You will also notice that some eras are represented with more photos of existing garments than others. Let this be a general guide to availability.

Both the publishers and I have tried to make the book as aesthetically pleasing as the Victorian and Edwardian clothes it features. Not only do I hope you will gain much collecting and historical information, but I hope you will find yourself drawn to gaze through the book on a lazy afternoon.

Oh, and one last thing. I still cherish that dress from my mother's antique shop; you'll find it pictured in *Chapter 9.*

Chapter *One*

Collecting Victorian and Edwardian Fashions

In 1839 a young, pale, dark–haired girl became Queen of England. Her sense of style and morality was fresh and sometimes innovative—and ladies everywhere wished to emulate her. As she grew older, the women of the Western World grew with her—beginning in girlish dresses, graduating to more mature (and heavier) fashions that slowed them down and no longer permitted them to bounce about, and finally adopting a mature, smart style of wearing tailored suits. When King Edward took over the throne in 1901, it seemed that though women were now mature in their fashions, they were in need of more variety—and more variety they got. First came the ultra–feminine, lacy, pigeon–fronted dresses of the early 1900s, quickly followed by a mish–mash of styles like no other period in history had ever seen, until, finally, around 1920, women completely dispelled the look and feel they had cherished for eighty–some years and adopted the new 'modern' look of the Roaring Twenties.

The entire Victorian and Edwardian period is one unlike any other. Nowhere else will collectors find clothing as opulent, frivolous, or beautiful as they will

in the years 1840 to 1919. But like anything else, a collection of antique clothes will be considered much more valuable and noteworthy if it is handled well.

Avoiding "Mistakes"

It is nearly impossible for the beginning collector not to buy a few "mistakes" before she or he gains more experience. For instance, my very first acquisition was a silk turn-of-the-century dress. Beautiful though it is, unfortunately over the years it has disintegrated considerably. (Read *The Importance of T.L.C.* for the reasons why.)

New collectors also typically buy items that are in poor condition. While its certainly smart to pick up inexpensively priced garments whenever possible,

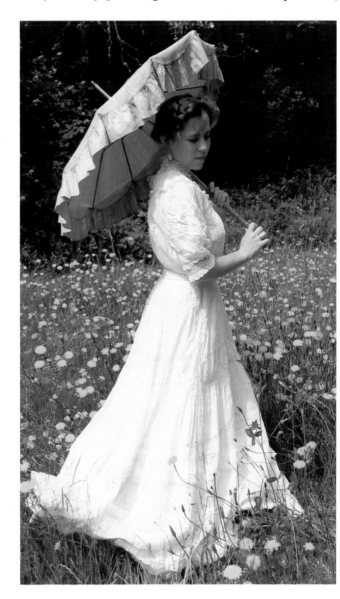

A 'lingerie' dress and parasol, both typical of the early 1900s. *Courtesy of The Very Little Theatre.*

care should be taken that their condition is reasonable. A few small holes are acceptable and to be expected, but any large rips or holes are definitely to be avoided. Collectors should also avoid garments which have been altered by modern hands. It is interesting and enlightening to own a garment that has been restyled several times in the nineteenth or early twentieth century, but a garment with a rip repaired with iron-on tape was obviously repaired by a modern collector. Such repairs and alterations reduce the value of your collection.

As in every field of antiques, reproductions can be seen displayed in antique stores and markets, priced and marked as though they were authentic. Unfortunately, there is no reliable way for new collectors to spot reproductions; it takes an eye that is thoroughly familiar with the real thing. However, most reproductions are actually theatrical costumes, and as such, clues to their background can often be found. If a garment seems hastily sewn, if it has what appear to be modern notions (such as a zipper), if the fabric looks and feels modern, you should avoid the garment. Unfortunately, however, with the advent of historical fairs

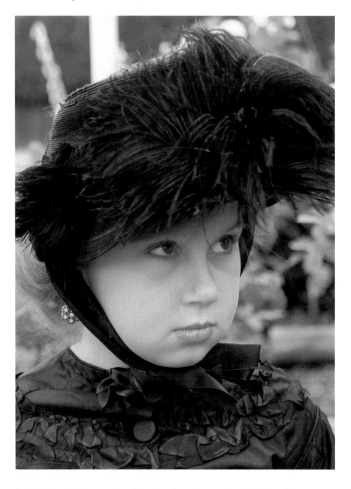

A feathered hat and taffeta bodice from the 1870s. *Courtesy of The Very Little Theatre.*

and re-enactments, extremely authentic-looking reproductions are also on the market. Here, again, only an experienced eye can spot a fake. Yet another variation to this confusing scenario is that sometimes authentic garments are used in the theatre or for re-enactments with the addition of some modern lace, a zipper, and similar notions; such garments can sometimes be carefully restored and be a boon to a collection. Once again, a careful eye is necessary.

The best advice for beginners is to trust your instincts. Study the photographs in this book. Get familiar with authentic period garments. Then, when shopping, use a careful eye and your best judgment. If something tells you the fabric a certain dress is made of just seems too modern to be from 1880, then walk away.

The Importance Of T.L.C.

If antique garments are cared for properly, not only will their value increase, but they will remain in a condition that future generations can enjoy and learn from. Only so many Victorian and Edwardian clothes were ever made, and perhaps half of those have survived to this day. No more will ever be created. Thinking of your collection in these terms, you'll quickly realize that proper care is essential.

Every garment in your collection needs a home. Unlike your everyday clothes, antique garments should rarely be hung. Occasionally, if space is at a premium, hanging a very lightweight dress or blouse on a padded hanger is all right, but all other garments should be stored flat. Find a trunk, a dresser, or some boxes; line them with a clean white sheet, and then layer your garments (heaviest on bottom), separating each garment with acid-free tissue. (No, regular tissue paper won't do. Go to your local art supply store for acid-free tissue—which won't cause yellow spots to appear on antique clothing.) Pad all folds well with acid-free tissue to prevent permanent wrinkles and fold lines from appearing. Shoes, purses, and hats should also be gently stuffed with acid-free tissue, then wrapped in muslin for protection. It will be necessary to replace your acid-free tissue paper about once a year. Because fabrics need to breathe in order to remain healthy, you should *never* place any antique garment in a plastic bag. If you think extra protection from dust and dirt is necessary, use a cotton cloth bag. (Be certain not to use bleached muslin, however, since the chemicals in it are said to wash out only after many years of use.)

During the late Edwardian period, sleek, sophisticated evening gowns were the height of fashion. *Dress at right courtesy of The Very Little Theatre.*

Silk fabrics require special care. Every antique fashion collector needs to know that silk can be an iffy investment; many silk garments from the nineteenth and early twentieth centuries already have worn–out spots (referred to as "shattering") where it appears a cat has torn a section of the garment to shreds. But don't blame the cats; silk is generally an unstable fabric and eventually destroys itself, even with very careful care. If you buy any silk garments, purchase them simply because you love them and bear in mind that their value may decrease with further age. If you already own a silk garment, keep it in the best condition possible by never allowing the fabric of the garment to touch itself. This is best accomplished by padding the entire inside of the garment with acid–free tissue; any folds made in the garment for storage should also be padded. If the silk is especially fragile, but the lining is still strong, turning the garment inside–out while in storage will also help protect it.

Whenever you acquire any garment, be certain to ask the previous owner if the garment was recently cleaned. If their answer is yes, do not clean the garment again; cleaning is very hard on old fabrics—which are always more fragile than they appear. In fact, unless the garment is noticeably dirty, cleaning should be avoided altogether.

Musty-smelling clothes can be aired either on a bed or table in a room where all the windows have been opened, or, less preferably, outside on a white cotton sheet. In either case, the garment should be kept out of direct sunlight, which can cause irreparable harm to old fabrics. If the garment is persistently bad–smelling, try steaming it. Using a hand–held fabric steamer (available for a reasonable price at most drug stores), carefully steam the garment while it hangs on a padded hanger. Be prepared for the pungent odor. After steaming, remove the garment·from the room and air it.

Cotton garments can often be carefully washed at home. Whites are your safest bet, but colored garments may be washed also, if first tested on an inside seam for colorfastness. To wash an antique garment, place a pillowcase at the bottom of a sink (or a large sheet at the bottom of your bathtub), and fill it slowly with lukewarm water. Add cleanser to the water. Never use the same detergent you use on your everyday clothes; even "gentle" products such as Woolite are much too harsh for antique fabrics. Instead, either use Orvus (a special product used by museum curators; you can probably find it fastest by looking for the brand name "Quilt Care" in your local fabric store), or liquid Neutrogena (available in the face wash section of drug stores). Add only enough to give gentle bubbles; too many bubbles will just make your job more difficult.

Next, gently lower the garment into the water and agitate by hand. Do not allow the garment to sit in the water for more than a half hour, since any dirt that has fallen off the garment will tend too seep back into the fabric after thirty minutes. Remove the garment from the water by lifting up two edges of the pillowcase or sheet. Drain the sink or bathtub. To rinse the garment, lower the pillowcase or sheet back into the basin and fill it slowly with lukewarm water. Gently press bubbles out of the garment (do not squeeze or twist). Repeat this process until all the bubbles have been removed.

Dry a hand–washed garment by placing it on a clean screen (either the kind created for sweaters or, for larger items, a piece of fiberglass screening purchased at a hardware store). Be sure any rough edges are covered well with masking tape, and keep the garment out of direct sunlight.

If handwashing is out of the question, dry cleaning is the next best bet. Take your antique garments to a dry cleaner who specializes in bridal wear. If you're lucky, you may even be able to get a local museum's recommendation on a good local dry cleaner. Ask the

cleaner to place your garment in a mesh bag, and be sure he runs the garment through his machinery only *after* he adds fresh solvent to it. It should be noted, however, that dry cleaning can be a risky proposition. In many cases, the chemicals used in the process make old fabrics more brittle and more likely to rip and tear.

To Wear Or Not To Wear

Some collectors feel that the only real way to appreciate a collection of antique clothing is to wear it. While this may be all right with garments that are in very poor condition, I strongly suggest (as do many authoritative historical institutions) that you do not wear your antique garments. By wearing antique clothes, you run a high risk of staining, ripping, tearing, or otherwise damaging the condition of the piece. Not only does this drastically affect the value of your collectibles, but it also affects the historical significance of the piece. If you wish to enjoy your collection more than is possible by storing them in trunks and cases, try displaying them in archive–quality display cases and frames with ultra–violet light protectors. (However, it is wise to rotate displayed items frequently, since light, heat, and humidity are great destroyers of old textiles.) Another option is to lend pieces of your collection to local museums for their rotating display.

If you wish to dress in period attire, reproductions are available in a variety of places. Patterns for historical clothes abound, and ready–made reproductions are advertised in almost every antique–fashion–related magazine.

Certainly, if we wish to preserve history's fashions for future generations to enjoy, these seem reasonable precautions.

I do realize, however, that no matter how much I wish no one would wear antique garments, there will always be those who do. For those people, please allow me to make a request or two. First, I would ask that you never alter any antique garment; this destroys both the monetary and historical value of the piece. Second, I would ask that you avoid garments which are in good condition. Many times, garments with rips, tears, and other faults can be purchased very inexpensively at antique stores and markets. Once repaired and donned, no one will be able to tell they once were in such poor shape. One last thing: When you do wear antique garments, please be certain to wear appropriate undergarments. This includes not only bustles and crinolines (since these help support old, fragile fabrics), but also proper modern undergarments. A slip or chemise with sleeves and underarm shields is absolutely essential in protecting garments from perspiration and other body chemicals.

Documentation And Value

There are many rewards for documenting your collection. Any collection that is well documented tends to be perceived as more valuable by others—including those who many eventually acquire it or a piece of it. A well documented collection is also easier to appraise and will please your insurance agent. And documentation can *increase* the actual value of your collection—sometimes as much as ten percent. Perhaps most importantly, a well documented collection will help you to focus on what direction your collection is headed and what you may wish to focus on in the future.

If you already have a large collection, taking the first few steps to documentation may seen daunting—but it doesn't take as long as you may think. And once your existing collection is documented, it won't take much time at all to document newcomers.

If your collection is not yet large, or if you're a fairly new collector, documentation has the further advantage of teaching you a great deal about antique fashions; no other approach will teach you as much as the "hands on" method.

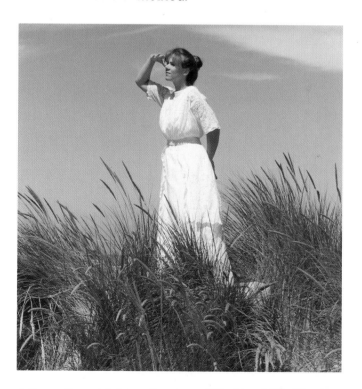

A 'teens 'lingerie' dress. *Courtesy of The Very Little Theatre.*

Creating A "Brag Book"

The first step toward good documentation is labeling and coding. This is easily done with garment labeling cloth tape (available through a conservation supply company). If this convenient product isn't readily available, you can create your own with strips of unbleached muslin. These can then be marked with a permanent-ink pen and tacked into the garment (usually at the center-back neckline of dresses and blouses, or at the center-back waistline of skirts). If you prefer, you may instead use stringed tie-on paper tags (available at office supply stores), but these are less preferable, since the paper such tags are made of is not acid-free.

Next, code each garment with its own individual number. Over the years, museums have developed a simple, yet effective way to do this which private collectors can easily adopt. If, for instance, I had a turn-of-the-century shirtwaist that I had purchased in December of 1994, I would code that garment: 94.12 (that is, the year 1994, the month of December). If you are a heavy-duty purchaser, you may wish to also add the *day* to your code. For example: 94.12.15 (1994, the month of December, the 15th day). Another important part of coding is adding some indication of where you purchased the garment. For example, the addition of the initials PVC to the end of any code in my collection indicates that I purchased the item from a local shop called Persona Vintage Clothing. Keep a list of these initials (and the names, addresses, and phone numbers of the dealers). Finally, add an acquisition number to your code. If, for example, that turn-of-the-century shirtwaist was the twentieth garment I had purchased for my collection, its code would be: 94.12.PVC.20.

While labeling you collection, its also a good idea to make a rough sketch of where every item in your collection lays within your storage area. This will prevent needless rummaging when you're looking for a specific piece.

Now you can get down to actually creating you documentation book (what I affectionately refer to as a "brag book"). This can be as simple or elaborate as you wish. Probably the most functional brag book consists of a three–ring binder with 8.5 by 11 paper inserted into plastic protective sheets. Type (or neatly write) all pertinent information about the item onto your sheet. Add a photograph of the garment, plus photocopies from any relevant value guides, magazines, or books.

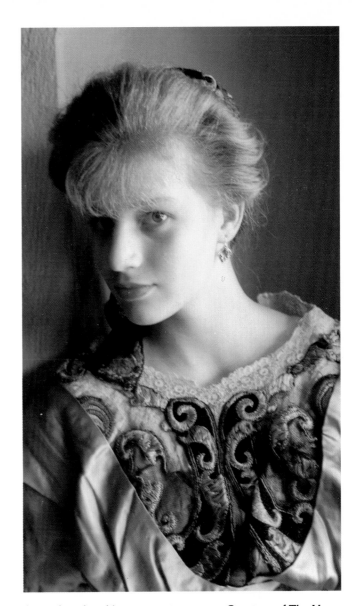

An embroidered 'teens evening gown. *Courtesy of The Very Little Theatre.*

Add the sketch of your storage area to your brag book, in addition to your dealer coding and addresses. This is also an ideal place to keep your insurance information, appraisals, bills of sale, or any other papers pertinent to your collection.

Victorian women wore layers of underclothing—including
shape-forming corsets and absurdly wide hoopskirts.

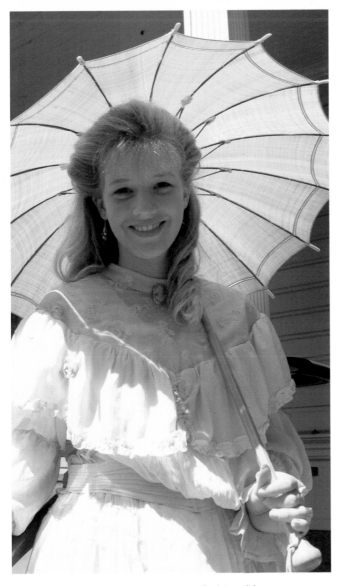

Accessories were important to every fashionable woman; parasols not only gave an air of grace, but also helped to shield the face from the tanning affects of the sun. *Courtesy of The Very Little Theatre.*

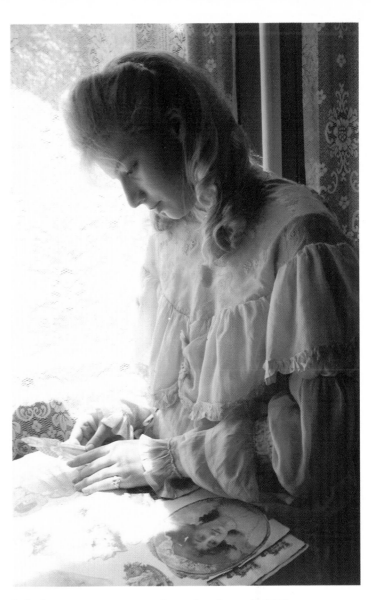

Soft, flowing garments were favored in the early 1900s. *Courtesy of The Very little Theatre.*

The type of silk deterioration most often seen looks like this and is called 'shattering'.

Sometimes silk deterioration looks like holes 'rusted out' of the fabric.

White dresses were a staple in the early 1900s. *Courtesy of The Very Little Theatre.*

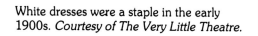

An early 1900s ensemble featuring a white silk skirt and a woven, striped bodice. *Bodice and parasol courtesy of The Very Little Theatre.*

An early 1900s silk parasol. *Courtesy of The Very Little Theatre.*

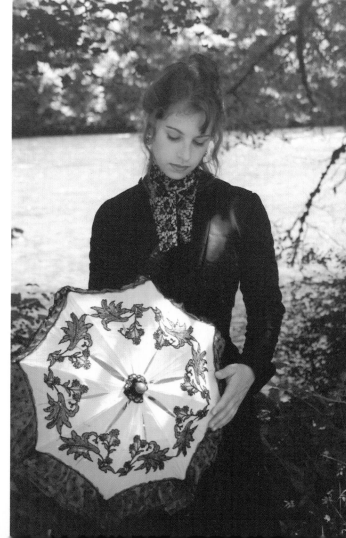

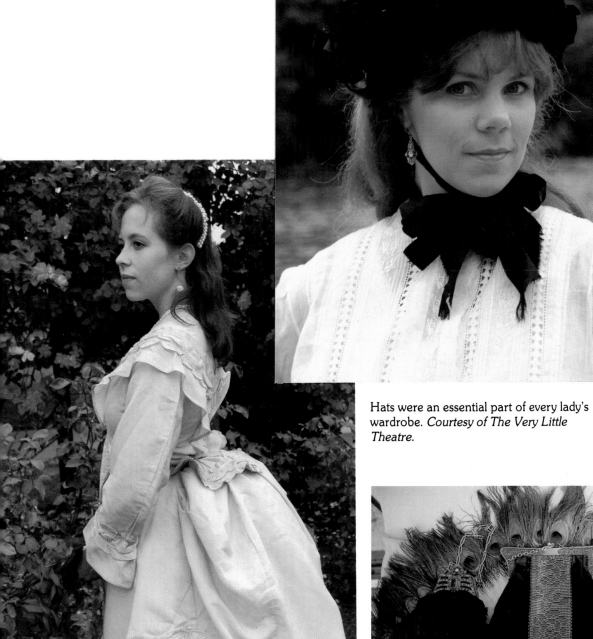

Hats were an essential part of every lady's wardrobe. *Courtesy of The Very Little Theatre.*

An 1870s wedding gown. *Courtesy of Reflections of the Past.*

Three turn-of-the-century handbags. *Courtesy of The Very Little Theatre.*

A page from the author's 'brag book'.

A modern 1880s lady on the steps of a befittingly 1880s Victorian home. *Courtesy of The Very Little Theatre.*

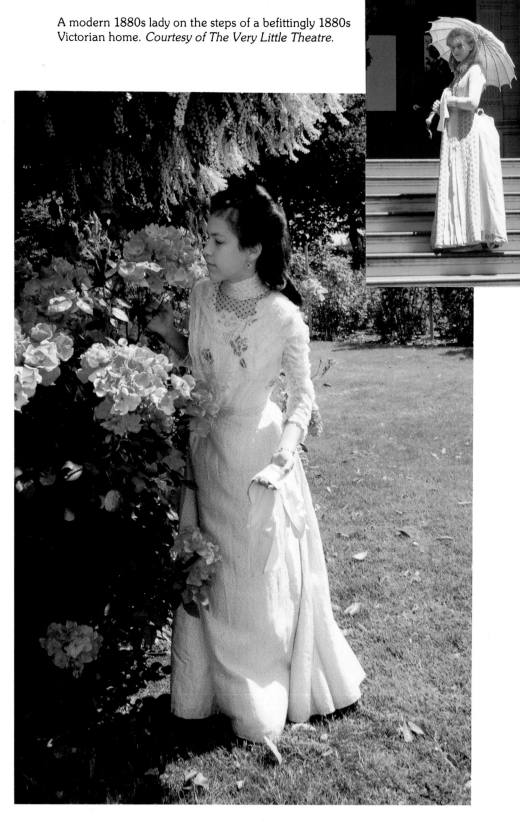

A late 1890s ensemble.

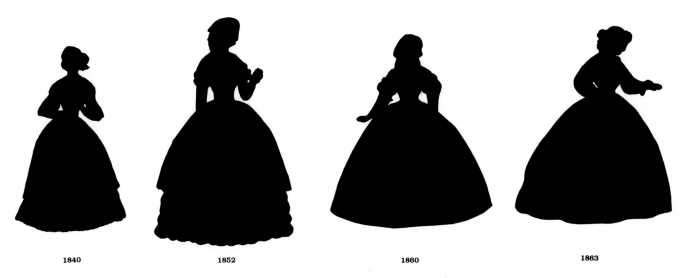

1840 1852 1860 1863

Chapter Two

Identification and Dating

Some collectors go through their entire collecting careers without ever knowing exactly *what* they are collecting. I've never understood this, since learning about the history behind my collection has great appeal to me. At the very least, I think, all collectors should know how to date garments within the eras they collect—if for no other reason than to make sure they know exactly what they are purchasing.

This book guides you step by step through the Victorian and Edwardian eras, helping you to identify and date your collection through descriptions and illustrations of both the *exterior* and *interior* of period garments. Though this book contains photos taken from period fashion magazines and photographic portraits, this should not keep you from amassing your own collection of them. You can never have too many illustrations of period fashions—you never know which one will match a garment in your collection most closely. In fact, a good collection of fashion plates, photographs, and magazines can, in itself, be quite collectible and valuable.

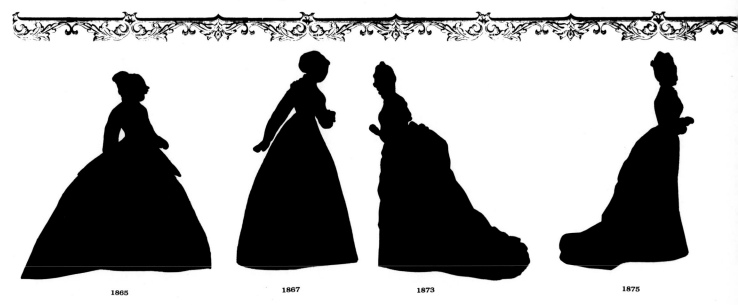

1865 1867 1873 1875

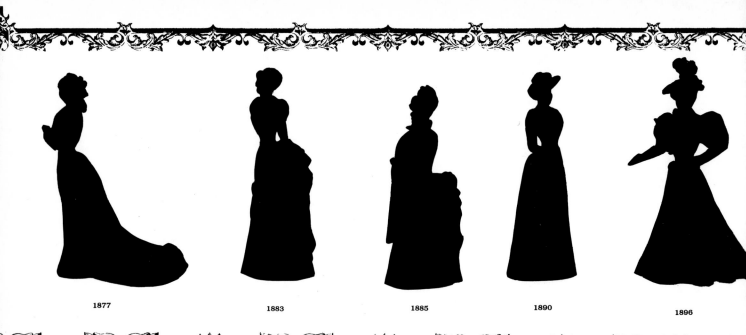

1877 1883 1885 1890 1896

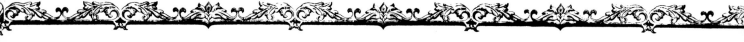

Silhouette

The general shape of women's clothes is a good place to begin your identification. Using the timeline given here, you can easily identify the general era of any Victorian or Edwardian garment, then turn to that era's chapter in this book to uncover more details. Though it shouldn't be the *only* method used to date garments, its a great place to begin. For best results, place the garment on a mannequin (for a three–dimensional look) and then compare its silhouette to those on the timeline. If no mannequin is available, lay the garment *completely flat* on a clean table or floor. Also remember that if proper undergarments aren't worn under some period garments, the silhouette will be altered; a skirt or blouse with a great deal of excess fullness in the back was probably worn with a bustle, and a skirt hem that seems to drag all around was probably worn with hoops.

1898 1900 1909 1911 1913 1915 1919

It's In The Details

Once you have an idea of the general period of the garment, study it for details as described and pictured in each chapter. Examining the *inside* of garments is just as important as examining the outside, so don't skip over information about construction and craftsmanship. Remember too that you'll probably never find an *exact* picture or description of any garment in your collection; most antique clothes are one of a kind. Instead, look for strong similarities in sleeve styles, waistlines, necklines, et cetera.

There are also some other, more general, guidelines to keep in mind:

• While the sewing machine was invented in the 1840s, most experts agree it wasn't in widespread use in American until the late 1850s. All through the Victorian and Edwardian eras, however, many dresses contained both machine and handstitching, so examine a variety of seams. If you are not very familiar with the various methods of sewing, study the seams under a magnifying glass. If adjoining stitches seem to come out of the same hole, the seam was machine-stitched—*unless* the stitches on the underside overlap, in which case the seam was handstitched with a technique called backstitching. Also bear in mind that around the early 1900s, a number of very fine lingerie dresses were sewn entirely by hand, and throughout the nineteenth and twentieth centuries, some special occasion dresses were also almost entirely handstitched.

• Anything with a zipper probably isn't authentic. The zipper was patented in 1893, but wasn't used in women's clothes until the 1930s (and even then, it was primarily used by only a few high-fashion designers).

• Black clothes aren't necessarily mourning clothes. Black was just as much a fashion color in the Victorian and Edwardian eras as it is today. It was also eminently practical for clothes that could not be washed.

• Occasionally, you'll run across a garment that has elements from several eras. At such times, look for signs of alterations; the original nineteenth century owners may have re-styled the garment several times in order to keep up with ever-changing styles.

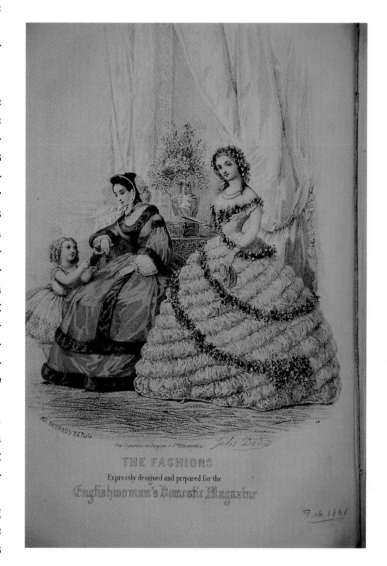

THE FASHIONS
Expressly designed and prepared for the
Englishwoman's Domestic Magazine

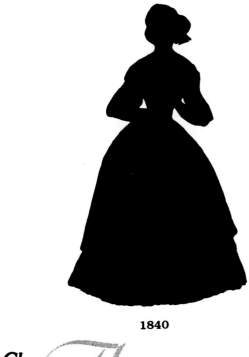

1840

Chapter *Three*

1840s: Little Woman

"The modern stay extends not only over the bosom but also all over the abdomen and back down to the hips;" *The Handbook of the Toilet* informed its readers about the new 1841 style of corset. "Besides being garnished with whalebone, to say nothing of an immense wooden, metal, or whalebone busk...they have been growing in length...the gait of [women] is generally stiff and awkward..." It was not just an encompassing corset that made it difficult for ladies to move, however; the child–like garments Queen Victoria helped bring into fashion were built in such a way that their wearer's were virtually useless: Sleeves and shoulders were fitted so snugly women could hardly raise their arms, and skirts were so long and full they weighed their wearers down. Dresses—and even corsets—fastened up the back, making the help of a sister, maid, or husband absolutely necessary in order to get dressed. (Thankfully, informal clothes created to be lounged in at home allowed ladies to dress themselves with front fastenings.)

Fashion was making some improvements, however. Stylish clothes were extending to all classes, for instance; period fashion magazines regularly complained that "even housemaids" were able to wear the new style of bustle with the aid of old dishtowels, and that dressing maids wore nearly as many petticoats as their mistresses.

The art of creating clothes also progressed; as skirts grew wider and heavier, new innovations were necessary. Because the new wide skirts appeared so unwieldy when gathered to the bodice, dressmakers employed the new method of "cartridge pleating," which created the regular, flat, and tubular pleats which were so prevalent in the Forties. Another new technique, called "gauging" (a method of gathering which required four to eight rows of handstitching), made its premiere in the Forties and would continue to be used throughout the nineteenth century. In the early part of the decade, another new technique was created: the insertion of an inner-waistband. Made up of a piece of grosgrain ribbon tacked to several inner seams and secured around the waist with a hook and eye, this simple device was a great aid in keeping the bodice from shifting upwards with movement. "No one who has not tried this simple improvement can imagine what an advantage it is to the figure," *Miss Leslie's Magazine* proclaimed in 1843.

An 1849 fashion plate featuring dresses with highly fashionable scallops.

Skirts

Why women of the Forties thought shaping themselves like bells made them more graceful and attractive is dubious. But in order to achieve the bell look, skirts were usually heavily lined, small bustles were often built into skirts, and dresses of heavy fabrics frequently had pads at the hip and derriere, sandwiched between the dress and its lining. By the end of the Forties, skirts grew so heavy and the extreme bell shape was so desired that skirts were often lined with stiff crinoline.

By 1843, skirts were sometimes trimmed to look as though they exposed a matching petticoat, or had a few flounces or frills near the hem which were often pinked or scalloped—but very plain skirts were most favored.

Bodices

The bodice of the Forties featured the essential diagonal line from shoulder to waist, which gave women a helpless, childish appearance. Whether created by seaming, trimming, or striped fabric, this diagonal line is typical of the period. Also typical of the Forties is an elongated, pointed waistline that reached well below the waist. To keep this line smooth, bodices were usually lined in muslin and had three bones placed in a fan-like position at the center front, plus a bone under each arm, and sometimes bones in the back seams. Bodices cut on the bias of fabric also helped the fabric cling to the figure, as did piping, which was often placed in all seams.

Necklines were generally low, but were often filled in with the help of a chemisette (what we today call a dickey). Bertha collars were especially popular coverups, and were frequently made in fabric matching day dresses, or in lace for evening.

The first few years of the decade saw 1830s sleeves that were re-shaped to conform to the new 1840s styles. This often meant that the fullness of the past decade's sleeves were held down with fabric or trim bands and sewn up tight to the upper arm. The rest of the fullness was then allowed to puff out at the elbow.

After 1843, sleeves were long, straight, fitted, and frequently cut on the bias of the fabric; when made up in striped fabric, this made the stripes appear to wrap themselves around the arms like serpents. By 1844, sleeves started to become a little fuller and Bishop sleeves were commonplace. Fitted

An 1846 fashion plate featuring a 'low corsage' dress.

undersleeves, worn under shorter, fuller upper sleeves, also made their appearance around 1846, and continued to be popular throughout the decade; these were one of the few practical aspects of women's clothing, since the undersleeves could be removed for easy cleaning. Occasionally, bodices also had two separate sets of detachable sleeves that could be interchanged for day or evening wear.

Dresses

Economical and practical ladies created for themselves dresses with two matching bodices—one appropriate for day wear and one designed for the evening. The only real difference between these two bodices was that the day bodice had long sleeves and a higher neckline or matching Bertha collar, and the evening bodice had a low decolletage nearly falling off the shoulders, and minuscule sleeves.

Watch pockets were common in the bodices of day dresses and large skirt pockets can be found in both day and evening gowns. Dresses for day or night were sometimes trimmed to look as though they fas-

tened up the front, but garments from the Forties always fasten up the back. (The exception to this rule was the dress designed for mothers who were nursing, which, of necessity, fastened in the front.) Toward the end of the decade, waistlines rose and rounded off and skirts had slight trains, though dresses from 1840 to 1847 followed the same general lines as separate bodices and skirts.

Stripes were the most notable fabric type used in the 1840s; damasks and silks were also eminently popular. Pink, light blue, lavender, and pea green dominated most of the decade, though deeper reds, purples, greens, and greys were favored in the latter part of the Forties. Tone-on-tone was the style of ladies of taste—but unusual color mixtures were worn by many; one period magazines described an average outfit thus: "A crimson opera-dress, worn with a light blue mantle, and pale green velvet leaves in hair."

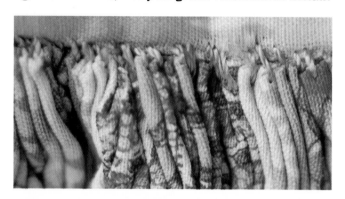

Detail of a skirt gauged to a bodice. Notice that while the stitches are prominent on the inside, they are barely visible from the outside of the garment.

Undergarments

Petticoats were the most important undergarments of the decade. In the 1840s, petticoats were layered to create wide, increasingly bell-shaped skirts; five to ten petticoats could be worn by fashionable ladies—the undermost often made of stiff horsehair or crinoline fabric. But while layers of petticoats gave

ladies the fashionable look, they had their problems; not only were petticoats extremely hot, they wrapped themselves around ladies legs and made walking nearly impossible.

Drawers, though criticized by some as being "too masculine," were now being worn by more and more women. The drawers of the Forties were possibly the most simple garments ladies wore, basically consisting of two tubes attached to a waistband. Though they were always open-crotched, they were cut full enough to conceal.

Small fabric bustles composed of several layers of stiffened fabric tied to a waistband were often worn over layered petticoats, even when bustles were built into dresses. These bustles, unlike similar bustles used later in the Victorian period, extended all the way across the derriere and to the sides of the hips.

Corsets (often called "stays" at the time) were long, heavily boned, and uncomfortable. Unlike corsets worn in the following decades, they had only one opening—in the back—and had to be re-laced each time a lady wished to get in or out of it. However, the most common complaint about corsets of the decade was that their busk was too large and therefore too uncomfortable. This "busk," or wide piece of boning placed at the center front of the corset, was designed to keep ladies' stomach's as flat as possible. An ankle-length, nightgown-like chemise was worn under the corset (to help keep the corset clean), and a camisole was often worn over the corset (to protect snug-fitting bodices from sharp corset bones). Vests—usually made of wool—were sometimes worn over the camisole (or in place of the camisole) for added warmth, as they were through much of the Victorian and Edwardian period—but many ladies went without them because they added girth to the figure.

Fancy Dress

Occasionally, antique clothing collectors will run across garments that don't seem to fit into the general style lines of any particular period; at least two possibilities should then be explored. One is alternative dress (see *Chapter Six*); the other is fancy dress.

The Victorian and Edwardian eras saw a revival in interest in masquerades and costume balls; the trend-setters of the era—including Queen Victoria and Alva Vanderbilt—were well known for their elaborate fancy dress parties. For the most part, however, collector's will find that fancy dress is rare; often, cos-

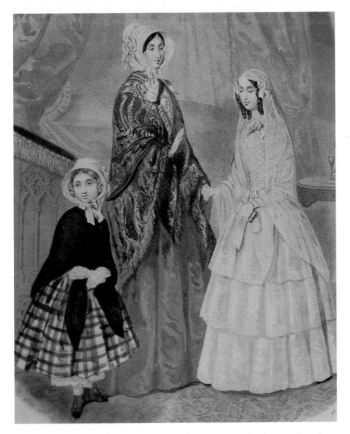

A wedding gown featuring deep flounces and a long, shawl–like veil. The mother of the bride also wears a full shawl and bonnet, giving her a demure appearance.

Other Important Garments

Bonnets were extremely popular in the Forties, and had a great deal to do with the demure look of fashionable ladies. They sometimes had cane hoops inserted into them horizontally to help them stick straight out, and they were almost always trimmed with flowers and ribbons *inside* the brim. Bonnets and evening headdresses reached far down the sides of the face and bonnet brims nearly met at the chin.

Mittens and wrist-length gloves were also extremely fashionable, and would be through the 1860s. Often found made up in lace, they were not only reserved for evenings, but were worn by day, as well. Soft, flowing shawls—like gloves—were almost always worn by ladies.

So-called "Miser" purses were much favored by the middle and upper classes. These odd-shaped purses separated different types of coins in each of their rounded ends, and were held in hand at the center. Purses heavily decorated with hanging beads were also popular, as were reticules made in fabrics to match specific outfits.

tumes were re–made until they wore out completely.

Several important details will help you to discern whether or not you have uncovered a piece of fancy dress. First, it is important to realize that while fancy dress often depicts fashions from earlier times, it almost always follows the silhouette of whatever era it was worn in. Take for instance the women's fancy dress costumes pictured here. Though this fashion plate pictures "Greek Costumes," it clearly follows the silhouette of the 1840s, with drooping shoulders and bell-shaped skirts. In the same vein, an 1880s costume depicting Joan of Arc would be worn with a bustle, and an 1860s costume depicting Mary Queen of Scots would be worn with a crinoline—even though Mary never wore a cage crinoline and Joan never even lived to see the invention of the bustle.

Not all fancy dress costumes depicted historical (or even fictional) characters, however; many costumes may be difficult to discern from other types of evening wear because they depicted abstract themes such as "Spring," "Music," or "Love." Such costumes can be recognized by shorter skirts and unusual color combinations or decorations. For instance, one period costuming book suggested that an abstract costume be made of cotton batting flecked with black ink.

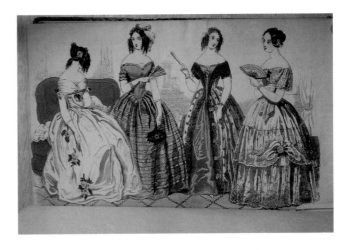

An 1845 fashion plate featuring off-the-shoulder evening gowns.

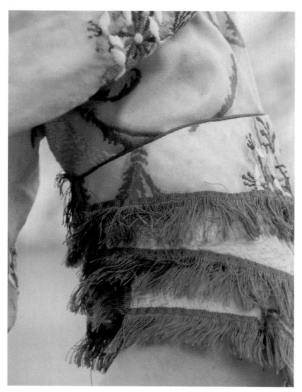

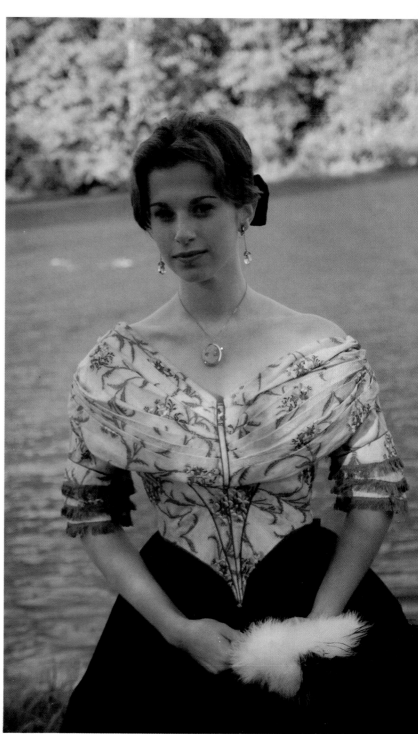

A circa 1841 silk and wool evening bodice from Norwich (an English weaving center) with an all-over embroidered design and sleeves edged with silk fringe. *Courtesy of Reflections of the Past.*

An embroidered and painted picture taken directly from an 1845 fashion plate.

A circa 1846 fashion plate featuring two flounced evening gowns.

An evening bodice from about 1849. The pointed waistline is accentuated with jet passementerie; ruched gold faille accents the sleeves and neckline. The buttons in front are fastened with separate, removable straight pins. *Courtesy of The Very Little Theatre.*

A circa 1848 dress of pastel purple shades, a shaped and smocked waist, and a moderately bell-shaped skirt. *Courtesy of Reflections of the Past.*

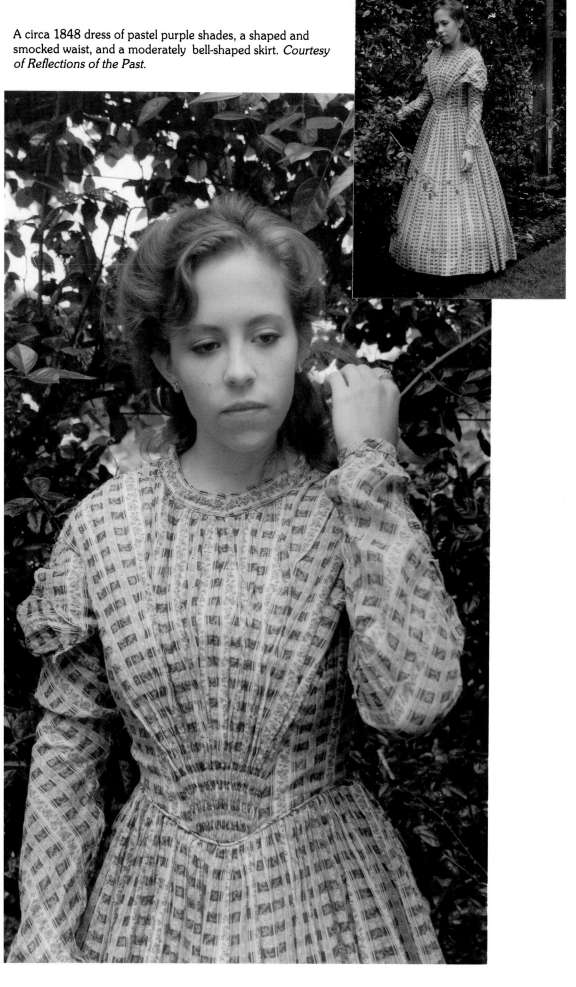

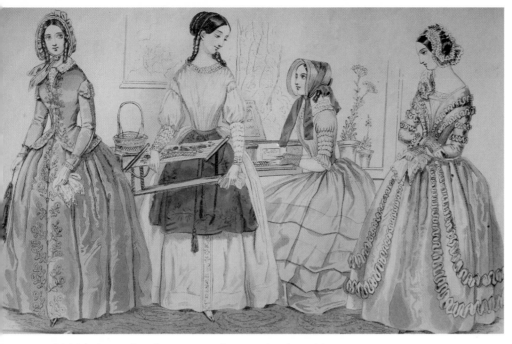

An 1845 fashion plate featuring a white muslin dress. Notice how the sleeves on all the dresses are in the stitched-down style.

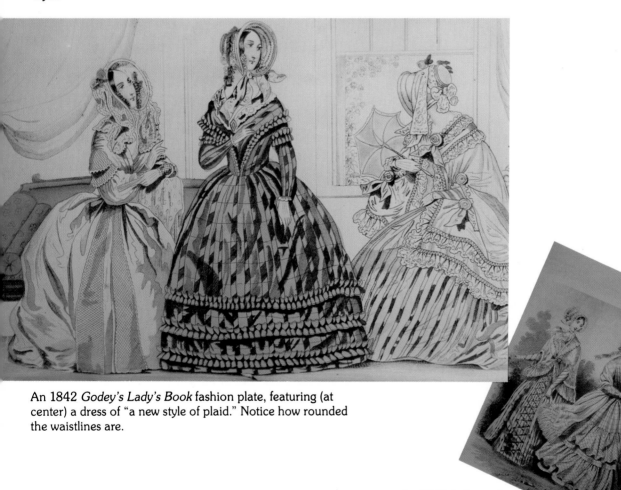

An 1842 *Godey's Lady's Book* fashion plate, featuring (at center) a dress of "a new style of plaid." Notice how rounded the waistlines are.

An 1848 fashion plate.

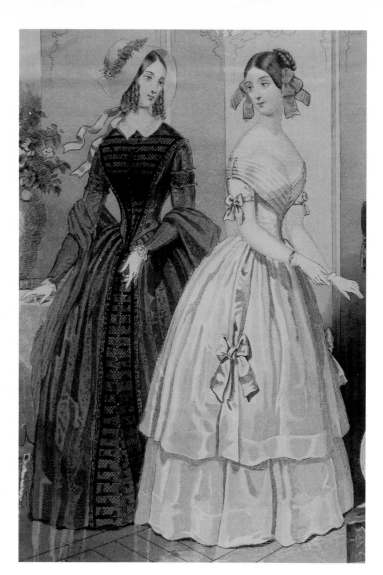

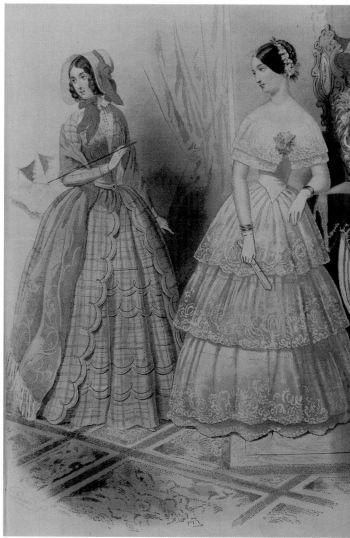

Two 1846 fashion plates.

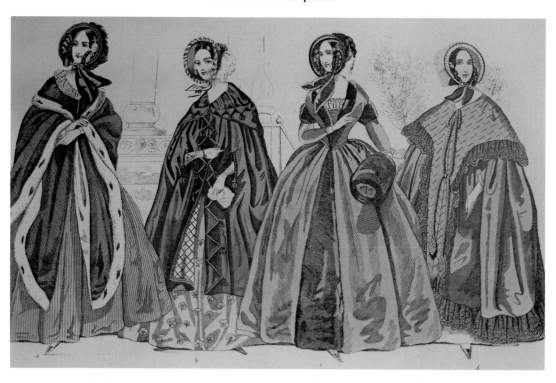

A circa 1849 fashion plate featuring widening skirts.

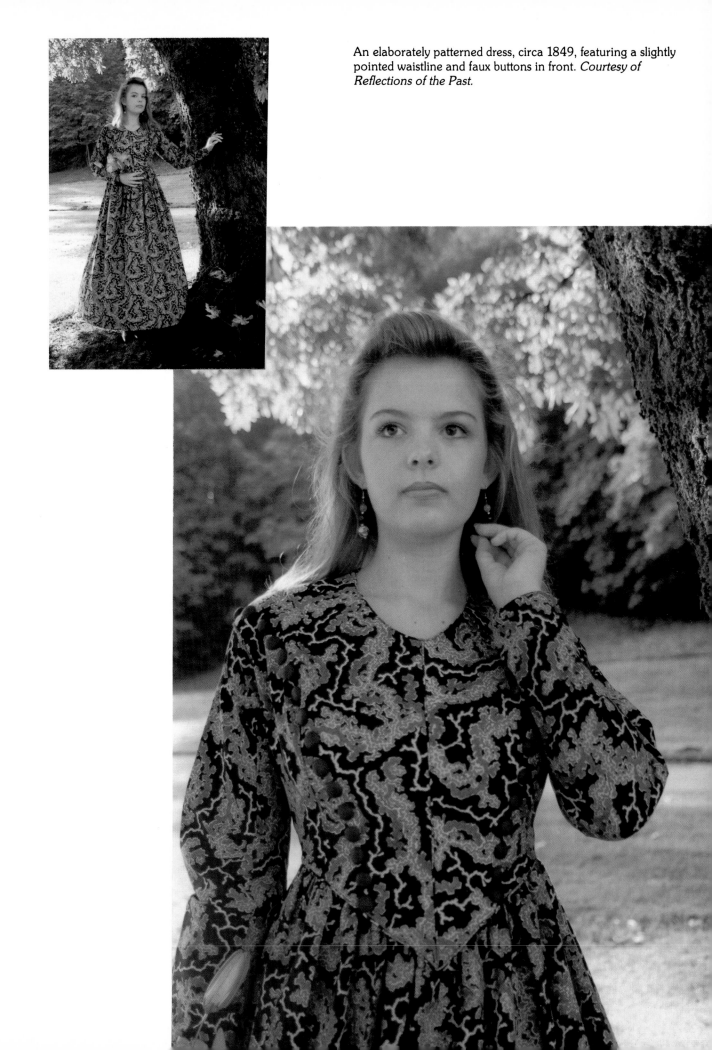

An elaborately patterned dress, circa 1849, featuring a slightly pointed waistline and faux buttons in front. *Courtesy of Reflections of the Past.*

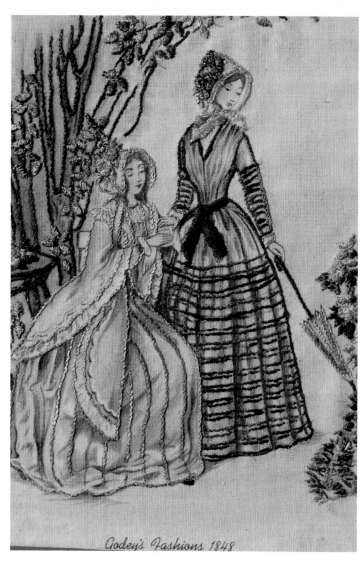

An embroidered picture taken from an 1848 *Godey's Lady's Book* fashion plate.

An early 1900s shepherdess fancy dress costume.

A circa 1899 fancy dress costume of an unusually short length.

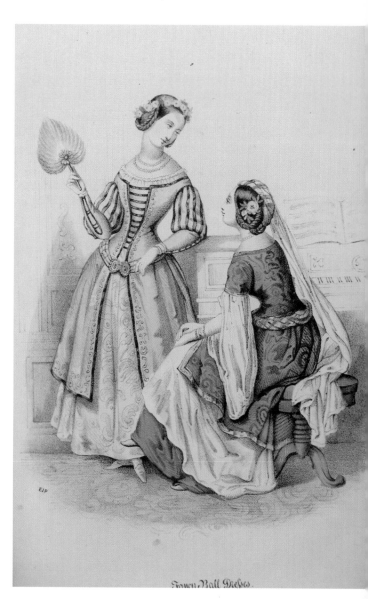

An 1845 fancy dress fashion plate.

An 1845 fashion plate featuring cape and coat styles.

An 1842 *Godey's Lady's Book* fashion plate illustrating how mittens, scarves, and headdresses were coveted by fashionable ladies.

An abstract "field of flowers" fancy dress costume from 1913.

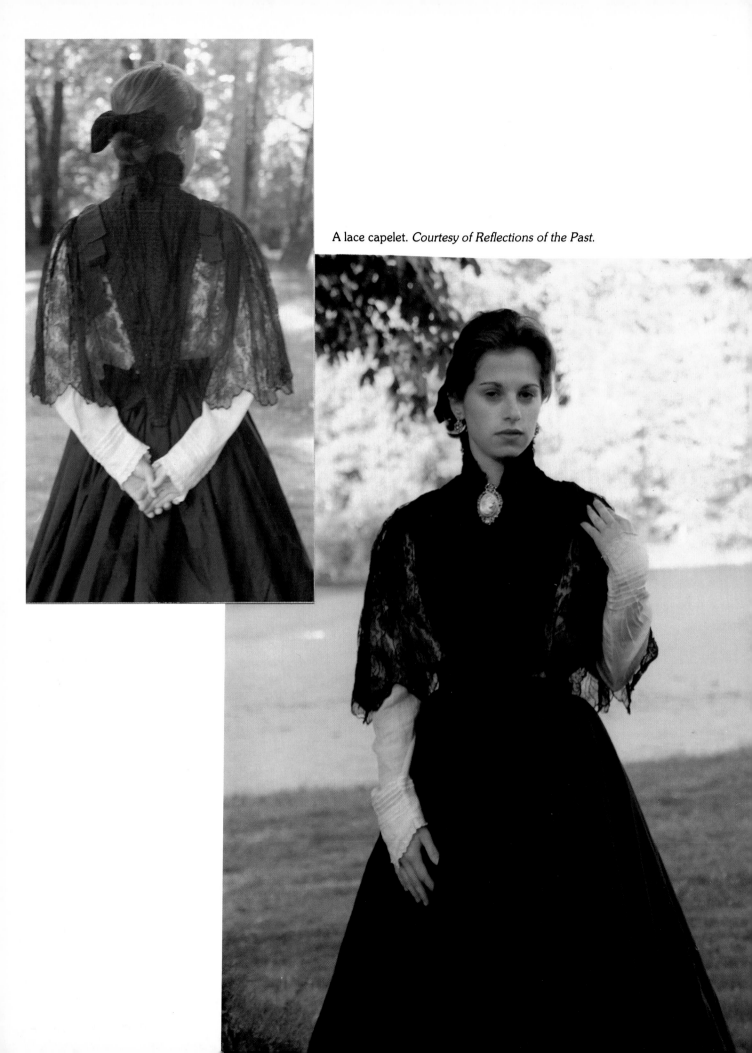

A lace capelet. *Courtesy of Reflections of the Past.*

Chapter *Four*

1850s: Whoop For Hoops

"Captain Lucust, of the Metropolitan Force, having chased two notorious Burglars to a house in Water Street, proceeded to search the premises," *Harper's Weekly* reported in 1857, "but...he obtained no trace of them till he entered a closet which the lady of the establishment used as a Dressing Room. There, at infinite risk, he succeeded in dislodging fourteen Herculean Brigands from the inside of a Fashionable Hoop." And so it was that in the 1850s hoopskirts became the favorite subject of newspapers and magazines—both on and off the fashion pages. Despite the possible criminal implications of hoops, *Harper's* also reported that a fashionable lady and her husband got caught walking in a violent thunderstorm; "The gentleman," they reported, "received a severe shock, but the lady escaped uninjured, the steel hoops which expanded [her dress] proving a perfect lightning conductor. She was terrified and fainted away, however; but here the hoops proved their utility in another direction, and supported her, so that it was impossible for her to fall to the ground." Therefore, *Harper's* concluded, hoops had at least one good purpose.

While certainly such accounts were told tongue-in-cheek, there is little doubt that increasing skirt sizes and hooped petticoats did take their toll on society. In New York City, for instance, women wearing hoopskirts took up so much extra space on omnibuses that higher fares were charged for them. And on the opposite side of the nation, where pioneers were settling, hoops had become so utterly impractical for ladies that a woman who wore them was in danger of being thought a prostitute.

The 1850s also saw the rise of another important invention: the sewing machine. Though at first dressmakers were skeptical of the machine, by 1857 it was in regular use and was making an impact on fashionable clothing; because the time involved in creating clothes was now considerably shortened, the average woman could now afford to use more trimmings. It would take nearly another decade for the sewing machine to make its full impact upon American society, however.

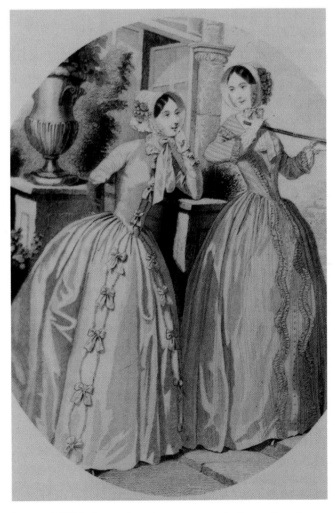

A circa 1850 fashion plate depicting simple, but soft and feminine, styles.

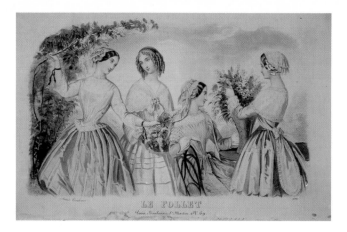

A fashion plate from 1858, showing 'everyday' clothes.

Skirts

By the Fifties, a skirt three yards at the hem was not unusual, and ultra-fashionable ladies sometimes wore skirts taking up five yards at the hem. During the first half of the decade, before hoops were worn, skirts were frequently lined with stiffened muslin or crinoline. Hems were sometimes also trimmed with braiding to help add stiffness. One period magazine even reported that some of the better dressmakers were placing "slight whalebones" in skirts in order to give "the ample fan-like form which is so graceful and so rarely obtained;" this technique, though by no means in standard use, was usually used in skirts of lightweight fabric. Because of the growing width of skirts, gathers were very rarely used, and pleats—especially flat pleats—became the norm.

Perhaps the most easily distinguishable feature of 1850s skirts were flounces. Though not all skirts from this decade featured them, a large number showcased two to four flounces, and the most elaborate garments had up to twenty. Fabric manufacturers took advantage of this trend by printing specially designed border prints which could be lined up along each flounce. By 1854, in the constant effort to achieve the bell shape, flounces were frequently stiffened with the likes of muslin, crinoline, or even straw. The last years of the decade saw the end of fashionably flounced skirts.

Occasionally, skirts featured a strip of fabric or a string about one-half the length of the skirt which was sewn to two sides of the waistband and could be matched up with buttons on the lower part of the skirt; the skirt could then be lifted on the sides to reveal a lavishly decorated petticoat. Skirts worn in the evening frequently had a looped-up look, usually trimmed with bows and ribbons.

Bodices

In the Fifties, women stole several articles of clothing from men. By 1851, ladies were wearing both waistcoats and vests—usually embroidered and decorated as lavishly as possible. But fashions were still quite feminine: snugly fitted bodices revealed curvy figures, and a profusion of ruching, braids, bows, and ornamental buttons covered ladies from head to toe.

Bodices were still lined and well boned, but now front fastenings were also fashionable. Sometimes bodices were even left open above the waist to show off an embroidered or cut-work chemisette or collar. With this new style also came a number of bodices that extended well past the waist and were gathered at the waistline in a peplum fashion.

A silk tartan plaid evening bodice. *Courtesy of Reflections of the Past.*

Two-piece sleeves that were fitted on top, loose at the bottom, and featured an undersleeve remained popular. By 1857, sleeves had widened considerably and the upper sleeve was often slitted to accommodate the fullness of the undersleeve. One-piece Bishop sleeves were also fashionable. Usually, all sleeves of the Fifties had a single seam, placed on the underside of the arm.

By 1854, necklines generally were ending at the base of the neck—though bodices worn in the evening still featured décolletage and often exposed the shoulders.

Paletots—draped, cape-like garments—saw a continual rise in popularity until their pinnacle in the 1860s. Jackets also became increasingly important to ladies and can be distinguished from those from some later decades by their lack of boning.

Dresses

Dresses from the 1850s were usually made up of a separate bodice and skirt; two bodices—one for evening and one for day—were still coveted by practical ladies. In almost every case, the skirt was fastened in the back, and the bodice in the front. This new trend of front fastening garments may have been due in part to new strides in button making. Pearl buttons, for example, are commonly seen on garments after 1855 because they could then be manufactured instead of being made painstakingly by hand. Advances in manufacturing also made ornamental buttons within the budget of most ladies—and with the invention of "split pins," they could easily be pinned onto one dress in the morning and then transferred to another in the evening; this explains why some dresses of the period lack buttons or any evidence that they ever had buttons.

The 1850s also saw the introduction of "the short dress," created for ease in walking; the dress was ankle-length—and not readily accepted by most ladies.

The use of trimmings on day dresses increased dramatically in the Fifties; ribbons, ruches, and braids were used as extensively on day dresses as they were on evening gowns. Jet became *the* trim for mourning clothes. Silk was the fabric desired by all ladies, but because so much fabric was necessary to create popular fashions, most women had to settle for brocades, challis, taffetas, velvets, and cottons. The "invisible" look was fashionable in summer evening gowns; gauzes, laces, nets, and mousselines were frequently chosen by fashionable ladies. Tartan plaids—a favorite of Queen Victoria—were worn extensively, both in this decade and the one to follow. Mauves, purples, and browns were favored colors. "Check materials," one upper-class period magazine claimed, "are not worn by the ladies, being entirely given up to the nether integuments of the sterner sex." Nonetheless, checked dresses are often found from this period.

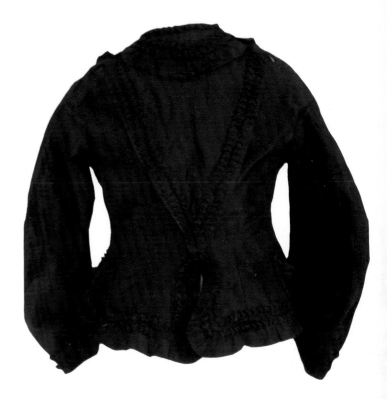

A basic bodice from the 1850s, showing the essential V-line. *Courtesy of The Very Little Theatre.*

Undergarments

By far the most important undergarment of the 1850s was "the artificial crinoline," or hoops. When the first hoops appeared around 1856, they were hailed as marvelous inventions because they eliminated layers of petticoats that wrapped around women's legs and made walking difficult. These early versions of the crinoline were usually petticoats with cane inserted into them horizontally. In 1850, *Godey's Lady's Book* also featured a petticoat with reeds inserted in it—but unlike most hoops, it was one-half the length of the skirt. Another variation shown was a corset with a hip-length peplum with hoops inserted through it. The "cage" crinoline was also available, which was made of a series of metal bands. Yet another variation was a combination of fabric strips and flexible steels extending from a waistband.

Though crinolines were much praised for lightening the load of clothes ladies wore, they certainly had their drawbacks. Most dangerously, they made it nearly impossible to save ladies from burning, and in fact, thousands of women were reported to have died because of the crinoline. On the lighter side, many gentlemen complained that American women weren't graceful enough to walk in hoops without wobbling; only ladies who took tiny steps could avoid this humorous gait.

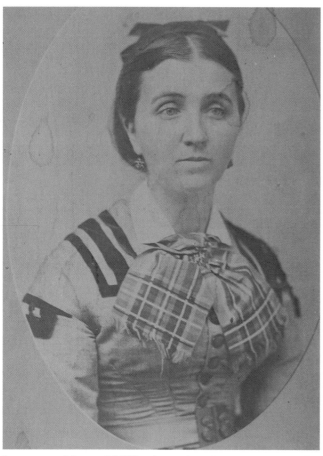

A woman of the mid-1850s, dressed in plaid, velvet, and silk.

Hoops, unfortunately, can be very difficult to date. One might think you could date hoops by the size of their circumference, but this measurement varied greatly according to personal preference. The average middle-class woman might wear a 50" hoop for day, but a 90" hoop for evening; while it would seem likely that a working woman would wear a moderate 45" hoop, many period photographs show maids and factory girls wearing 60" to 70" hoops. And while 1858 fashion magazines claimed "the hoop has reached its utmost extent unless our doors are to be made wider," the pinnacle of the width of hoops was 1860. However, just because one lady wore a 118" hoop in 1859, doesn't mean every lady did; according to period photographs, many ladies preferred 60" and 80" hoops in that year.

Some hoops will have manufacturer's labels attached to them; these hoops can sometimes be dated by locating the manufacturer's original ads in period magazines. It is important to point out, however, that crinolines from the 1850s were always perfectly circular; unlike crinolines from later decades, Fifties hoops placed their wearer in the absolute center of the crinoline.

Crinolines also brought about the regular wearing of another piece of underwear: drawers. The reason for this is told perfectly in a story about the Duchess of Manchester. According to Queen Victoria's lady-in-waiting, in 1859 the Duchess "caught a hoop of her cage in a stile and went regularly head over heels lightening on her feet with her cage and whole petticoats remaining above, above her head. They say there was never such a thing seen—and the other ladies hardly knew whether to be thankful or not that a part of her underclothing consisted of a pair of knickerbockers (the things Charlie shoots in)—which were revealed to the view of all the world in general and the Duc de Malakoff in particular." Indeed, though drawers may have been thought masculine, most ladies decided they were better than the revealing alternative.

A single petticoat, usually tightly gathered or pleated in back to accentuate the derriere, was now worn *over* the crinoline.

For some time having being virginally white, petticoats suddenly became popular in scarlet red when Queen Victoria was reported to have switched to the color "to reawaken the dormant conjugal susceptibility of Prince Albert." Another traditional garment—the corset—was still part of women's repertoire; however, because the width of skirts naturally made the waist appear smaller, it wasn't thought as necessary to lace up tightly, and corsets had a tendency to be larger. To the appreciation of many ladies, corsets could now be hooked open or closed in the front, in addition to being cinched up in back.

Underclothes, with these exceptions, remained virtually the same in the Fifties as they had been in the previous decade. Tucks and laces tend to be a little more prevalent in Fifties underwear, though the new ready-made undergarments were generally quite plain. There was also a trend in the summer months for so-called "invisible underclothing." Almost as intriguing as their name, these garments were created in the finest gauzes.

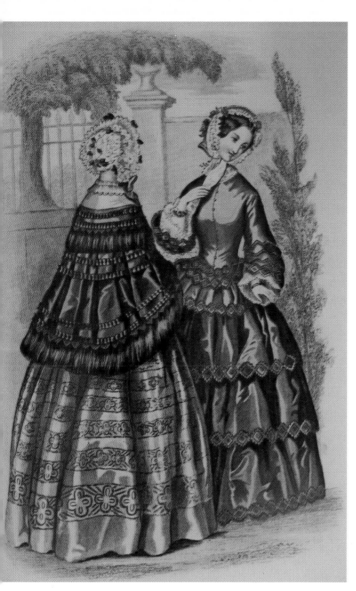

An 1855 fashion plate featuring sleeves worn over white undersleeves.

In keeping with this practicality, jewelry was often functional; chatelaines were a prime example. Though often elaborately decorated, these belt-like chains carried housekeys, scissors, and sewing tools.

A delicately printed lightweight wool dress, circa 1858. *Courtesy of Reflections of the Past.*

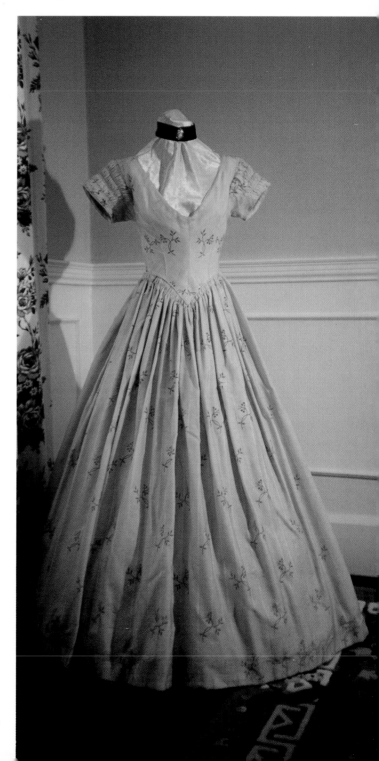

Other Important Garments

Bonnets, the darlings of the Forties, gradually became less and less obtrusive. Gradually, the face began peeking out from the bonnet's brim, and by 1855, the face could easily be seen in a lady's profile. After 1855, hats gradually began replacing bonnets—though bonnets would not go entirely out of fashion for some time.

But while "old fashioned" bonnets were slowly being ushered out, "old-style" pockets were once again coming into favor. Having been worn frequently in the early years of America, in addition to being worn by some in the early decades of the 1800s, detachable pockets that tied around the waist with string were once again being worn—this time, under the crinoline.

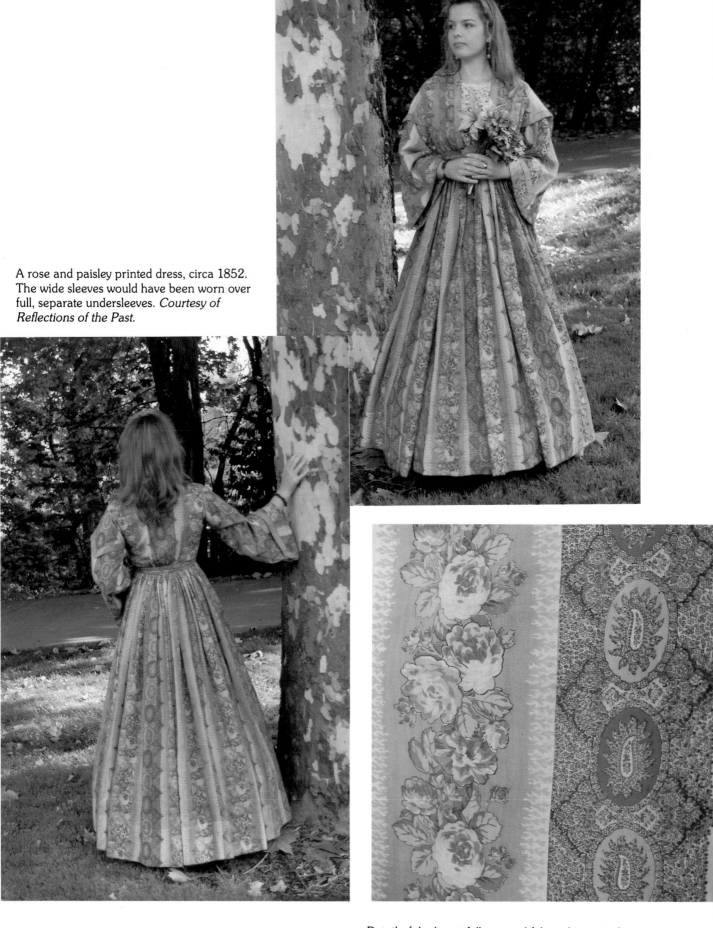

A rose and paisley printed dress, circa 1852. The wide sleeves would have been worn over full, separate undersleeves. *Courtesy of Reflections of the Past.*

Detail of the beautifully printed fabric shown in the previous two illustrations.

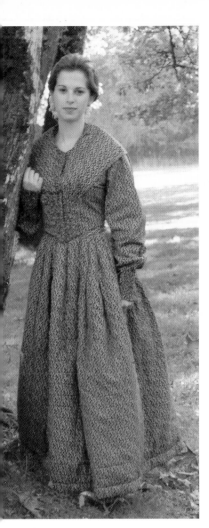

A finely quilted two-piece dress, circa 1850. *Courtesy of Reflections of the Past.*

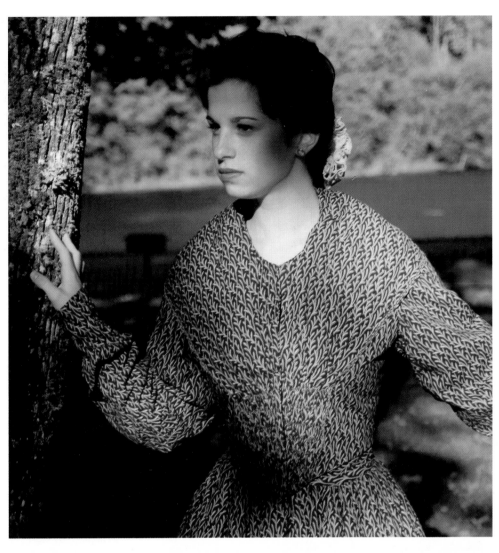

A circa 1859 fashion plate featuring a bride in a blushed pink wedding gown with a looped-up overskirt. The mother of the bride wears a simpler costume in shades of green and gold.

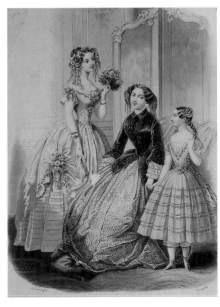

Detail of the inside of the dress pictured in the previous illustration. The fine quilting stitches are barely visible.

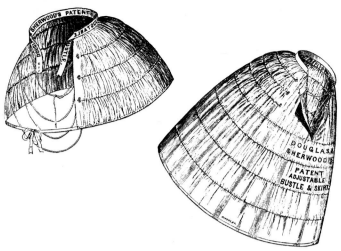

A hoopskirt much like the one from 1859 ,pictured in the photograph below, in addition to a much shorter version.

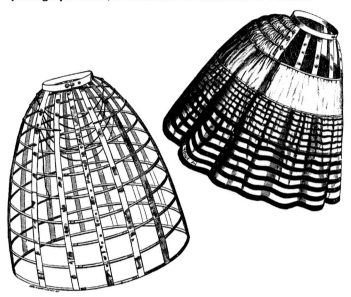

Two types of crinolines from 1858. The hoops on the left consist almost entirely of metal, while the hoops on the right feature decorative fabric.

A bustle–crionoline made of whalebone.

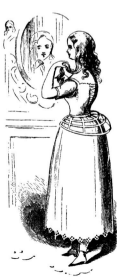

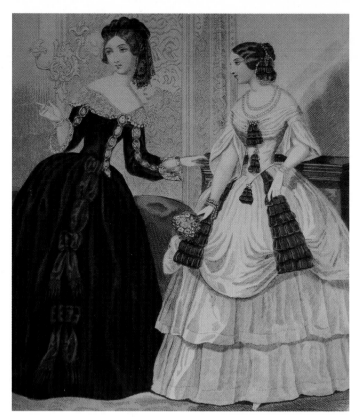

An 1850 *Peterson's Magazine* fashion plate featuring two exquisite evening gowns.

This hoopskirt made of cotton and cane is an amazing 116" in circumference; perfectly circular, it dates to 1859. The child's hoopskirt, which features an elastic waistband and snaps on the hoops (enabling it to be easily adjusted in length as the child grew) also dates to the same period. *Child's hoopskirt courtesy of The Very Little Theatre.*

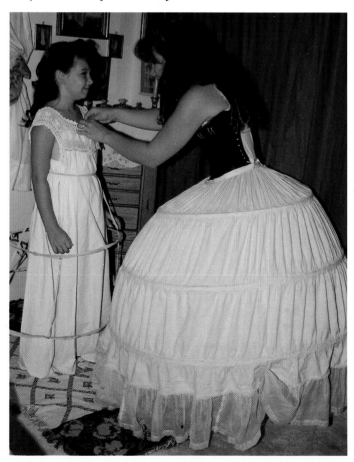

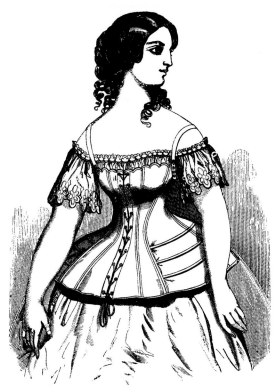

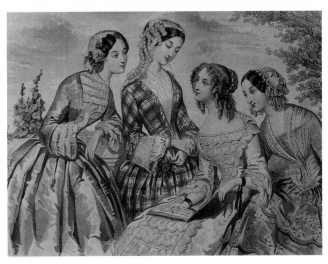

A *Graham's Magazine* fashion plate from 1859, depicting contemporary fashions as soft and flowing.

A "Douglas & Sherwood Tournure Corset," as featured in *Godey's Lady's Book*. This unusual item attempted comfort by combining the corset and hoopskirt into a single garment.

A delicate pair of soft and silky kid leather shoes, circa the late 1850s. *Courtesy of Reflections of the Past.*

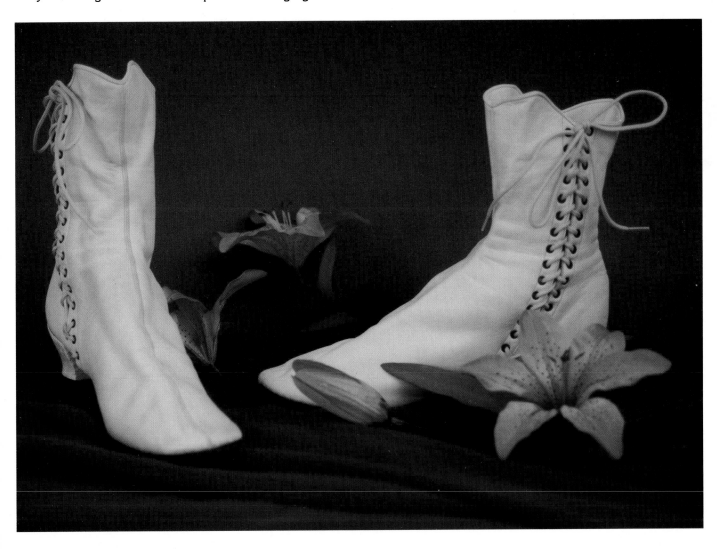

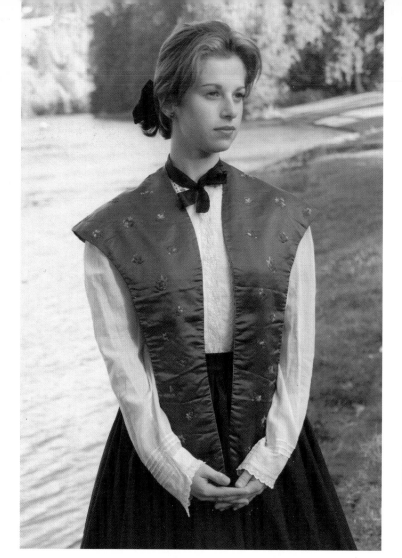

A silk embroidered shoulder cape. *Courtesy of Reflections of the Past.*

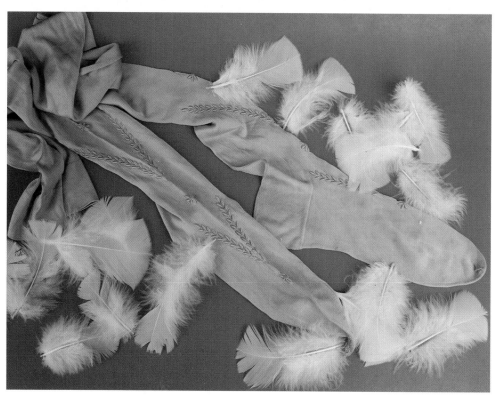

A pair of delicately embroidered silk stockings. *Courtesy of The Very Little Theatre.*

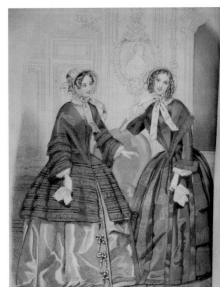

An 1850 *Peterson's Magazine* fashion plate featuring a fitted and flared jacket.

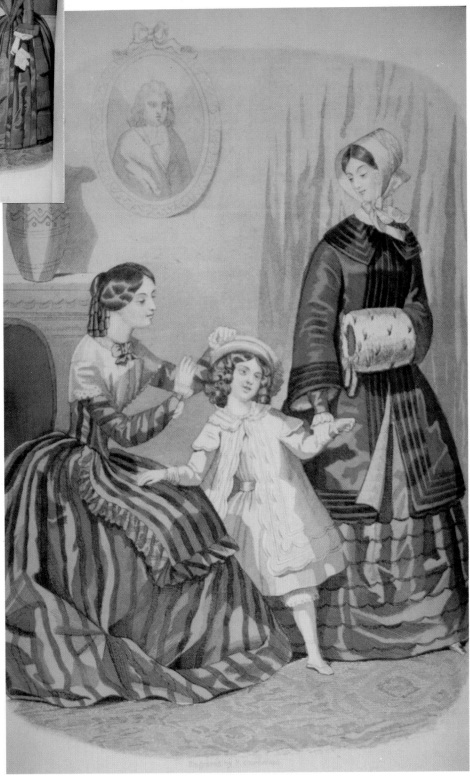

An 1850 fashion plate illustrating the clothing thought necessary for outings.

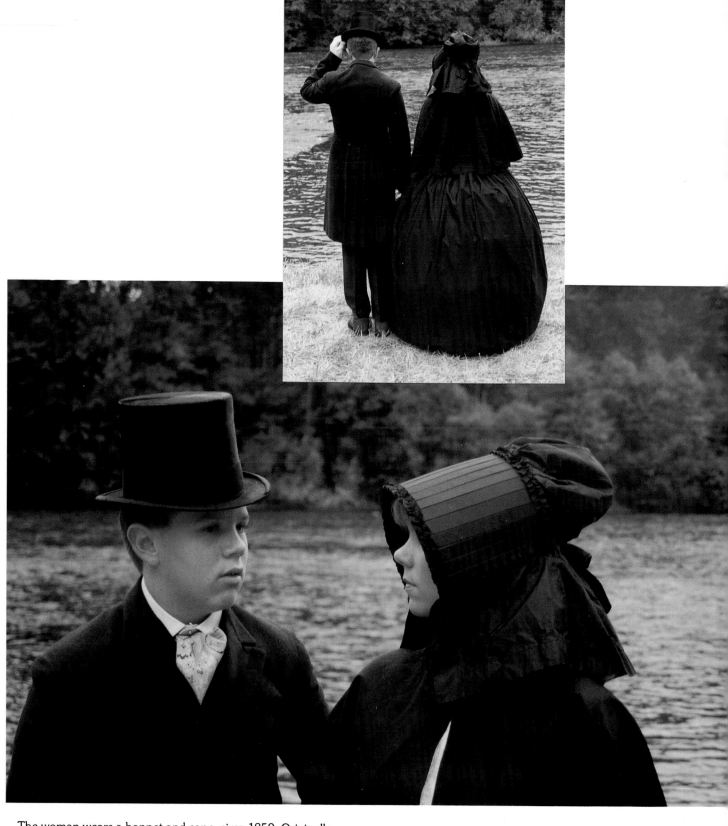

The woman wears a bonnet and cape, circa 1859. Originally worn by a widow while traveling from St. Louis, Missouri to Eugene, Oregon along the Oregon Trail, the bonnet features wooden slats in its stiff brim. The man's ensemble is also typical of the era, though the top hat was actually worn at the signing of the Treaty of Versailles (1919) by Solicitor General of the United States Fred Neilson. *Man's ensemble courtesy of The Very Little Theatre.*

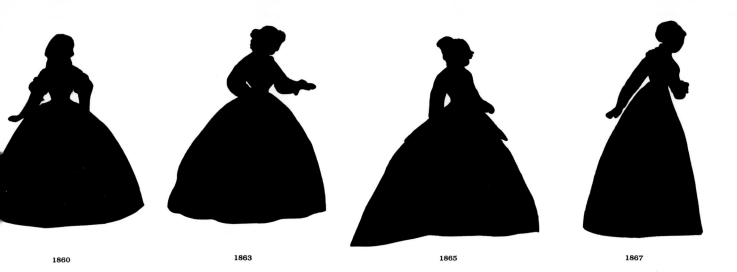

1860　　　　　　　　1863　　　　　　　　1865　　　　　　　　1867

Chapter Five

1860s: Transitional Years

The sewing machine's effect took its hold on women in the 1860s. Though not every woman could yet afford the machine, the majority of new clothes were sewn with it, and nearly every lady wished to own one—and with good reason, as *Godey's Lady's Book* pointed out. "Mrs. Mary R. Hubbard..." *The Lady's Book* praised, "earned with a Wheeler & Wilson [sewing machine] in 1868, $731.47, stitching 31,092 shirt fronts, equal to 886,122 feet of seam. At 20 stitches to the inch, this would give 212,669,280, an average of 708,891 per day, 88,612 per hour, and 1,477 per minute, or sixty times as fast as hand sewing...Sixty years in one!" This meant clothes made by dressmakers took far less time to sew, and were therefore less expensive—which may account for the increase in the average woman's wardrobe in the Sixties. Where once one or two dresses would be appropriate for a single day, now each day required a dress for morning, afternoon, visiting, walking, and evening.

By reading ladies' magazines of the period, one would hardly guess that a far more significant factor was affecting the way women dressed in America: the Civil War. America's most popular ladies' magazines spoke of matters of beauty and the toilet, marriage and etiquette, offered stories, poems, fashion plates, art engravings, and songs—but no mention of the war that was daily affecting every American's life. There was at least one exception to this, however; in 1864, a *Peterson's Magazine* reader wrote a letter that hinted at wartime: The fashions, they claimed, were becoming much too masculine. Though such a claim may be difficult for modern women to understand after gazing at period fashion plates filled with billowing skirts and petticoats, upon close examination the age-old tendency for women to dress in a more masculine fashion during periods of war is certainly evident. Jackets and vests were worn together in a suit-like fashion, decorated with rows of gold and silver buttons and stripes, and many blouses resembled men's shirts.

The war had other effects on women's clothing, also; in the South many items—including new fabrics and findings—were scarce. Just think of Scarlet O'Hara's ingenious dress made of old draperies. Fashion magazines (also scarce—remember Scarlet's complaints that she could no longer receive *Godey's Lady's Book?*) regularly featured designs created for "the hard times," from which old carpets, drapes, and utility fabrics could be fashioned into clothes. Similarly, in the North, though there wasn't as much of a scarcity of new fabrics, there was often a lack of information on new fashions, since mail was extremely slow, and often lost altogether.

Skirts

1860 was the pinnacle of width in skirts, seeing measurements of up to 120" in the hems of some skirts; however, while fashion plates of the era regularly feature skirts of this proportion and larger, the majority of women chose less dramatic widths.

Dresses

In the Sixties, though most dresses were one-piece, the bodice and skirt were usually sewn into a waistband one to two inches wide. Sometimes the waistline of dresses was raised slightly, allowing the bulk of petticoats, drawers, and hoops to remain at the natural waistline. There was also a fleeting attempt around 1864 to revive the high-waisted Empire look of the early 1800s, but it was not widely accepted.

Trends in dress decoration remained much the same as in the previous decade, though the mid-Sixties saw very little trimming; by the end of the Sixties, dresses were more heavily decorated. Throughout the decade, braided hems, piping, puffing, ruching, and fringe were popular trims.

Plaids remained popular, and large stripes and geometric prints became a new favorite. Reds, bright royal blue, emerald green, olive, silver-grey, mauve, gold, and magenta were used extensively throughout the decade. Taffetas and velvets remained popular, and satins, moires, alpaca, and sateen were also used frequently.

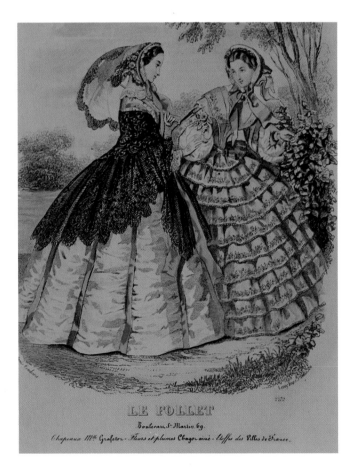

A fashion plate, circa 1860; the woman on the right wears a flounced dress featuring a border-print manufactured specifically for such designs.

After 1860, skirts evolved into an oval shape; around 1863, skirt fronts flattened; shortly after, the skirt's sides also flattened out; finally, the fullness of the skirt centered at the back, and included a slight train—giving the distinct impression that ladies were in constant, gliding motion, even when standing still. By 1869, the rear of skirts became larger than life and the bustle appeared. Indeed, the skirt was in a constant state of flux from the beginning of the Sixties; such a large amount of fabric was needed for fashionably wide hems that gathering—or even pleating—circular skirts was out of the question. So gored skirts appeared.

By 1868, skirts with flounces were definitely out of fashion. The new style was bands of contrasting fabric appliqued to skirt hems in geometric shapes. Pinked and scalloped edges also increased in popularity, and border prints remained fashionable.

At the end of the decade, when the bustle came into fashion, strings were usually sewn inside the back of skirts to control the fullness of the derriere. In fact, older, trained skirts are frequently found with strings which were attached in the late Sixties to help bunch up the old-style trains into new-style bustles.

Walking skirts from the Sixties often have loops of elastic on each side of the underside of the skirt, which allowed the skirt to be buttoned-up to the petticoat just below the waist. Author Gyp wrote in her book *Souvenirs d'une Petit Fille* about "short" walking skirts in 1863: "As they required less material and did not get dirty, everyone was wearing them. Day dresses that were not of the new fashionable length had *tirettes*, that is to say, cords sewn underneath to the bottom of the skirt which came out at the waist and were caught together with a button. One pulled the button and the dress rose like a tent over the petticoat which was held out by a cage [crinoline] and was always very elegant..."

Throughout the Sixties, skirts were often unlined—but hems were frequently stiffened with muslin about ten inches from the bottom. Some skirts from this decade are also totally lined with stiffened muslin or crinoline, and were probably worn by those who refused to adopt the cage crinoline.

Bodices

Bishop sleeves continued to be fashionable in the Sixties, and two-piece sleeves with detachable undersleeves became essential to the fashionable look—though by 1866, sleeves shrunk close to the

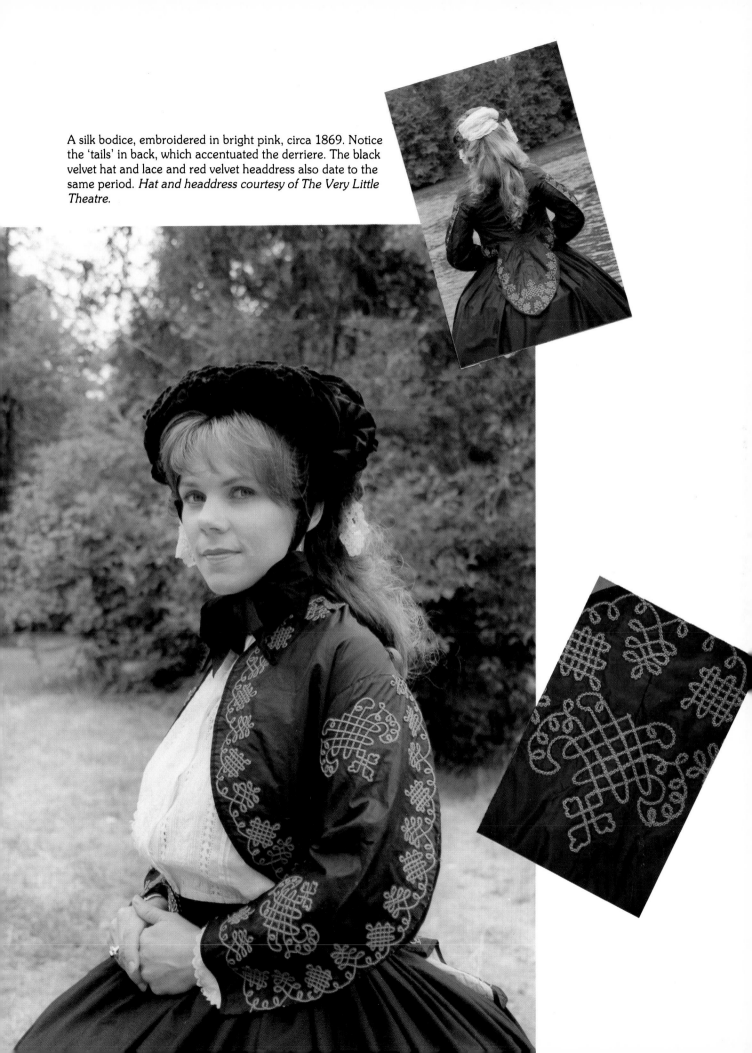

A silk bodice, embroidered in bright pink, circa 1869. Notice the 'tails' in back, which accentuated the derriere. The black velvet hat and lace and red velvet headdress also date to the same period. *Hat and headdress courtesy of The Very Little Theatre.*

entire arm. To look as though one had delicately drooping shoulders was once again the aim of ladies. This was achieved in the 1860s by placing the seam (where the sleeve and shoulder met) at the top of the arm; the shoulder seam was then stitched diagonally *behind* the shoulder near the neck, and several inches below the natural shoulder at the sleeve seam.

Necklines varied from the base of the neck to just slightly up the neck. Waists, in turn, were usually rounded and were frequently belted. Long, draped sashes were often worn around the waist up until about 1866. From 1866–68, bodices frequently included a peplum—especially if they were designed for evening wear. Watch pockets are often found in bodices of all types.

In the Sixties, boning in bodices usually consisted of two to three bones (only a few inches long) in the center front, and two bones four to six inches long on each of the bodice sides. Bodices which were pointed (in this decade, almost never seen except on evening gowns), usually relied more heavily on boning.

Undergarments

Crinolines were still a lady's most important undergarment—even some Catholic nuns wore crinolines under their habits; most ladies went without hoops only while horseback riding, swimming, or sleeping. At the beginning of the decade, crinolines usually had up to nine hoops in them—though some fashionable evening gowns were worn over crinolines containing up to eighteen hoops. From 1860 to 1866, crinolines varied in circumference from about 70" to 118"—according to their wearer's personal preference. Like skirts, hoops naturally changed in shape throughout the decade; for the first eight or so months of 1860, they were circular, then the front subtly flattened. By 1863, their sides flattened, also. Finally, in 1864, crinolines were shaped so that nearly all fullness was in the back. Crinolines worn in the day were often flatter in the front than those worn under evening gowns. By 1868, if a lady chose to wear a crinoline, it usually consisted of only three or four hoops suspended by fabric bands from a waistband, and wasn't more than six feet at the hem.

By 1868, however, the bustle had almost completely taken the place of the crinoline. In these early years of the bustle, it often looked like a modified version of the crinoline, usually consisting of a straight-fronted petticoat with a few steels or canes creating a fashionable hump at the back.

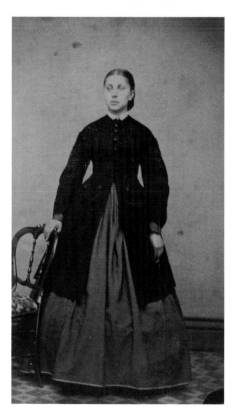

A middle-class woman of the Civil War era, wearing a simple ensemble.

Petticoats, still worn over the crinoline or bustle, remained virtually unchanged in the 1860s—though they were often made sleeker by goring. Petticoats were sometimes created especially to be worn under walking dresses and featured a profusion of scallops, tucks, lace, and ribbon. Sometimes the hems of these specially created petticoats were lined with oilcloth, for easier cleaning. Drawers were worn by most women in the Sixties; these either ended at or just below the knee and were still cut quite full. Sometimes they were also secured just below the knee by elastic or a buttoned band. "Those who are fond of gardening will find these most judicious things to wear," *Godey's Lady's Book* praised.

The snug, but not tightly cinched, corset remained important to ladies throughout the 1860s. Early in the decade, ladies learned a much shorter corset (usually ending just a few inches below the waist) suited their needs—and their comfort—much better than the long corsets of previous decades. While new types of corsets were almost constantly being thrust into ladies' laps, only a few caught women's attention. The "Thompson's Patent Glove-Fitting Corset" was one that had some lasting power. Manufactured with snaps in front—in additional to the traditional hooks—it was praised for preventing accidental openings.

The chemise was still worn in the Sixties and usually measured about one yard at the hem. Corset covers were also still worn. Undergarments in general were only occasionally made up in bright colors, white (and the intermittent red petticoat) remaining the most popular.

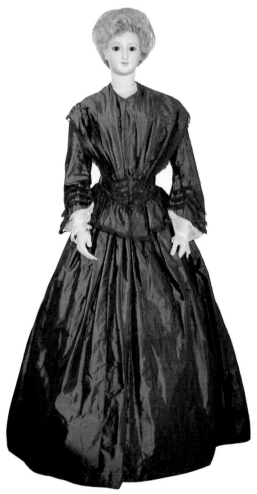

An iridescent dress trimmed with cobalt blue fringe. *Photograph courtesy of Reflections of the Past.*

Sportswear

The 1860s saw the genesis of a new kind of women's clothing: sportswear. Before this time, if a lady wished to partake in sports, she either did so in men's sporting clothes (if she was particularly brave), or in her everyday attire. Shorter skirts (usually reaching the top of the ankle) and sets of hoops which could be drawn up to the thigh or collapsed entirely were created for walking, hiking, and mountain climbing. But by far the greatest advances seen in women's sportswear in the Sixties were in bathing attire.

Before the 1860s, if a woman wished to swim, she either did so in the nude or in a long, shapeless, nightgown-like garment. But in the Sixties, much ef-

fort was made to make swimming an activity that men and women could enjoy together without being scandalous. Thus, the bathing suit was born. By 1863 fashion magazines wrote such things as: "The loose blue gown like a bottomless sack is no longer considered the right thing for a bathing costume and a little more attention is paid by fair bathers to avoid looking like down-right frights...Very pretty costumes are [now] made; trousers long and straight to the ankle in the shape of knickerbockers, and a long half-fitting casaque; or else a blouse-tunic with trousers; these are made in flannel of red, black with blue or red worsted braid; white is to be avoided for obvious reasons."

Other Important Garments

Small hats were preferred over bonnets by ladies of fashion. Other essential accessories included: paletots, square-toed shoes, mitts (instead of gloves), and snoods (which were little more than glorified hairnets).

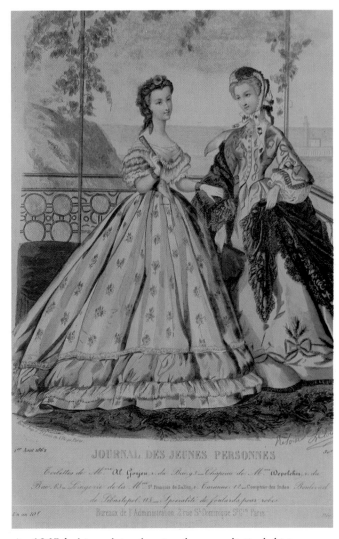

An 1865 fashion plate, showing the new eliptical skirt.

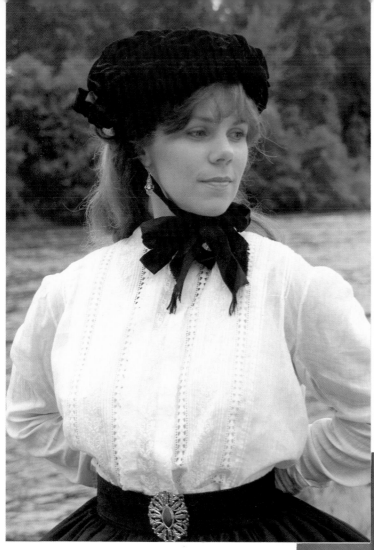

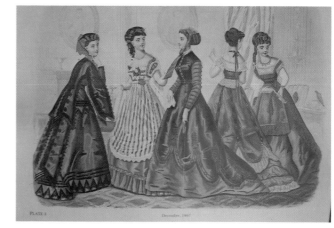

An 1876 fashion plate showing slightly raised waists and slimming skirts.

A shirtwaist from the 1860s, featuring lace insertions in front.

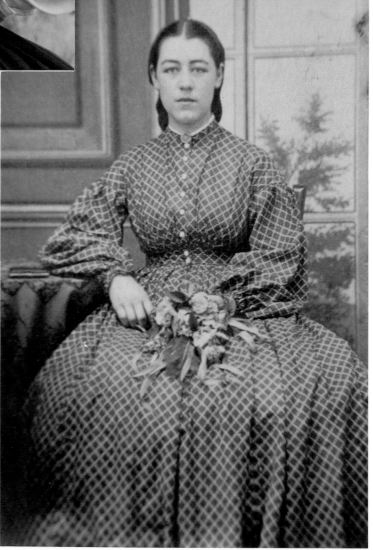

Glorious fashion plates aside, the average 1860s woman looked like this.

A jet beaded vest worn over a simple shirtwaist. *Vest courtesy of The Very Little Theatre.*

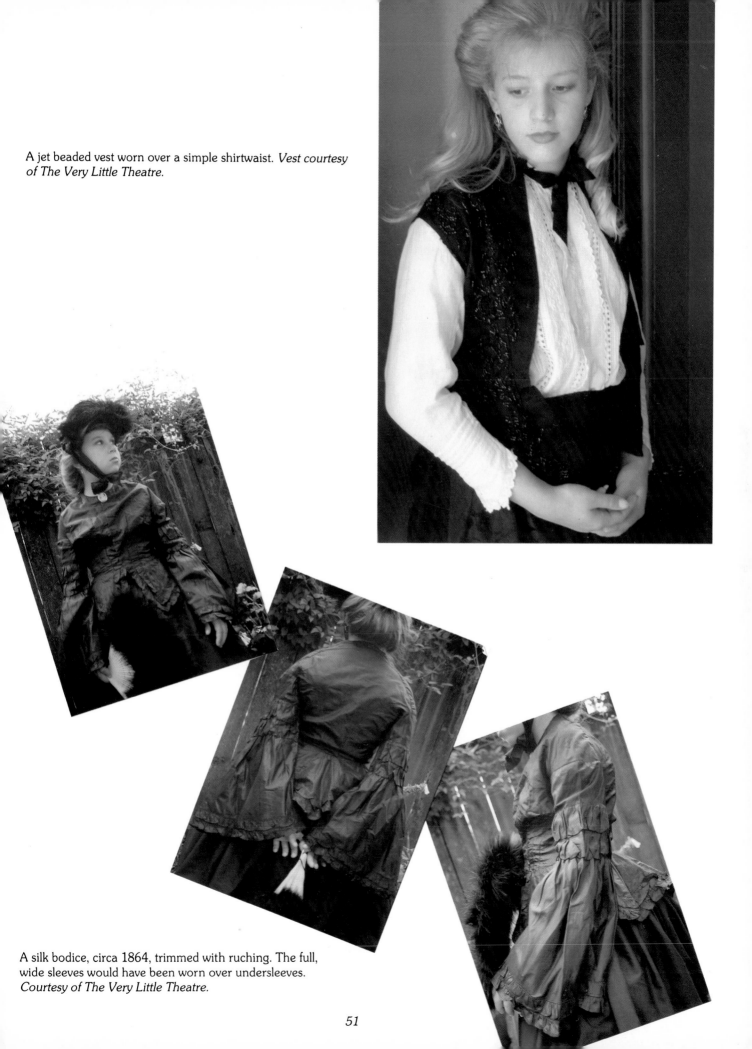

A silk bodice, circa 1864, trimmed with ruching. The full, wide sleeves would have been worn over undersleeves. *Courtesy of The Very Little Theatre.*

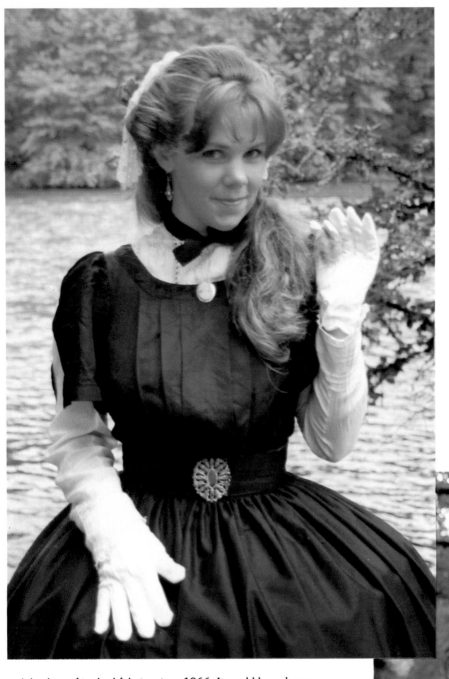

A bodice of tucked fabric, circa 1866. It could have been worn over a long-sleeved blouse, as pictured; it is more likely, however, that the split sleeves featured full, separate undersleeves. *Courtesy of The Very Little Theatre.*

This blouse, vest, and belt ensemble date to about 1862. Notice the black grosgrain ribbon-tie on the blouse. The belt consists simply of a wide grosgrain ribbon attached to a decorative metal buckle.

A paletot from about 1869. *Courtesy of The Very Little Theatre.*

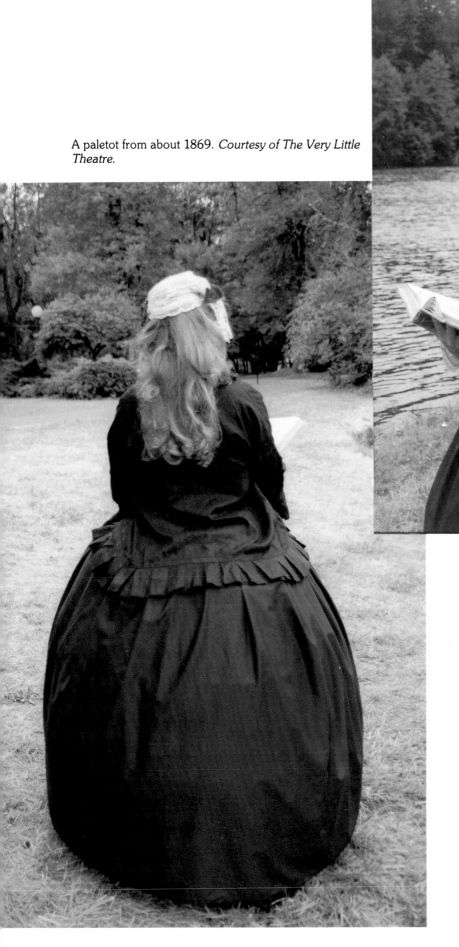

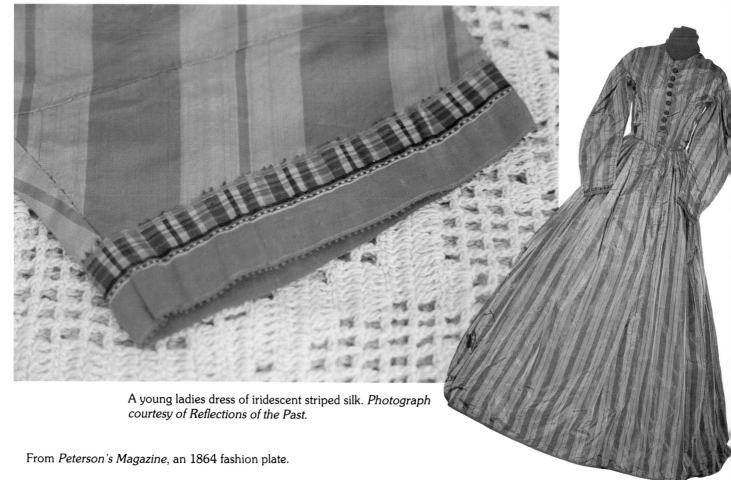

A young ladies dress of iridescent striped silk. *Photograph courtesy of Reflections of the Past.*

From *Peterson's Magazine*, an 1864 fashion plate.

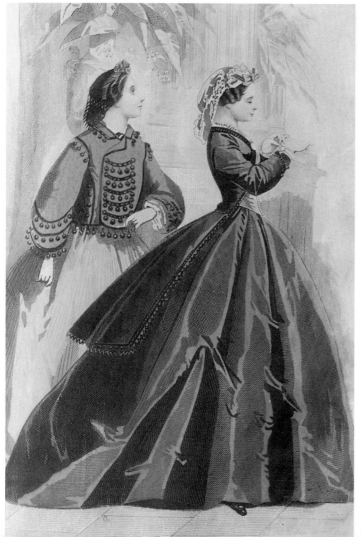

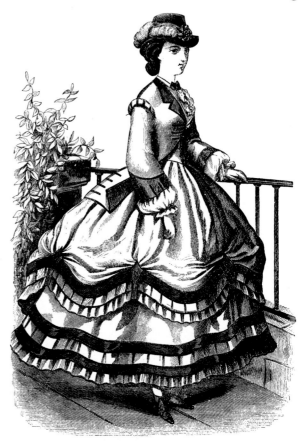

An 1864 'seaside' costume, featuring a skirt with a looped-up affect.

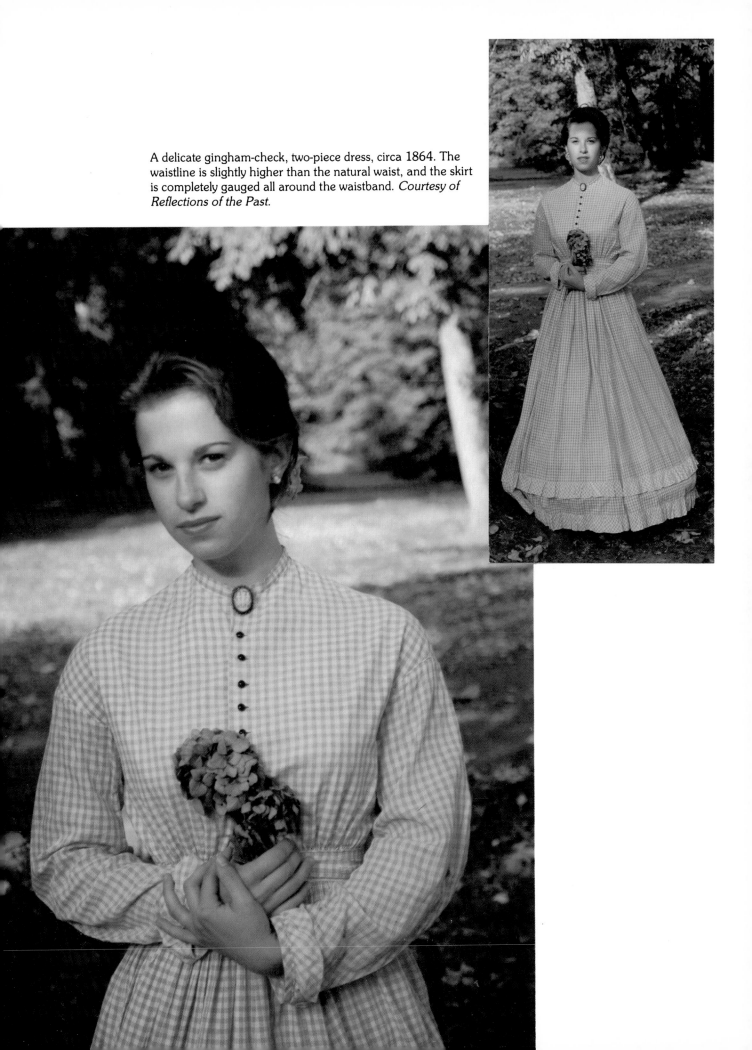

A delicate gingham-check, two-piece dress, circa 1864. The waistline is slightly higher than the natural waist, and the skirt is completely gauged all around the waistband. *Courtesy of Reflections of the Past.*

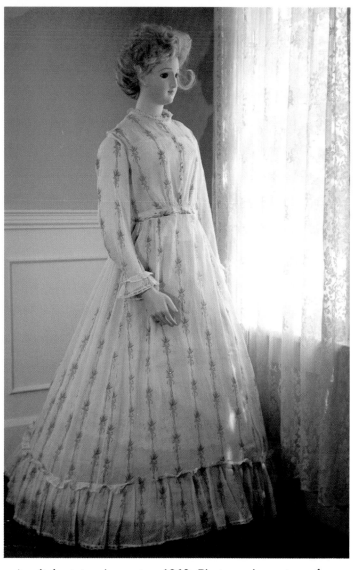

A soft, feminine dress, circa 1868. *Photograph courtesy of Reflections of the Past.*

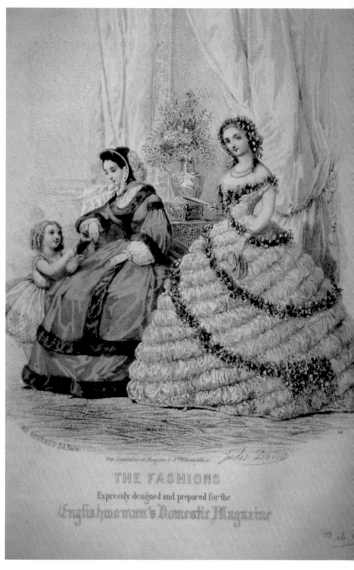

An 1861 *Englishwoman's Dometic Magazine* fashion plate, featuring an 'invisible' evening gown.

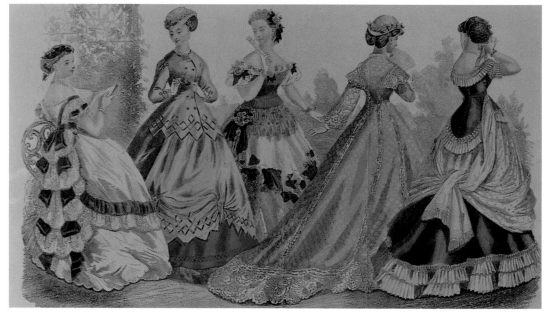

A circa 1867 fashion plate illustrating the new style in evening and visiting attire.

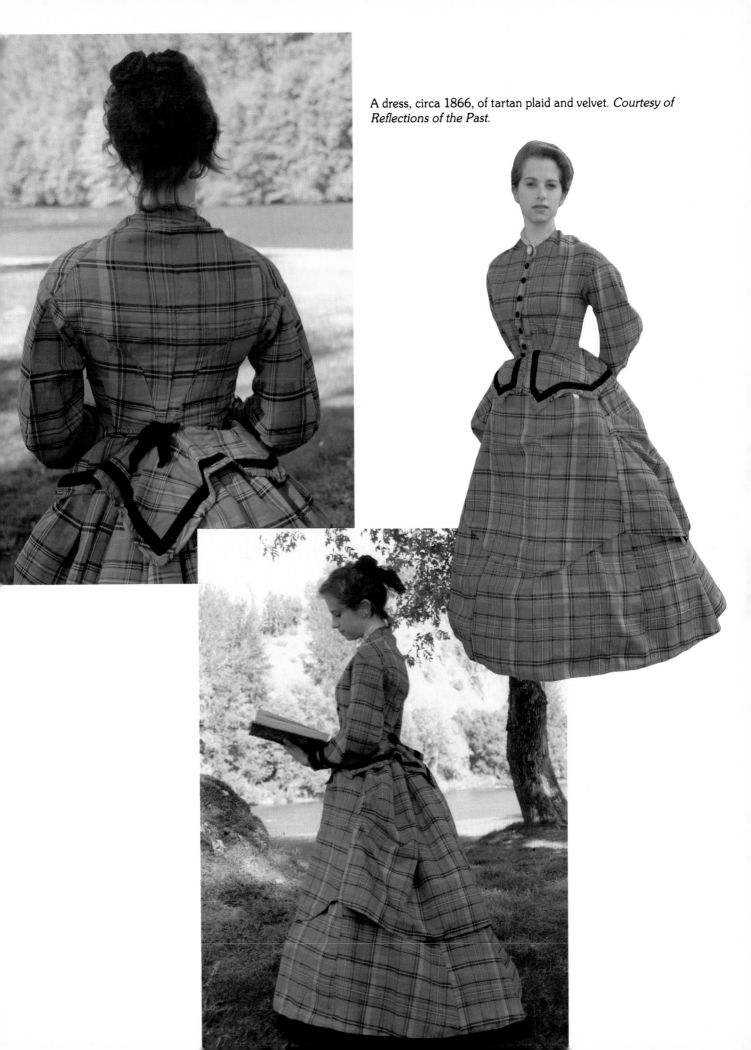

A dress, circa 1866, of tartan plaid and velvet. *Courtesy of Reflections of the Past.*

Detail showing the technique of gauging. Notice how two rows of stitching (here, in brown thread) are visible.

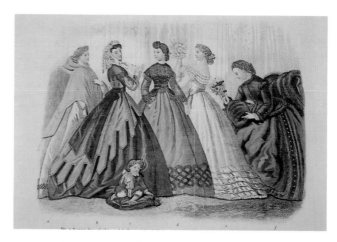

A fashion plate, circa 1865, featuring geometric designs.

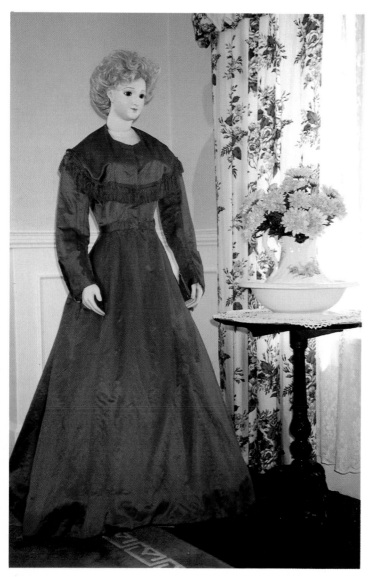

A stunning red gown, circa 1863. *Photograph courtesy of Reflections of the Past.*

A young lady's dress of iridescent striped silk. *Courtesy of Reflections of the Past.*

A circa 1869 dress with looped up sides which are held in place with tiny elastic loops and inconspicuous buttons. *Courtesy of Reflections of the Past.*

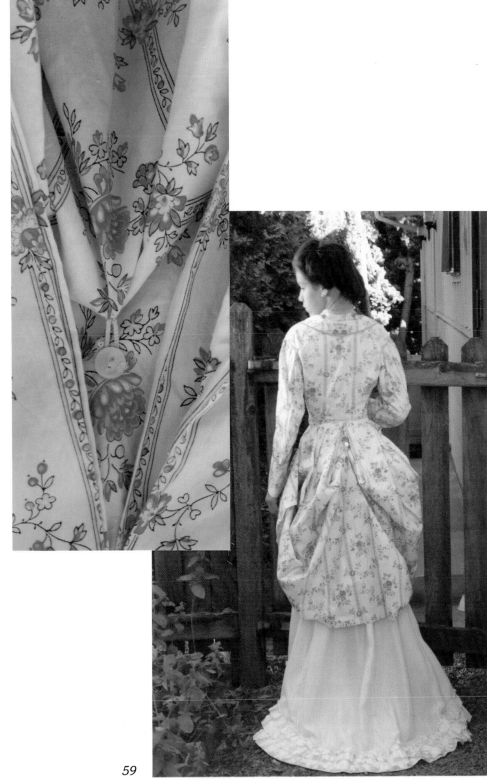

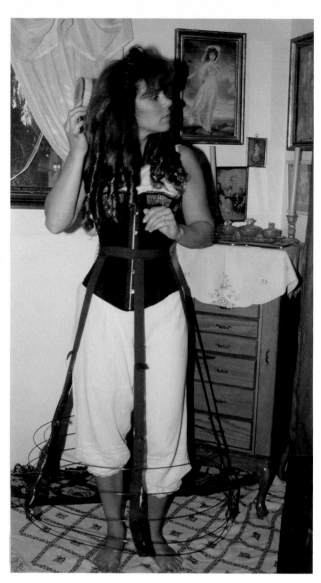

Two dresses from 1867. The dress below was featured in an August issue of *Godey's Lady's Book* and illustrates the type of dress worn just before the bustle began to take its hold. The more extreme dress on the left was pictured in *Godey's* in November of the same year and represents a fleeting period where Neopolian I style dresses were worn.

A circa 1862 hoopskirt made up of tape ties and metal hoops, and measuring 92.5" in circumference. *Courtesy of The Very Little Theatre.*

A corset from the early 1860s.

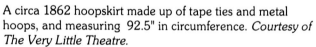

This 1860s woman wears a typically Civil War Era snood in her hair.

Two flannel bathing suits in shades of red, as featured in an 1865 *Godey's Lady's Book*.

A fashion plate from 1865.

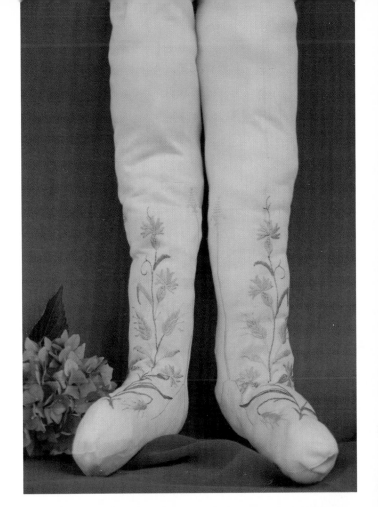

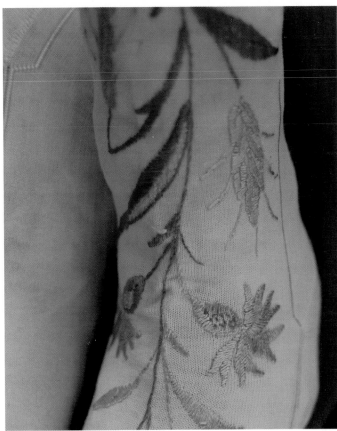

A pair of stockings, probably dating to the 1860s, embroidered in soft, natural tones. *Courtesy of Reflections of the Past.*

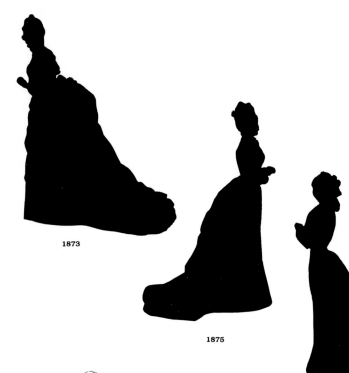

1873

1875

1877

of the mass-produced trims that had once been out of reach of their budgets. The result was often gaudy; with typical Victorian flair, ladies decided that if a little trimming was good—more was better.

Skirts

The typical skirt of the early 1870s was nearly straight in front (though not fitted), and flared toward the back, where pleats, gathers, or an apron-like peplum rested atop a bustle. Trains were worn on all but walking skirts. Long pleats, ruching, or other decorative trims were favored at the hems of skirts for both day and evening wear.

Chapter Six

1870s: Mermaid's Tale

"A Pittsfield feminine Sunday-school teacher recently...lost her Bible and didn't know where to find it," *Godey's Lady's Book* reported early in the 1870s. "When she got home, the book of books was found wagging along on the bustle behind her, where it had been placed by a member of her class." In the Seventies, the bustle took almost as much flack as the crinoline had in the previous decade. Supposedly created to help women with tightly cinched waists comfortably hold up the mass of material designers placed at their rears, bustles created for ladies a large shelf-life derriere.

In 1873, however, one fashion magazine claimed the bustle was not the most outstanding feature of fashion. "What will characterize the present epoch in the history of Fashion," they wrote, "is the amount of trimming with which we have found it possible to load every separate article, from the slipper to the monument we have agreed to call the bonnet." Indeed, by the Seventies, ladies were definitely taking advantage of the sewing machine's cost-effectiveness. Now that dressmaker-made clothes were more quickly created (and therefore, less expensive), ladies took advantage

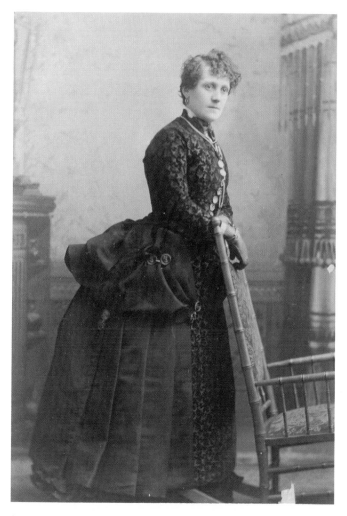

A photograph taken circa 1872 of a fashionable lady dressed in rich velvets and brocades.

A waist worn to an 1875 Christmas dance, featuring large buttons and ruching. The straw hat trimmed with feathers also dates to the same period. *Courtesy of The Very Little Theatre.*

By 1871, the apron-like peplum that had once only covered the derriere, could now also cover the front of the skirt, giving the appearance of an over-skirt. In 1873, the "Polonaise" skirt firmly took its hold on fashion. Designed to look like an over-skirt that opened in a ∧ shape in front, many underskirts were designed to look like lavishly decorated petticoats.

"Skirts are worn much closer to the figure..." one period magazine reported. "In order that the skirt may cling closely in front, it is usual now to border them with a fringe or to lead them." This snugness in skirt continued until, by 1874, ladies stood in front of a draped ellipse. By 1875, the bustle became much smaller. This trend toward slimmer skirts continued, and by 1879, skirts were nearly straight except for their trains. Ultra–fashionable women followed the look of fashion plates and wore dresses that outlined every curve of their figure. One fashionable lady wrote that if it weren't for women's "mermaid's tails" (their trains, that is), they would look as though they had "a towel wrapped 'round" themselves. At this time, also, fashionable ladies often swathed scarves or bands of fabric around their knees—which gave them a curious waddle and made walking upstairs nearly impossible.

All through the Seventies, skirts frequently contained strings sewn into the side seams—which were tied to the rear to control fullness and keep the front of the skirt flat. Skirt trains—much discussed as filthy things that swept the street—now had a new feature: *The balayeuse,* or "dust ruffle." Made of durable, washable fabric, these heavily pleated or gathered strips of fabric could be easily untied, unbuttoned, or, if tacked in place with loose stitches, ripped away from skirt hems to allow for easy cleaning.

Bodices

While rounded waists were still sometimes worn in the early Seventies, waistlines that came to a point at center front were most favored. Bodices were frequently created to look like jackets which opened in front and had a wide peplum in front and back. By 1874, bodices reached well beyond the waist, often extending over the belly.

In 1875, one period magazine complained that "bodices fit the figure as though they were glued there." Often corset-like in design, the chief variation in bodices was decoration; however, sleeves also added some variety to fashionable bodices. In the early 1870s, long sleeves, straight (but not too tight) above the elbow, and very full below it, were fashionable. Straight sleeves were also fashionable and usually featured lace, pleating, or tucks at the wrist. Melon puff sleeves appeared around 1872, and continued to be worn until about 1875. From 1875, straight, fairly plain sleeves were fashionable, sometimes featuring large, decorated cuffs.

Squared necklines were a strong feature during the Seventies, but rounded and V-shaped necklines were also worn. After 1875, necklines were generally high, rounding off at the base of the neck and sometimes topped off with a standing or falling collar.

Dresses

Beginning in the early 1870s, dresses were once again frequently made in two pieces—this time because the weight of bustled skirts pulled uncomfortably at bodices if the two pieces were attached.

One of the new and notable styles of the early Seventies was the so-called "Dolly Varden" dress, named after a Dickens character. Consisting of a full, bustled skirt worn over a polonaise-style bodice with a peplum, the dress was ridiculed by the upper class, but frequently worn by the average woman.

"The ideal at present," *Harper's Bazar* reported in 1875, "is the greatest possible flatness and straightness: a woman is a pencil covered with raiment." Though this report was greatly exaggerated, it did predict the loss of the cumbersome bustle around 1876. By 1879, Lilly Langtry—actress and ideal Seventies beauty—made fashionable the jersey dress. As the name suggested, the outfit consisted of a mid-thigh length bodice made of clingy jersey fabric (usually in red or blue) with a serge or flannel pleated skirt worn beneath it. Unfortunately, it was terribly unflattering to all but the trimmest, curviest figures.

Princess-style dresses—also clinging to the figure—were eminently popular between 1875 and 1881. Lined to the hips and boned fully in the bodice, princess dresses served to accentuate the hourglass figure. Unfortunately, however, their draped bustles and long trains gave women a definite mermaid appearance.

For evening, styles were virtually the same as for day; however, evening saw more cleavage than day dresses, and—as in the past—sleeveless styles were permitted at night. Though trains were also seen on day dresses, for evening they were most extravagant, measuring up to 70" in length.

Heavier fabrics were most favored in the 1870s, as were darker colors. Heavy silks, foulards, alpacas, and velvets were prescribed by fashion magazines; greys, black, maroon, plum, emerald, browns, and sapphire blue were recommended colors.

Undergarments

Occasionally bustles—hoops and all—are found sewn into dresses; this, however, is rather unusual. More often found are small pads or layered ruffles sewn to the rear at the waistband. Even so, separate bustles were worn by all fashionable ladies. Around 1872, stiffened fabric bustles made up of several ruffles and tied to the waist with a string were regularly featured in fashion magazines. Under these, a full-fledged bustle was usually worn. These often consisted of strong cotton in the shape of a straight (often frontless) skirt; inside the skirt, several strings were sewn to side seams and could be tied toward the rear in order to

control fullness. Some more severe bustles also contained flexible hoops at the derriere.

As the decade progressed, these awkward bustles were gradually replaced by lighter, smaller "wire baskets," made of pliable metals. By 1876, the bustle virtually disappeared until the early years of the next decade.

A jacket of midnight blue velvet, trimmed with silk ribbon, circa 1875. *Courtesy of The Very Little Theatre.*

The corset remained virtually the same until about 1875, when the new long, sleek look became fashionable; at this time, the corset grew in length, in order to help flatten the stomach. The Seventies also saw a new optional feature to the corset: suspenders. At first worn over the shoulder, then gradually attached to the corset, these new contraptions made their first marked appearance at Paris' *Grande Opera Bouffe*. Here, period newspapers tell us, the dancers appeared with "naked thighs" and suspenders holding up their stockings. Though it caused quite a row at first, it wasn't long before many ladies were wearing them daily—finding them much more comfortable than garters.

The chemise also took on a slightly new look by adopting the princess–cut, which allowed it to cling close to the figure. Drawers, now sometimes fastening closed with buttons, had a new rival: combinations. These new garments, designed to reduce bulk, combined the chemise and drawers all in one. The popularity of combinations was limited in the Seventies, however.

Around 1875, when dresses began growing more snug, some women abandoned the bulk of petticoats altogether. Such women then buttoned their skirts to the waistlines of their corsets and sewed a simulated petticoat ruffle to the hem of their skirt. More often, however, ladies wore one or two petticoats cut in gores for ultra-slimness.

Alternative Dress

Since 1800, a fleeting variety of fashion reform societies had existed. Either complaining that women's clothes were unhealthful, uncomfortable, or just plain ugly, these societies had varying impacts upon fashions worn by the masses.

The first alternative fashions to have any impact on contemporary fashions were 'bloomers', introduced around 1849 and named after a woman who greatly encouraged their use: Amelia Bloomer. These full, Turkish-style pants were frequently mocked, however, and were only adopted by a small number of brave women. Still, their long-term impact was great, and in the 1860s women adopted bloomers for swimwear; by the 1890s, they were also widely worn for bicycling, gymnastics, and hunting.

The 1860s also saw a small group of women wearing full trousers under knee–length skirts. Mostly worn by doctors and other scientists, such women were mocked for 'wearing the pants'.

It was in the late 1870s, however, that a more widespread form of alternative dress appeared. Unlike past dress reform movements, successful Seventies and Eighties alternative movements touted clothes more closely resembling contemporary fashion plates—except they were looser, lighter, and free from bonings and bustles. Though some women (mostly wealthy) choose to wear so-called "aesthetic" Grecian-robe-style reform dress, it was less radical styles—like those shown in Annie Jenness Miller's magazine *Dress*—that won the most favor. Such fashions varied from contemporary fashions in varying degrees. Some were no more than contemporary fashion plates, loosened for uncorseted waists; others were made up of less fashionable style lines.

This type of alternative dress had the strongest impact upon fashion. Most obviously, it made negligees (or teagowns) a more acceptably seen garment (many wealthy women wore these almost exclusively while resorting in the summer). 'Prairie' dresses of the 1850s through 1890s, also—of necessity—followed the general principals of alternative dress. By the early 1900s, a great many women choose to be entirely corsetless, and by 1910, looser dresses were widely worn everyday.

Alternative dress does pose particular problems for collectors, mostly because it can be difficult to identify and date. For instance, the difference between maternity and other types of alternative dress is largely undeterminable; only sack–like gowns with very little adornment can be called "maternity gowns" with much certainty. Then there are dresses like the one pictured here, which has fashion elements from several decades; the sleeves resemble the 1860s, but the skirt is definitely in the style of the late 1870s. Was the dress worn in several decades? Or was it simply styled without contemporary fashion held strongly in mind? Fortunately, studying alternative dress fashion magazines proved the latter to be most likely. However, not all collectors have access to such rare publications.

Still, the average collector *can* usually discern alternative dress from fashionable dress—and can keep their eyes open for more information which will aid them in dating these rare additions to their collection.

Other Important Garments

As corsets and dresses grew tighter in the second half of the decade, women increasingly favored the wearing of teagowns. Once only worn in the boudoir, it became more and more popular to wear them to the breakfast table and before morning outings. As more friends and family were apt to see the garment, it also became more and more elaborate, made up in silk or faille, and trimmed with laces, tucks, and trims.

Similarly, as clothes grew increasingly uncomfortable, house dresses became more important. Looser, more simplified, and washable garments, house dresses were largely frowned upon by elite fashion magazines, but certainly, a large number of women favored their practicality.

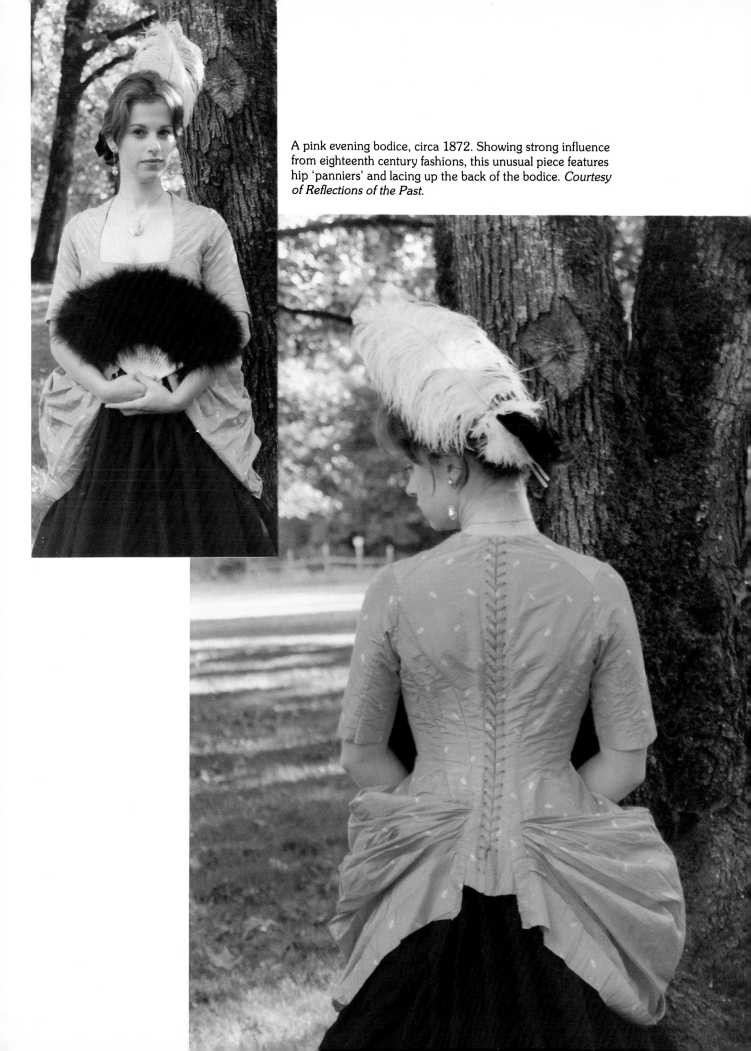

A pink evening bodice, circa 1872. Showing strong influence from eighteenth century fashions, this unusual piece features hip 'panniers' and lacing up the back of the bodice. *Courtesy of Reflections of the Past.*

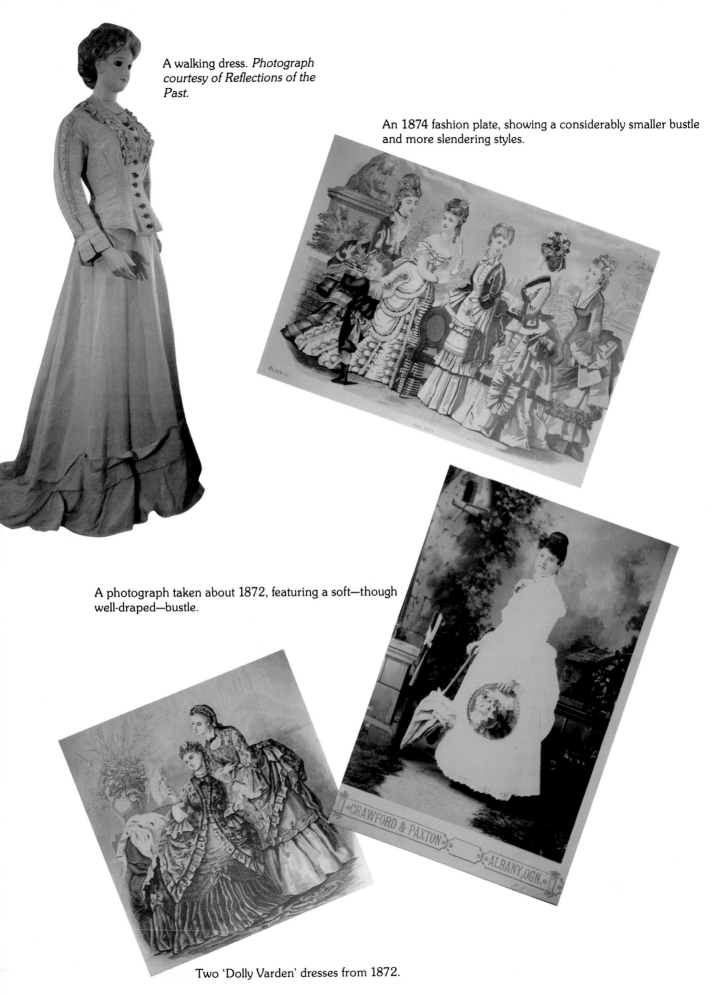

A walking dress. *Photograph courtesy of Reflections of the Past.*

An 1874 fashion plate, showing a considerably smaller bustle and more slendering styles.

A photograph taken about 1872, featuring a soft—though well-draped—bustle.

Two 'Dolly Varden' dresses from 1872.

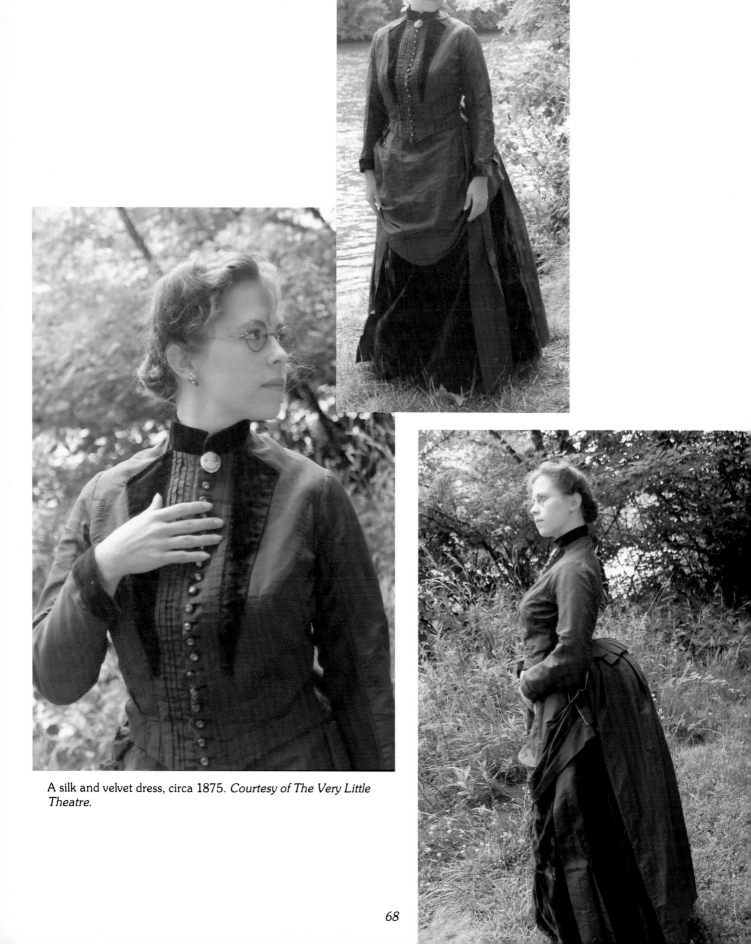

A silk and velvet dress, circa 1875. *Courtesy of The Very Little Theatre.*

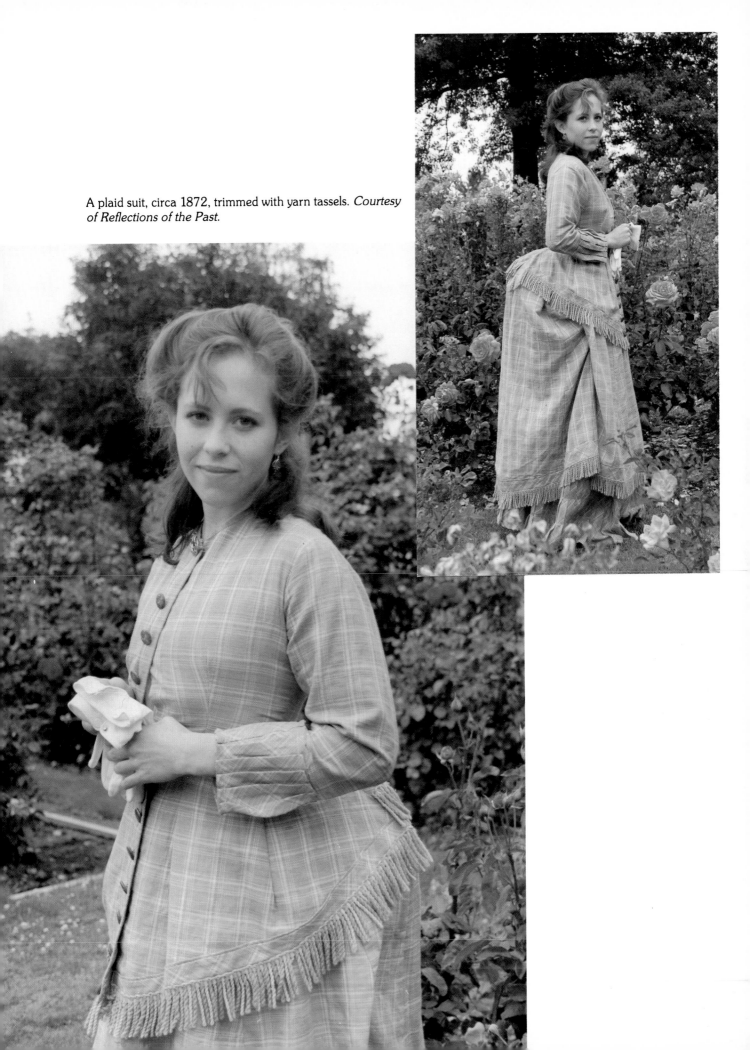

A plaid suit, circa 1872, trimmed with yarn tassels. *Courtesy of Reflections of the Past.*

A three-piece dress with a woven flower design, circa 1873.
Photograph courtesy of Reflections of the Past.

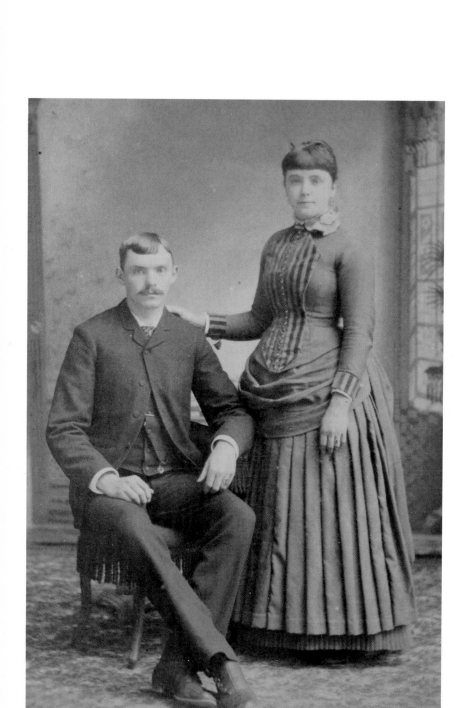

Kilt–pleated skirts worn under draped, bustle skirts were
considered a sensible style.

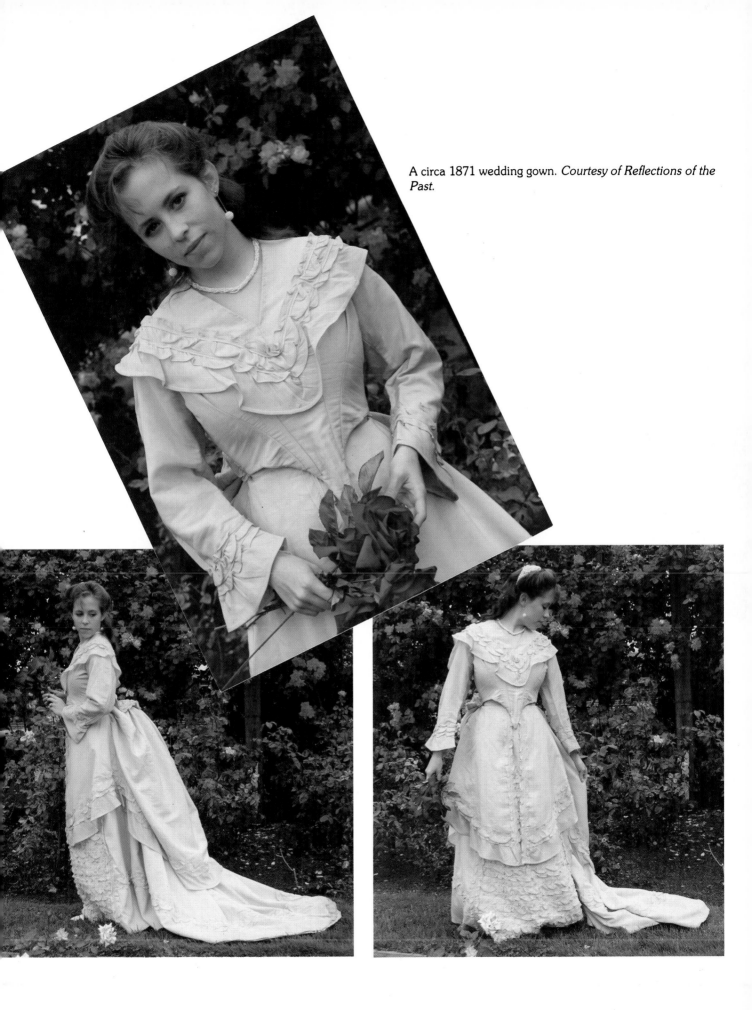

A circa 1871 wedding gown. *Courtesy of Reflections of the Past.*

A fashionable lady photographed in 1876.

An 1877 fashion plate, featuring snugly-fitted, trained dresses.

A fashionably round lady dressed in a bustled gown trimmed with ruching. Circa 1874.

A 'prairie' dress. Though farm and ranch women couldn't wear snug-fitting dresses of silk or satin, they managed to incorporate a great deal of fashion into their cotton and wool dresses. *Courtesy of Reflections of the Past.*

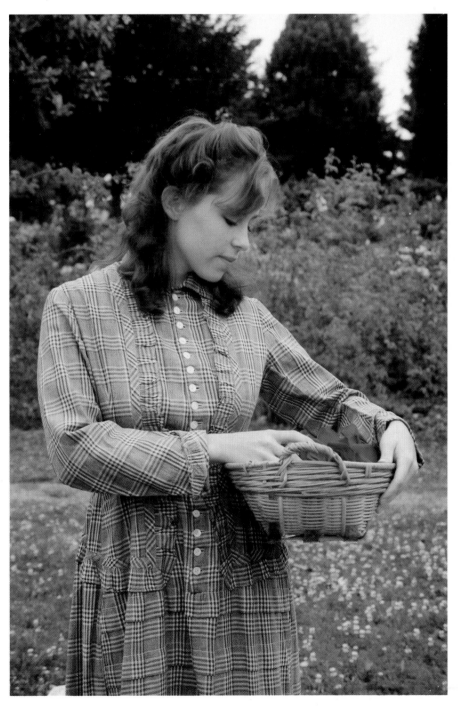

A 'mermaid' style princess dress, circa 1876. Profusely ruched in front and tucked along both sides, this dress hugs the figure closely.

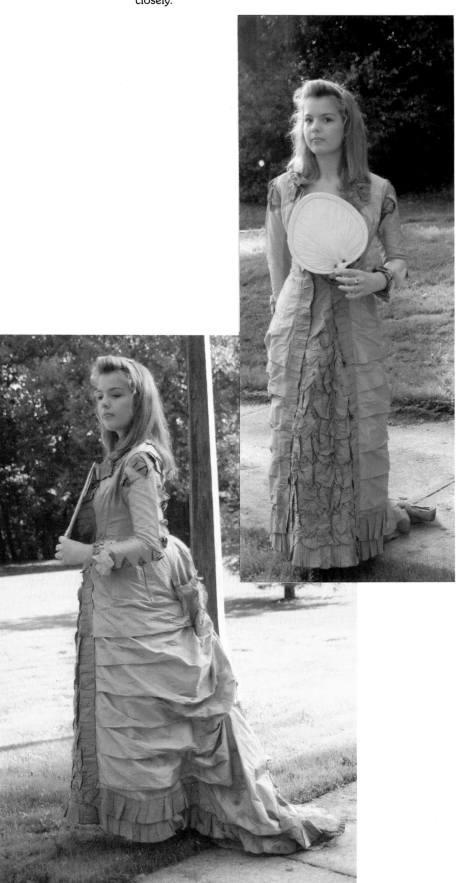

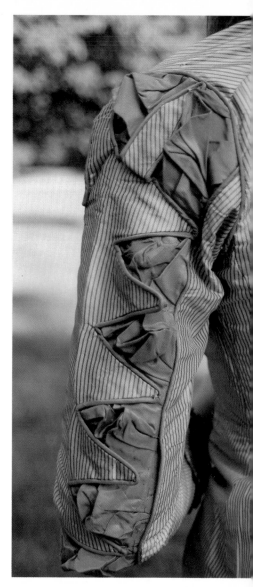

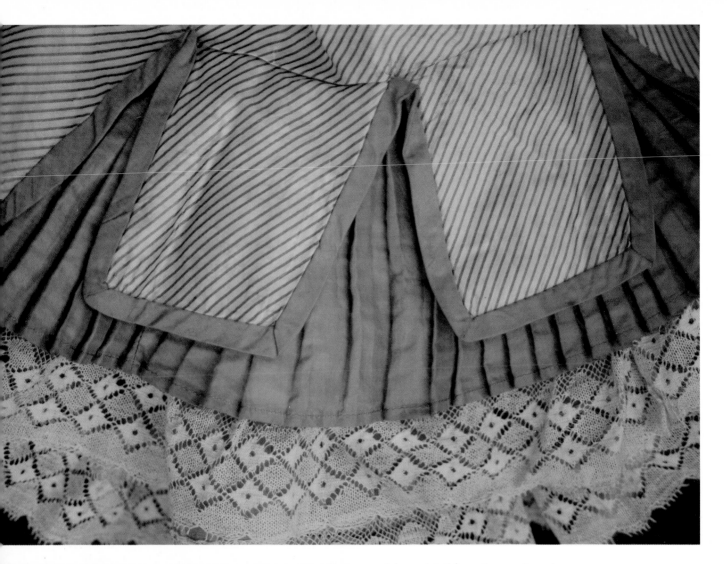

A hem detail from the previous dress.

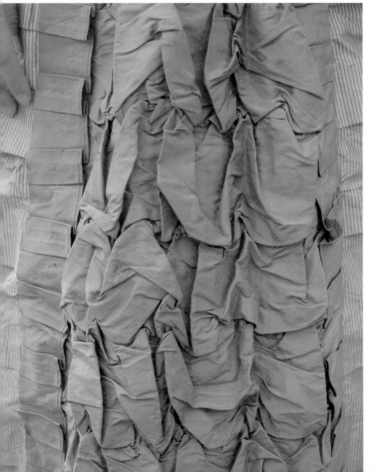

A detail of the ruching on the previous dress.

A young bride wearing a 'mermaid' style dress, circa 1876.

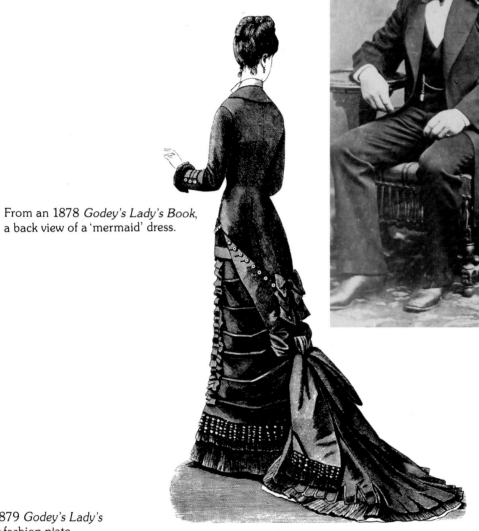

From an 1878 *Godey's Lady's Book*, a back view of a 'mermaid' dress.

An 1879 *Godey's Lady's Book* fashion plate.

Detail of the inside of a bustled skirt, circa 1875. The strings, located at center back, controlled the fullness and drape of the bustle.

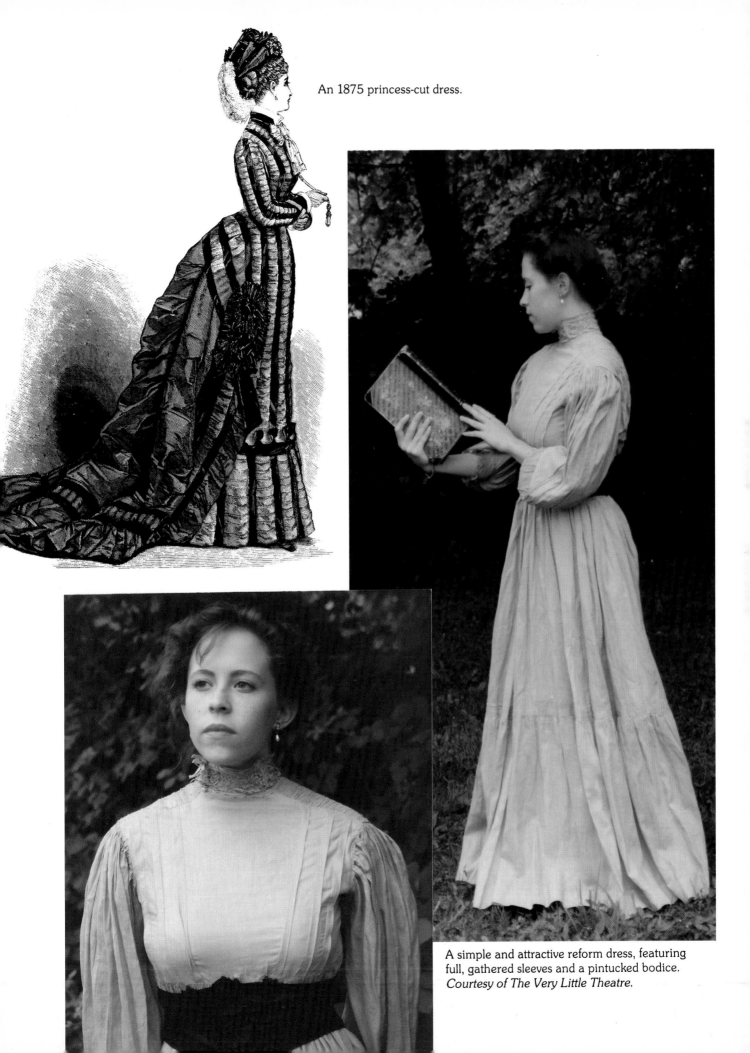

An 1875 princess-cut dress.

A simple and attractive reform dress, featuring full, gathered sleeves and a pintucked bodice. *Courtesy of The Very Little Theatre.*

When bloomers were first introduced, they were widely ridiculed, though some brave, forward-thinking women did adopt them, as illustrated in this fashion plate.

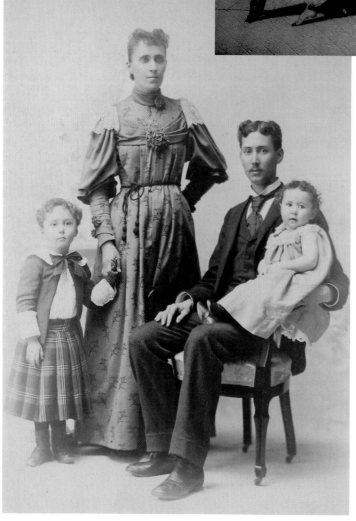

An 1890s photograph featuring a woman in a maternity dress.

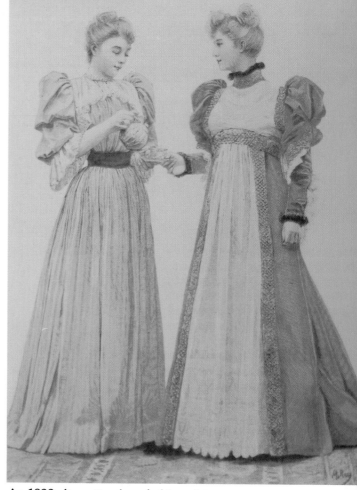

An 1893 alternative dress fashion plate.

A reform dress of silk and corduroy, which contains style lines
from several decades.

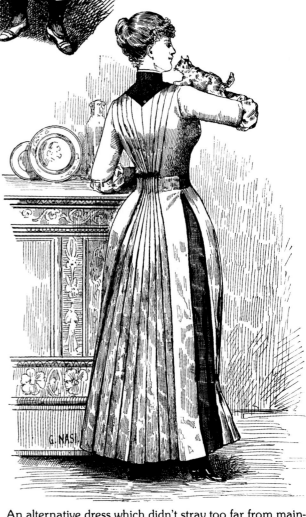

While mainstream fashion dictated that women wear 'everday' attire while playing tennis, this fashion plate from an issue of *Dress* illustrated a more pratical outfit.

It was usually only the wealthy who indulged in the Grecian robe-style alternative dress.

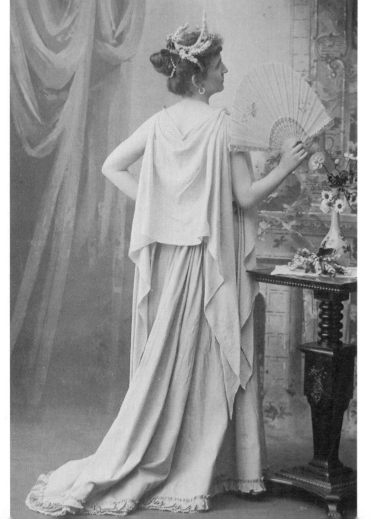

An alternative dress which didn't stray too far from mainstream fashion.

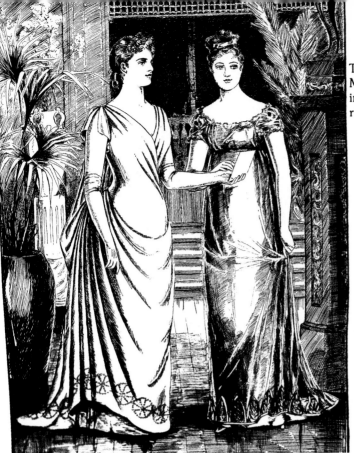

Two alternative dresses as they appeared in Annie Jennes Miller's magazine *Dress*. The costume on the left takes its inspiration from Ancient Greece, while the garment on the right is based upon Napoleon I fashions.

An embroidered silk robe, circa 1876, lined in quilted silk and fastened with cord toggle. This princess-cut robe has never been worn-the tassels hanging from the waist are still wrapped in their original paper. *Photograph courtesy of Reflections of the Past.*

A reform dress featured in an 1880 issue of *Dress*.

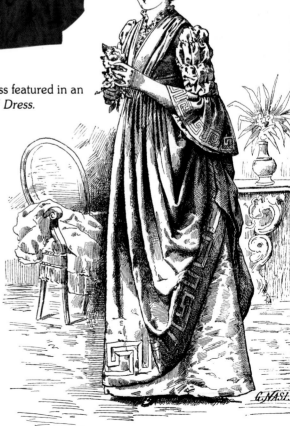

Wire mesh bustles, as they were advertised in *Dress*. Designed to give ladies a fashionable look, these bustles varied from most others in that they did not extend down the legs and were made of lightweight materials.

81

A negligee, circa 1875, consisting of a trained underskirt and a slightly bustled over-dress. *Courtesy of Reflections of the Past.*

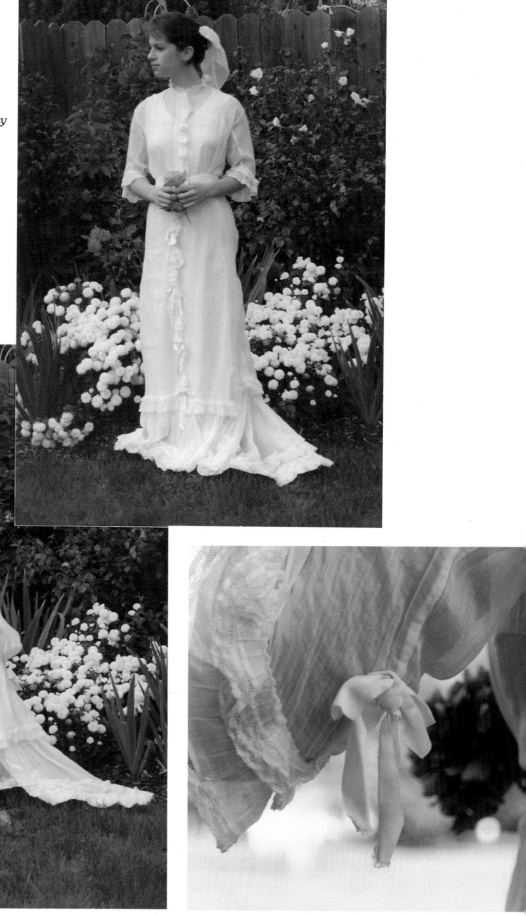

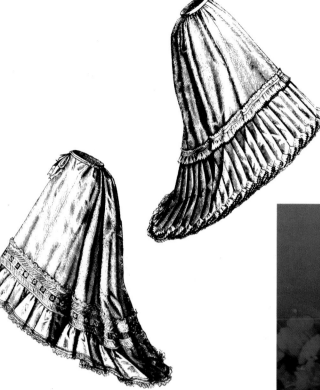

Two petticoats, as pictured in an 1872 issue of *Harper's Bazar.*

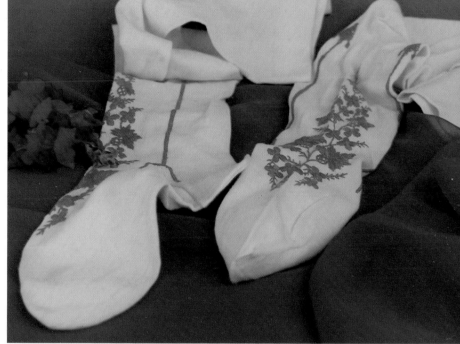

Stockings embroidered in brilliant red, probably dating from the 1860s or 1870s. *Courtesy of Reflections of the Past.*

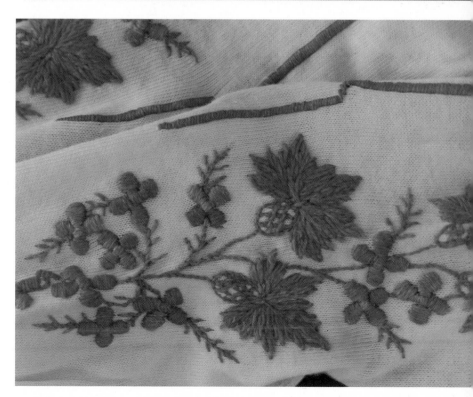

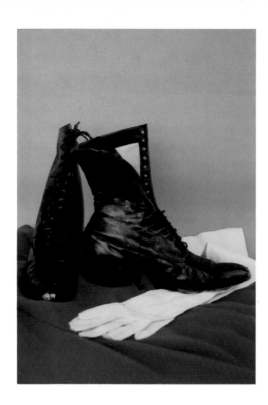

A pair of 'everyday' shoes, with flat heels and wide toes designed for comfort.

A circa 1875 goat-hair mantel with a great deal of Oriental influence. Containing the label "Halling, Pearce & Stone, Waterloo House, Pall Mall & Cockspur St., London," this is an unusual and stunning piece. *Photograph courtesy of Reflections of the Past.*

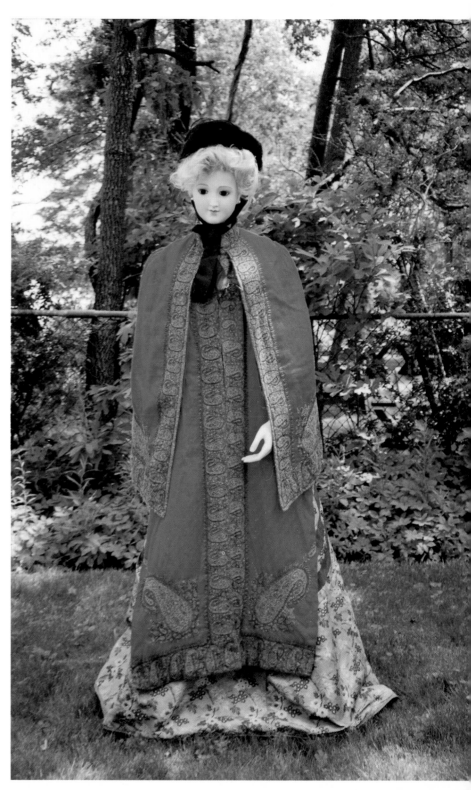

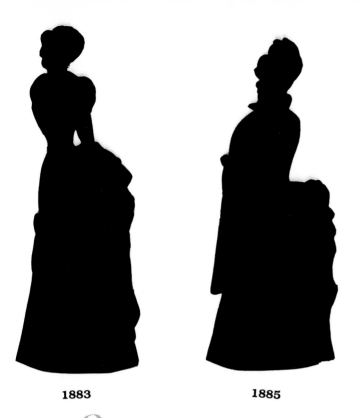

1883 1885

Chapter *Seven*

1880s: Bustles Up To Athens

While the aesthetic dress movement grew, even those not inclined to don Grecian robes or stayless gowns perhaps found some fashion freedom in the 1880s. Never in the Victorian era were fashions so erratic; "no two persons dress alike," period fashion magazines claimed. American women had a new-found sense of individual style and many liberties were taken in color, fabric—and especially trim. But there were still intense fashion trends that governed what ladies wore. In the Eighties, perhaps the most obvious rule of fashion was that, as one period fashion magazine put it, "simplicity is out of fashion. Present modes are observable for glitter and glare, varied and intricate patterns...[and] amalgamations of colour."

One other increasingly important element of fashion was the rise and fall of the bustle. In the early Eighties one contemporary fictional character exclaimed his amazement at what fashionable women looked like in "the big city:" "Some of the ladies had bustles on that would have literally throwed the whiskers, and the thing that wore them, entirely in the shade...I saw bustles up to Athens, that, if they'd been made out of real flesh and blood, would've broke the

back of any gal in Georgia to carry 'em. It's a fact. Why, some of them looked jist as much out of proportion as a bundle of fodder does tied to the handle of a pitchfork. If anything would made me sue for divorce, it would be to see my wife toting about sich a monstrous pack on her back as some of them I saw..."

Such bustles were completely impractical. Not only did they make general movement uncomfortable, they made sitting a carefully learned art form. Unfortunately, other fashions of the Eighties were equally uncomfortable; corsets, skirts, and bodices were often skin-tight. One survivor of the 1800s pensively remembers that "for a few hours each day, I was comfortable..." When she took off her corset and donned her teagown, that is.

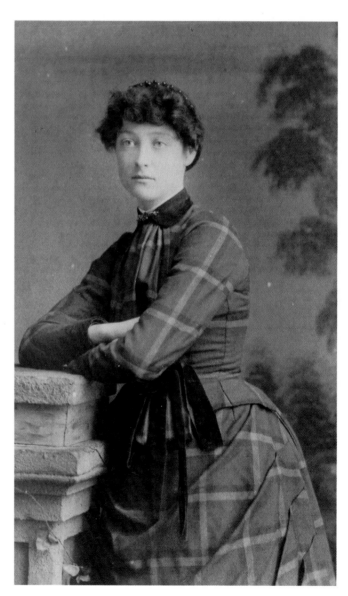

A photograph circa 1883, featuring a lady clad in ever-popular plaid.

Skirts

For some unknown reason, women of the Eighties had trouble dropping the bustle as easily as their mothers had dropped the crinoline. (Perhaps because, as one woman of the 1880s said, they felt "naked" without it.) Though a bustle-less (or nearly bustle-less) style had been fashionable in the late 1870s, by 1883, the bustle was back in full swing (literally). Skirts of the early Eighties usually consisted of a lower, petticoat-like underskirt worn under one to three draped overskirts. The 'curtain drapery' of the overskirts emphasized the hips as they had never before been emphasized. Called 'hip bags' by some Americans, there was great variety in the style and size of this drapery, depending upon individual preference.

By 1884, the more subtle look of a single skirt gathered or pleated at the derriere was also sometimes worn. By 1885, the bustle was at its fullest, showing a striking difference from the bustle of the Seventies with a harder, more shelf-like top. The end of the 1880s saw the end of the colossal bustle and as soon as 1887, the size of the derriere began to recede, falling back into its natural form in 1889.

All through the Eighties, tapes—or, more frequently, elastic bands—were sewn to the side seams of skirts to help control their fullness. Any drapery on the bustle was also controlled with inner tape ties. Steels were also sometimes sewn into the bustle area of skirts in order to help push them away from the body; this technique was much criticized by fashion magazines for the "jiggling" effect it produced. At times, bustle pads were also sewn into skirts.

Bodices

High necklines and collars predominated the Eighties—even in evening wear. Only occasionally were low necklines worn—and then, almost always, they were squared. Long, pointed bodices also prevailed—reaching all the way down a fashionably round tummy. By mid-decade, thirteen or more bones shaped the bodice to the figure. After 1885, bodices were often made to look like tailored suits—vest, jacket with revers, and cuffs, made all in one.

Sleeves held the most variety for bodices in the 1880s. Early in the decade, sleeves had a tendency to be set high on the shoulders. The standard length reached the wrist—though for evening, elbow lengths or sleeveless styles were worn; by 1883, three-quarter length sleeves were worn more frequently than full-

length sleeves. Through most of the decade, sleeves were straight, fitted, and usually simple. Not until about 1888 did small, puffed oversleeves appear—a style that continued into the early 1890s, also.

A French fashion plate from 1887.

Dresses

By day, dresses remained trainless. Heavily decorated, lush dresses were worn by many—and machine-made lace was no longer only found on 'cheap' dresses, but also on expensive designer gowns. When day dresses weren't opulent, they were tailored and suit-like. This trend was especially prevalent in the second half of the decade. By night, dresses were dramatically different, featuring small to medium length trains, decolletage, and plenty of arm.

Upholstery-like fabrics were common in the Eighties; dresses could easily weigh ten pounds. Heavy silk was favored, as always, as was sateen, gingham, batiste, crepe de Chine, and wool. Prints in the form of stripes, dots, and unobtrusive florals were popular, but solids were a definite staple. Gem tones such as ruby

red, emerald green, and amber were popular through most of the decade; after 1885, the softer shades of pink, daffodil yellow, light green, and sky blue were fashionable.

Undergarments

Bustles hadn't changed much since the Seventies, except that they had a more severe jut away from the back. Made of fabric "bustled-up" with adjustable tape ties, or of hoops and fabric, or of steels and fabric, or of wire mesh, there was an amazing variety available for ladies of all classes. The poorest of women used old dishtowels to create homemade bustles.

An 1881 dress as featured in *Harper's Bazar*.

Small, ruffled-fabric bustles were still worn by some to help plump out the derrière; these were worn over a larger bustle. Fabric pads were also worn—usually *under* a larger bustle, to help keep the false derrière from collapsing.

Next to bustles, corsets were the most important undergarment of the Eighties. Reaching past the tummy and well boned, they created a stunning hourglass figure. In the Eighties, corsets easily had fifteen or more bones. Spoon busks (stiff, curving bones placed at the center front of corsets) were used in most corsets. All through the Eighties, corsets were extremely restrictive and uncomfortable. Because of their length and rigidity, they had a tendency to "ride up" whenever a lady sat down; if they were laced tightly, the whaleboning also had a tendency to break suddenly, often causing injury to the wearer. By the end of the decade, steel had almost entirely replaced boning for this very reason. More emphasis was also placed on the beauty of corsets in the 1880s; frequently, printed fabrics, colorful ribbons, and soft laces were added to make a basic corset opulent.

The hourglass figure being ultra-fashionable, 'bust improvers' were available for women who felt they were not adequately endowed. Made of rubber, fabric and stuffing, or wire mesh, they were shaped like modern strapless bras and were usually worn inside the bust–area of the corset.

Petticoats of the era were very distinctive, containing a great deal of fullness (and tape ties to control that fullness) at the rear. Often, separate, extremely elaborate evening trains could be buttoned or laced onto everyday petticoats. The average petticoat was about four yards at the hem and was often stiffened with horsehair or crinoline.

Other Important Garments

Fashion magazines, while advocating every bit of the current style in their fashion plates, complained bitterly about them in their editorials. Shoes, they claimed, had become abusers of women, since they were now worn at least one size too small to accommodate the new, fashionable, skin-tight look. Even once-elegant gloves, they complained, had become a travesty, worn a half a size too small.

A great deal of variety was seen in accessories in the Eighties—perhaps because they were considered especially important during this decade. Red silk stockings were shown throughout the decade in a variety of magazines—though probably most women thought them too daring to indulge in. Parasols of innumerable shapes and sized were also seen; the most fashionable ladies had one or more sticks with interchangeable fabric covers made to match a variety of outfits. Feather fans and boas were also fashionable, and the small, straw hat that was so prevalent during the decade was almost always smothered with feathers.

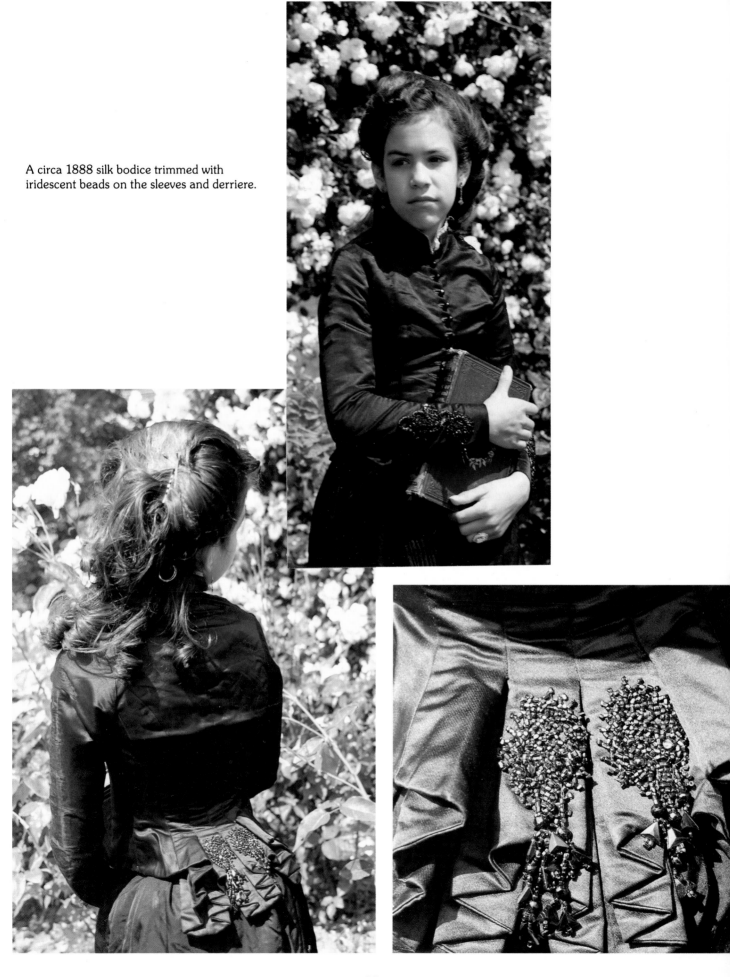

A circa 1888 silk bodice trimmed with
iridescent beads on the sleeves and derriere.

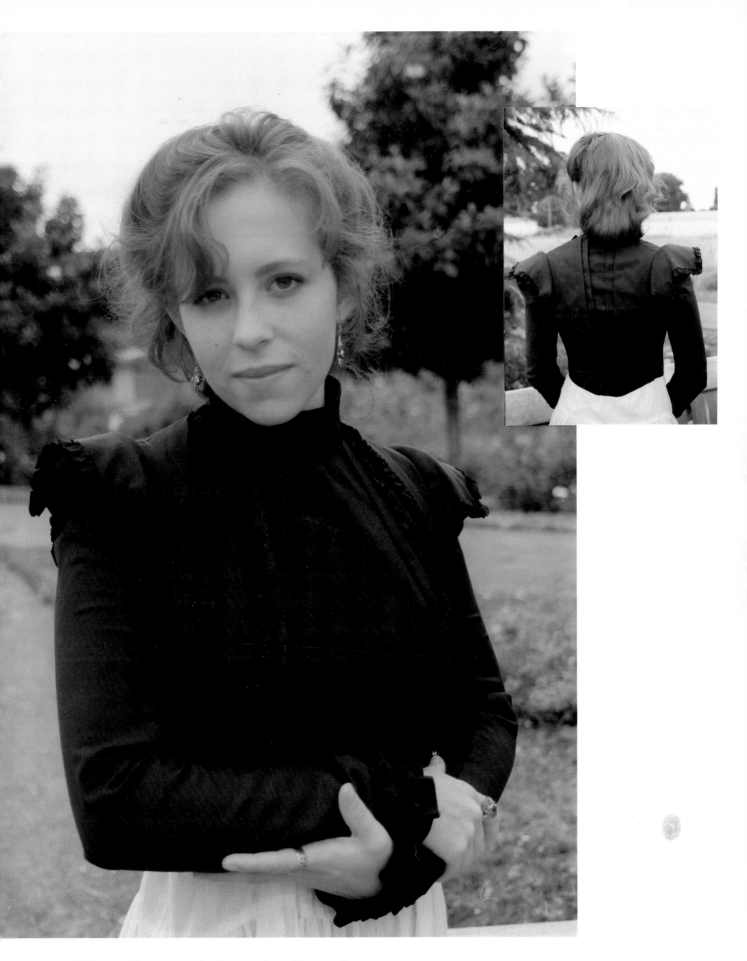

A circa 1889 waist, featuring ruched trim and small 'capped' oversleeves.

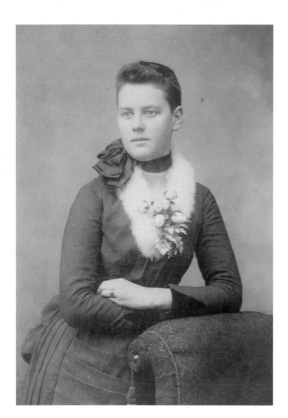

Boas were used in a variety of unusual manners. Circa 1884.

A debutante of 1883, wearing a sleeveless evening gown
trimmed with rosettes.

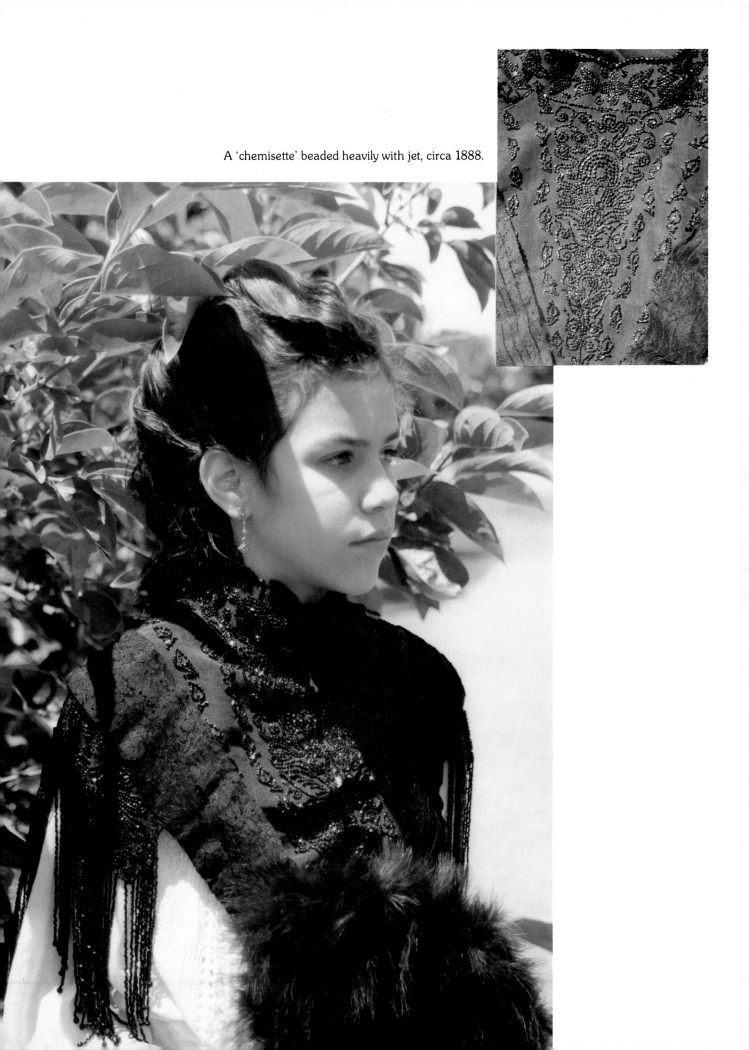

A 'chemisette' beaded heavily with jet, circa 1888.

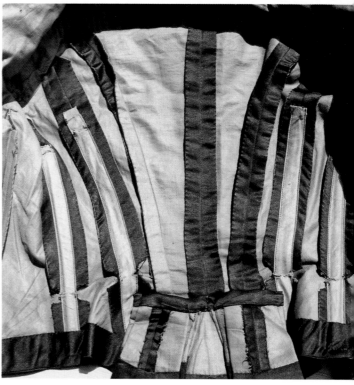

The inside of an 1888 bodice. Fully lined, it features ten bones and a watch pocket.

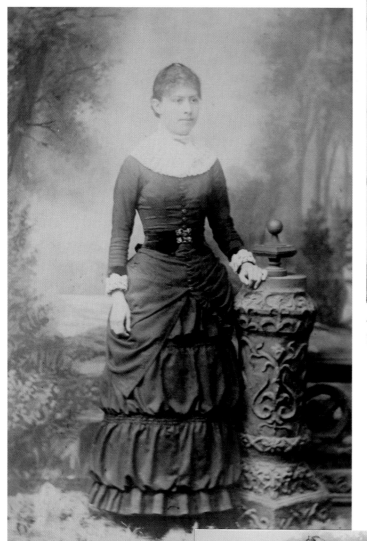

A woman wearing a fitted and heavily ruched dress, circa 1880.

An 1879 fashion plate.

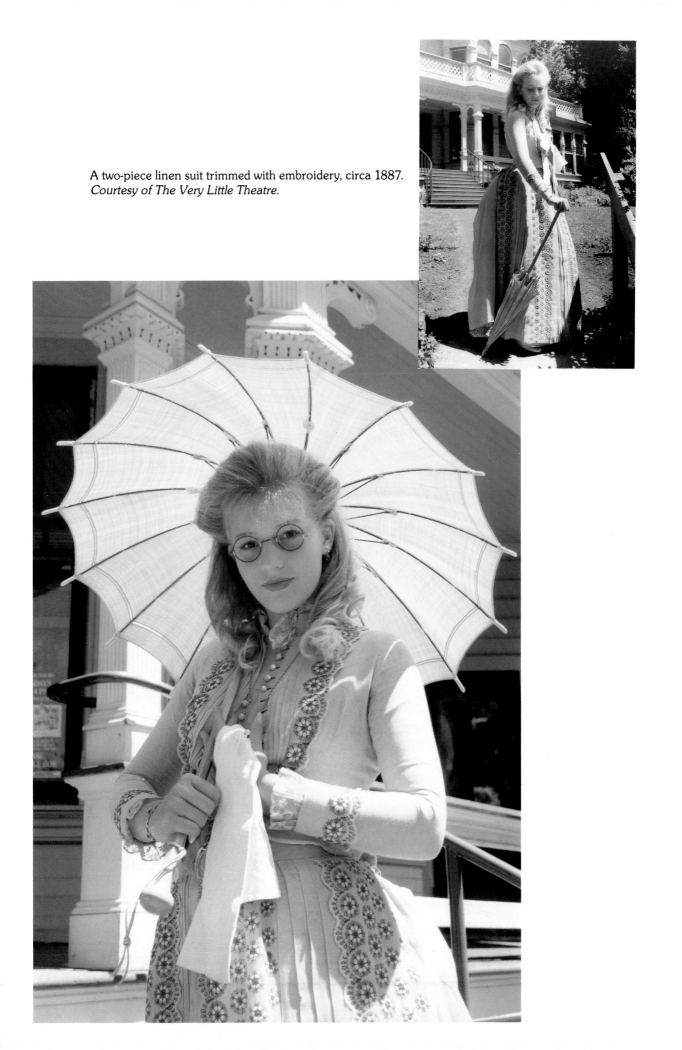

A two-piece linen suit trimmed with embroidery, circa 1887. *Courtesy of The Very Little Theatre.*

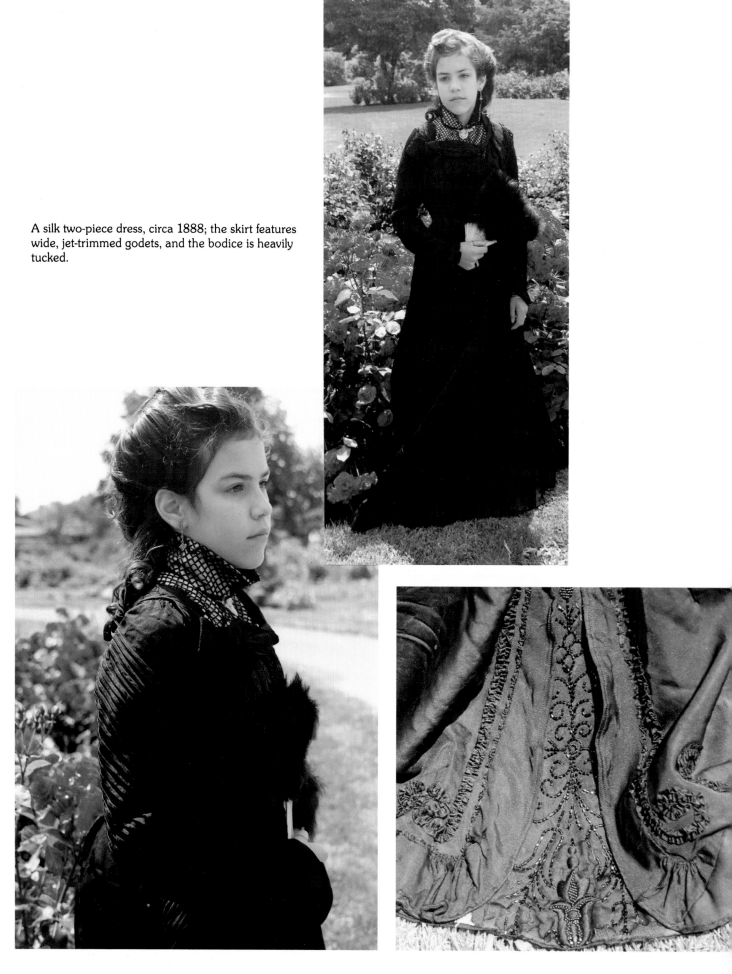

A silk two-piece dress, circa 1888; the skirt features wide, jet-trimmed godets, and the bodice is heavily tucked.

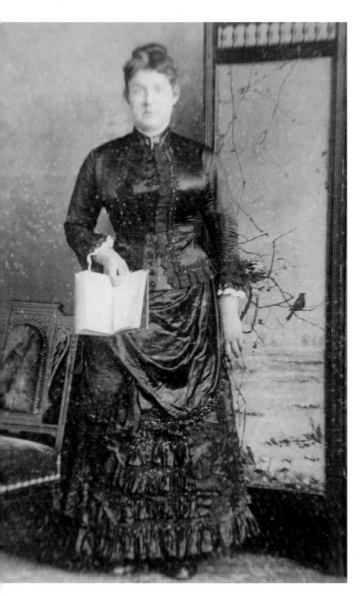

A rich silk dress, circa 1881.

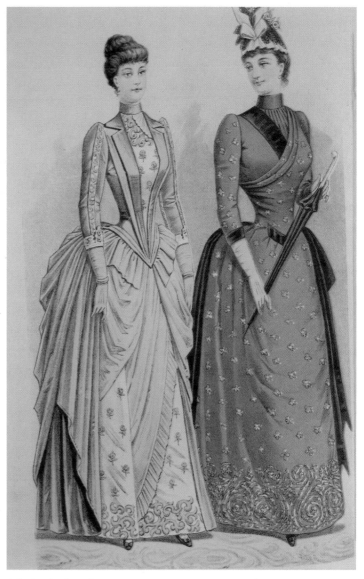

A fashion plate from an 1888 *Godey's Lady's Book.*

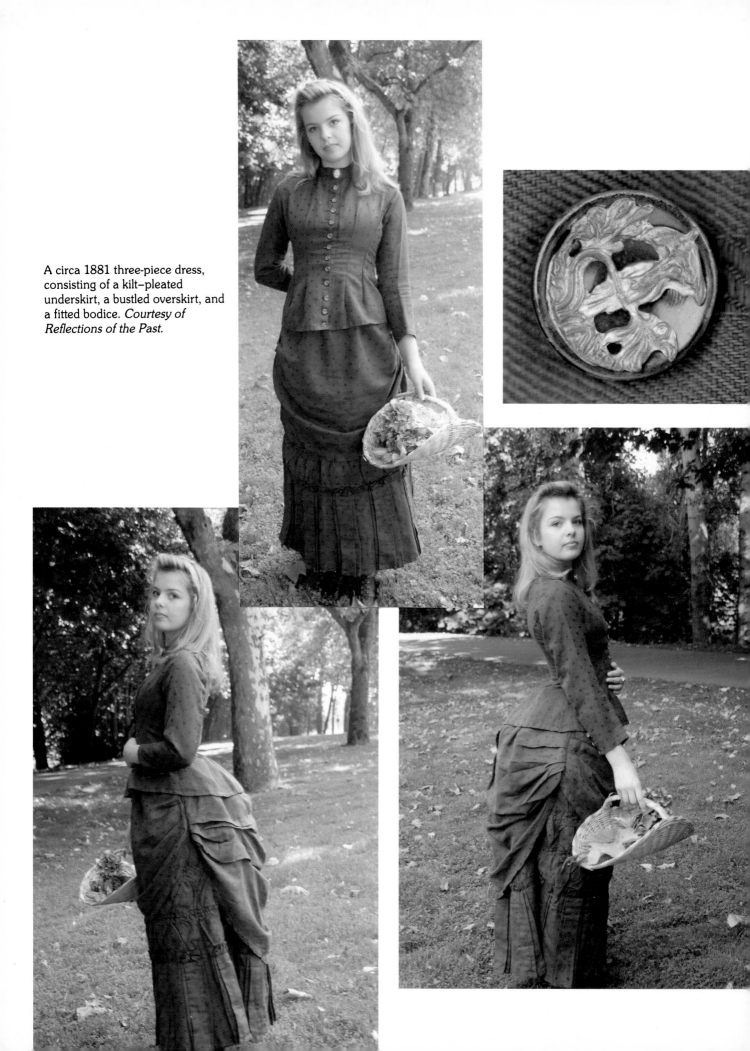

A circa 1881 three-piece dress, consisting of a kilt–pleated underskirt, a bustled overskirt, and a fitted bodice. *Courtesy of Reflections of the Past.*

A woman dressed in a sprightly print dress and a feathered hat. Circa 1882.

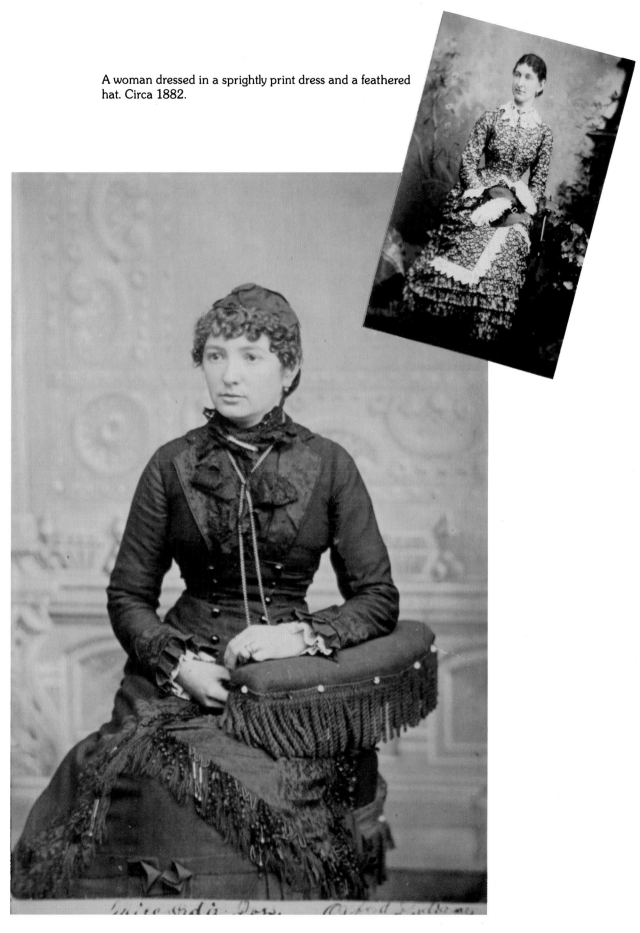

A wealthy woman wearing a dress lavishly trimmed with fringe, velvet, and jet. Circa 1881.

An angular suit of brilliant red and blue, circa 1889. *Courtesy of The Victorian Lady.*

A French fashion plate from 1889.

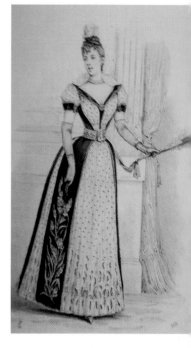

An 1888 French fashion plate, featuring heavy embroidery and a definite royal flavor.

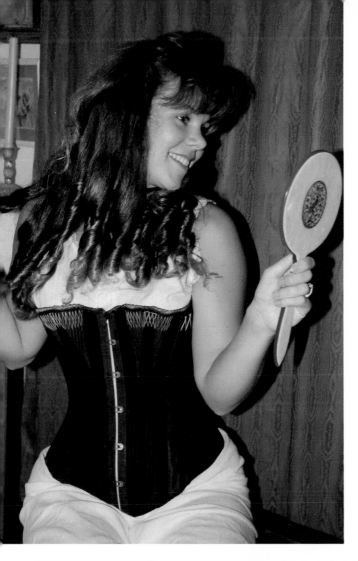

A corset with golden embroidery, circa 1887. *Courtesy of The Very Little Theatre.*

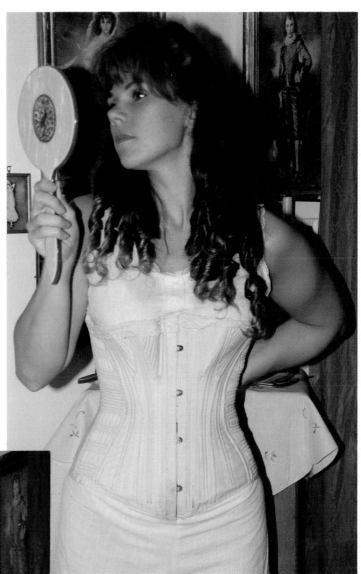

A corset featuring two panels of elastic, patented in 1881. *Courtesy of The Very Little Theatre.*

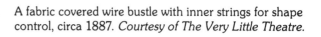

A fabric covered wire bustle with inner strings for shape control, circa 1887. *Courtesy of The Very Little Theatre.*

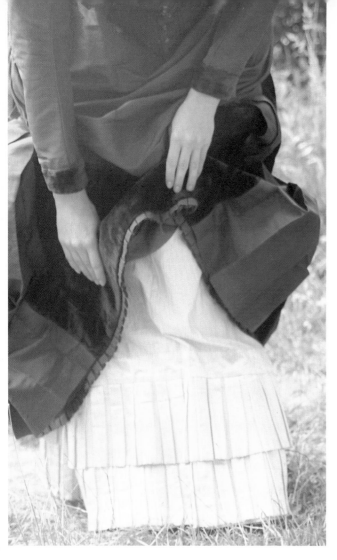

A kilt–pleated petticoat. *Courtesy of The Very Little Theatre.*

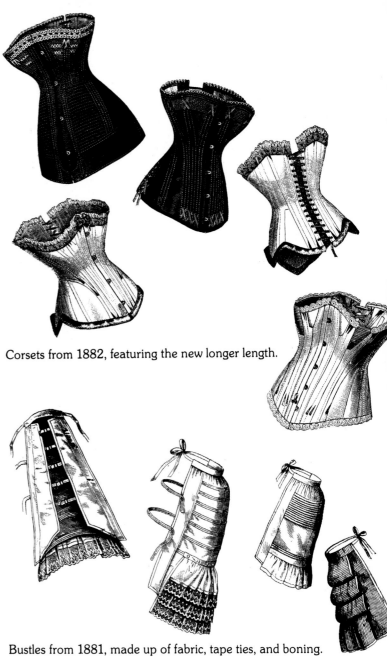

Corsets from 1882, featuring the new longer length.

Bustles from 1881, made up of fabric, tape ties, and boning.

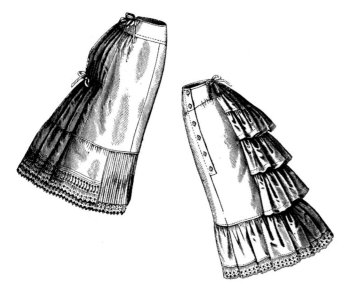

Two petticoats from 1882. The tape ties on the petticoat at left provide extra plumping to the derriere, while ruffles do the trick on the petticoat at right.

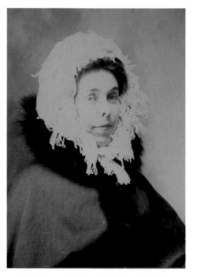

The feathers of fashion.

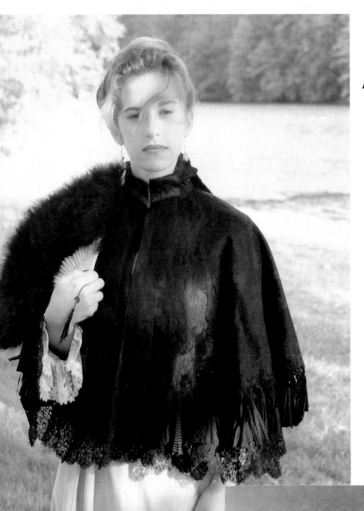

A heavy two-layer cape. *Courtesy of The Very Little Theatre.*

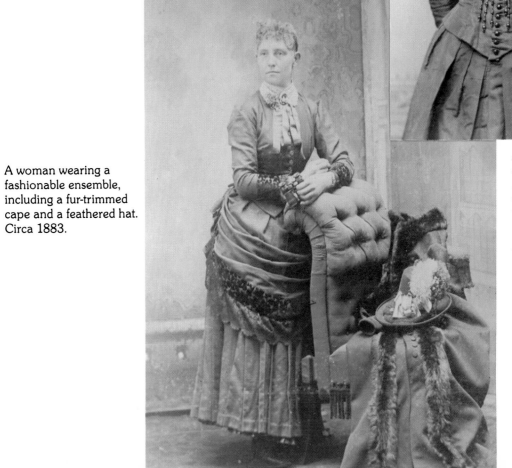

A woman wearing a fashionable ensemble, including a fur-trimmed cape and a feathered hat. Circa 1883.

A photograph taken circa 1889, picturing a fashionable lady wearing a heavily jet-beaded bodice. Also notice her unusual jewelry.

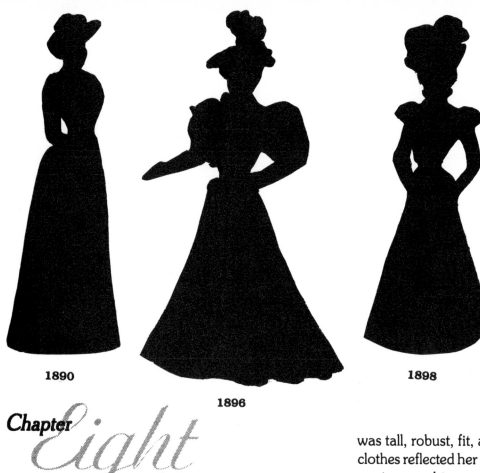

1890

1896

1898

Chapter Eight

1890s: Modern Girl

"I think that the most important inventions of the century are the bicycle and the shirtwaist," one spunky young gym girl touted in Alexander Black's 1899 book *Modern Daughters*; "each has had an important influence on the physical and economic situation of women. I have no doubt the bicycle will get full credit, but if no historian mentions the shirtwaist the shirtwaist will proclaim its own triumph." Such fortitude and thoughtfulness epitomized both the women and the fashions of the 1890s. It was a time of carefully planned, expertly executed female emancipation. It was a time when a new invention—the bicycle—brought women out into the world and gave them independence. The raving feminist clad in outrageous costume was now out-classed by a new generation of dainty, fashionable, and clever women who campaigned for and eventually won women's suffrage.

Femmes fin de siècle ("women of the end of the century"), they were called, and even contemporaries understood their unique position in society. No longer just doting daughter, wife, and mother, the woman of the Nineties was an important part of the workforce. Unlike her mother or grandmother, the 'modern girl' was tall, robust, fit, and reasonably independent; her clothes reflected her new position in society, also. Now, sewing machines, patterns, and ready-made basics were available to nearly every women (no matter how poor), making the effort put into her wardrobe minimal.

The woman of the 1890s seemed to celebrate her new independence with the most vivid of colors—often freely mixed to create shocking affects—giving the era its well known 'Gay Nineties' nickname. Modern women also celebrated the ease of the new fashions. Fabrics once too expensive for all but the rich were now used regularly by the average woman. These laces, velvets, brocades, and beaded fabrics gave the era another nickname: 'The Era of Opulence'. Though workmanship and quality may have been sacrificed often, the woman of the Nineties made sure she was the best dressed woman of the nineteenth century.

Skirts

Skirts were the first transitional garments for the woman of the Nineties. By 1891, fashion magazines were claiming "the greatest change of the year is the abolition...of the foundation skirt which has been worn for at least 20 years." The foundation skirt (the bustle) that had been so important to the well-dressed woman of the Seventies and Eighties and had been preceded by decades of hoopskirts, was suddenly disposed of.

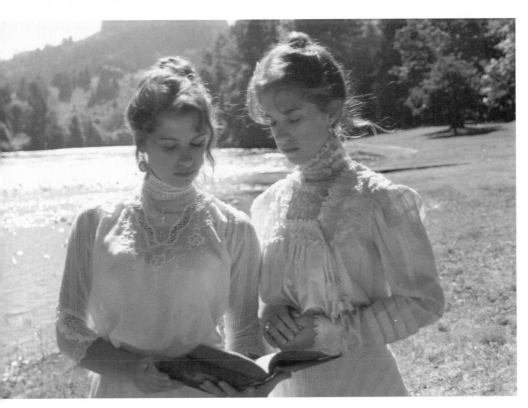

Two waists, circa 1899. The lady on the right wears an ecru silk waist trimmed with ruching, tucks, and ribbon. The lady on the right wears a less formal waist of white cotton. *Courtesy of The Very Little Theatre.*

Women of the Nineties were learning that freedom only meant something if it was practical to move about. Women still shuddered at the thought of having even a hint of their legs showing, however, so layers of petticoats remained and often new, stiffer linings and interlining were employed in skirts.

The slim, somewhat crippling skirts of the Eighties were also disposed of. Modern women, inspired by their mother's fashions, once more aspired to be shaped like a bell. The new bell shape, however, was clearly less melodramatic and far more practical. The desired shape was subtly achieved with gored skirts—never before used to such a degree. Next to gored skirts, 'umbrella' skirts were most popular. These were created by clever dressmakers, using only a single seam (which was often completely concealed by a pleat in the back of the skirt).

From 1890, skirts of all types were fitted at the hips and flowed smoothly to a wide hem. "Some time ago the lining and the skirt material were no longer attached," *The American Woman* wrote in 1890; "The lining—of silk for best dresses—was tight and narrow, while the outside material was allowed to hang in loose and graceful folds." Ever careful not to reveal too much of their womanhood, however, soon a wide variety of 'skirt supporters' were available, which helped control the folds of the skirt and were secured to the blouse at the waistline.

'Dress Elevators' were also advertised regularly in fashion magazines and were intended to help ladies appear elegant and graceful by 'elevating' their skirt trains when necessary. However, trains worn by the average woman were usually short, though very long trains (taking up to eight yards of fabric) might be worn on evening gowns, or by the affluent.

Every year skirts grew more snug round the hips. "Walking has become an impossibility and a sort of gliding motion has become the fashionable gait," one fashion magazine complained. But this was exactly the intention of the fashion makers. With most of the fullness of skirts at the rear, women were made to *glissade* elegantly—no trace of legs to be found. Unfortunately, these new "emancipating" skirts had other problems. The length of skirts made most women walk pigeon–toed in order to avoid stepping on their hems; even author Alexander Black—a true admirer of women—complained: "So many [men] have turned their faces away from the spectacle of a lovely creature who walked with a Delsartean lilt and seated herself with the inexpressible grace of a bird—but has...[mounted] a flight of steps with the roll of a breathless duck."

By 1894, a more ornate skirt appeared. Much like skirts of the Eighties, the new skirt had a looped-up look at one or two sides, which was set off by an ornate underskirt. This style was mostly reserved for the evening.

By 1897, the gored skirt began to decline in popularity and in general skirts became even tighter at the hip. Hems were often decorated with layers of ruffles, laces, and ribbons—a trend that lasted well into the 1900s. 'Girdles', or belts, though popular throughout the nineteenth century, became available in a wider variety in the Nineties. Decorated with pleats, tucks, lace, and beads, belts of this period served to emphasize the fashionable wasp-waist. Chantelains also continued in their popularly—though a lady's chatelaine now carried her purse more frequently than it carried her sewing tools or cleaning accessories...perhaps symbolizing her new role in the world.

Waists

"Bodices of all kinds are swathed around the figure in the most perplexing manner, and even to those initiated into the intricacies of the feminine toilet it is sometimes a mystery how the *fin de siècle* belle continues to get into her clothes," *Godey's Lady's Book* wrote in the early part of the Nineties. Truly, waists had reached a complexity never seen before; while skirts remained quite plain, bodices grew more and more elaborate. In her book of fashion reminisces, author Carrie Hall wrote that bodices were now "separate...This necessitated an opening in the side or back of the garment...This was supposed to be carefully closed with hooks and eyes, but——alas! many a tragic moment was the result of an insecure fastening!"

In addition to complex construction, waists became increasingly complex in design and most bodices were suffocated with frills and furbelows. This trend grew more and more intense until the turn-of-the-century, when layers of ruffles, rouching, tucks, and other frills covered nearly the entire bodice.

When waists weren't swathed with frills, then they were especially simple and refined. In 1899, *The Delineator* proclaimed: "Shirt-waists are such an important part of a woman's [wardrobe] that they cannot afford to be neglected." This was the era when artist Charles Dana Gibson created his famous all–American "Gibson Girl." Thoroughly modern, largely independent, and the epitome of Nineties beauty, the Gibson Girl was usually seen wearing a shirtwaist and plain skirt. And all "good girls" followed her example. If the Gibson Girl was especially modern, her shirtwaist featured a simple tie—though most women chose to wear a more frilly and feminine jabot instead. Though shirtwaists were rarely entirely undecorated

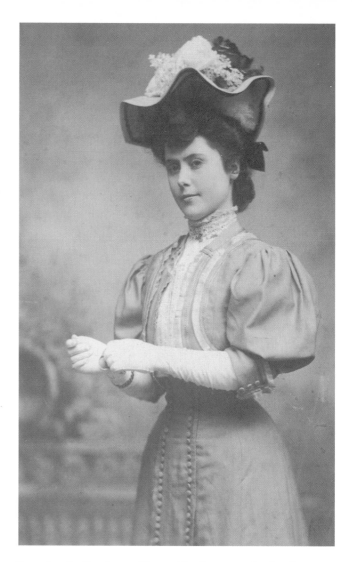

From her feather-topped hat, wide sleeves and tight gloves to her hip-hugging skirt, this lady epitomizes the 1890s woman.

(and usually featured tucks and pleats), by comparison to all other waists of the period, they were downright plain.

The 1890s saw emphasis move from the bustle (the derrière), to the sleeve (the shoulder line). From 1890 to 1892, sleeves were closely fitted to the arm (sometimes falling into wide folds below the elbow); then, from 1893 to 1896, they became huge at the shoulder. This widening sleeve was nearly necessary with the new bell skirt—helping to balance the figure and create a true 'wasp' shape. The largest sleeves were stiffened with eiderdown, lined with stiff muslin, or supported with small spiral steels. Such sleeves could sometimes take up to 3.5 yards of fabric. By 1897, however, sleeves once again shrank close to the arm; this time, often topped off with a small, poufy oversleeve.

Throughout the Nineties, collars and cuffs were often detachable, and were praised by fashion maga-

zines as being the least expensive and most attractive way a lady could add variety to her wardrobe. High collars were exceedingly popular from 1897 and usually contained small spiral steels in order to help keep them straight and tall. This tallness reached its peak in 1898, when collars were worn up to the chin and often nearly touched the ear lobes with sharply pointed sides.

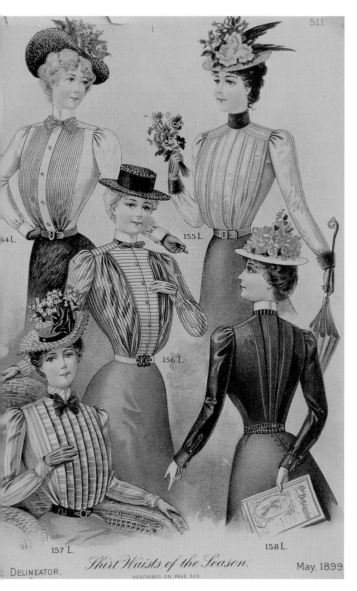

An 1899 *Delineator* magazine fashion plate, featuring the all–important shirtwaist.

By 1895, blouses took an important turn, becoming a little fuller in the front. This trend continued through the turn of the century, developing into the 'pigeon' look that epitomized the early 1900s. Another startling trend that appeared in 1899 and lasted well into the twentieth century: The 'peek–a–boo' or 'pneumonia' blouse. These lacy, flimsy garments caused quite a rue and were the topic of much conversation.

The pneumonia blouse, it was said, was not only the cause of numerous illnesses (thus its name), but was quite simply 'indecent'. Though, of course, the blouses were worn over very modest corset covers, the tiny holes in their eyelet or lace exposed flesh!

Dresses

The most significant change in dresses of the 1890s was the princess-style dress. Reaching its height of popularity in 1898, the princess dress remained a dominant fashion through 1900.

Another important development was the ladies' suit; though some women wore them as early as the 1860s, they really came into their own in the Nineties. Working women greatly favored their simplicity and practicality (compared to other fashionable female dress, at least) and dress reformers everywhere proclaimed at least partial victory with linen and wool women's suits.

Modern women also flirted with "The New Empire Dress," in their cautious attempt to find more practical (but still fashionable and beautiful) garments. All through the 1890s, this variation on the high-waisted dresses of the early 1800s was worn. One marked difference in construction made this style quite different from its predecessor, however; in keeping with the 'essential' hourglass figure of the Nineties, the New Empire Dress fit snugly over the corseted figure, instead of hanging loosely like its Napoleon I sister. Often made up in soft crêpes, silk mulls, laces, nets, and other transparent fabrics, New Empire Dresses were worn over fitted underdresses of silk, cotton, or lightweight wool.

White lace dresses (often called 'lingerie' dresses)— once only worn by the wealthy—were now being worn in profusion by all but the poorest women. Laces were now mostly machine made; their cost was low and their availability high. Reaching their height of popularity in 1898, lingerie dresses would be worn by women well into the twentieth century.

"No fashionable gown is tolerated without velvet sleeves of pre-posterous size," fashion magazines touted in 1892. Though sleeveless evening gowns were acceptable for 'nice girls', any gown with sleeves followed the trends of fashionable waists. "If the dress is of a simple style of fashion and material, it is rendered elaborate by profusion of ribbon trimmings," *The Young Ladies' Journal* wrote in 1894.

To add to their complexity, evening gowns were sometimes laced up the back, instead of being buttoned or hooked like most day wear. Extremely low décolletage added something of a shocking interest to many fashionable evening gowns. By 1897, the most significant trend in evening gowns was a transparent overdress with lavish beading and sequins worn over a simple underskirt. Most evening gowns were then finished off with long trains—taking as much as nine to eleven yards of fabric at the hem.

Unlike her ancestors, the woman of the 1890s favored lightweight fabrics—despite constant warnings by doctors that they would catch their death. Clingy, flimsy fabrics would remain in vogue well into the 1900s. While the decade opened with almost grotesquely brilliant colors, by 1898, vivid colors gave way to monochrome dressing and pastel, soft shades—a trend that continued into the twentieth century.

Undergarments

The woman of the Nineties spent nearly as much of her money on her undergarments (now fashionably called 'lingerie') as she did on her outergarments. Prettiness suddenly became important; frills and trims were now essential.

Petticoats probably reflected these changes more than any other type of lingerie. Enveloped with ruffles, tucks, cutwork, pleats, embroidery, lace, and ribbons, and often made up in flimsy fabrics, petticoats were worn layered one on top of the other; a fashionable woman might wear as many as ten petticoats at a time—and would probably try to show off their splendor by lifting her skirt slightly as she walked down the street.

Drawers were also usually well trimmed at the hem. Still usually open-crotched, drawers were cut much roomier and wider than in previous years and could measure up to two yards at the hem. Bloomers were also worn by some women; unlike drawers, bloomers were closed-crotched and often had a band along the leg that held itself snugly to the figure; these were particularly valuable to ladies who bicycled or participated in other sports where a fall might prove embarrassing if drawers were worn.

Combinations—though sometimes worn in the 1870s and 1880s—came into their own in the Nineties. By combining both corset cover and drawers, they minimized bulk and were especially suitable for wear under the new, sleek princess dress.

Corsets were now being cinched tighter than ever, as the hourglass figure became the only fashionable figure type. While diminishing the waist, new corsets also rounded out the bosom and hips—a shape the new gored skirts and princess dresses accentuated. Throughout the Nineties, corsets became works of art. It was now thought necessary to have beautiful undergarments (especially if you were married)—and the corset was now worn *over* the petticoat to emphasize its beauty. Made of nearly every color imaginable, the corset of the Nineties was well trimmed with laces and ribbons. By 1897, corsets were gradually becoming longer in front, and fashion magazines frankly told their readers to lift their tummies into the corset in order to achieve the new flat-stomached look that would persist into the next century.

By 1899, many women who were struggling for a more independent role in society began to question the integrity of the tightly cinched, heavily boned, constricting corset. Quite suddenly, many practical women shifted to lightweight corsets. Made shorter, more flexible, and (consequently) more comfortable, such corsets were worn well into the twentieth century—though devout fashion followers continued to languish in their long, cage-like corsets.

Though large bustles were *passé* by 1890, a plump derrière was still thought desirable by most of society. Many women chose to wear small fabric bustles. Either consisting of a small pad or several layers of stiffened and gathered fabric tied around the waist, such bustles created a slightly larger behind than most women were naturally endowed with. Small mesh wire bustles could also be purchased, but the average woman of the Nineties found fabric preferable.

Sportswear

Bicycling—a new 'sport'—was the rage among women in the 1890s, and a new style of garment had to be created for its purpose. In the bicycle's infancy, much was made of what a "good machine" it was for women—though countless accidents were reported of women's skirts getting caught in the gearing. Soon shorter skirts and trimmer drawers were devised which were simple in style and looked much like a shorter version of the tailored riding habit—but more modern women quickly adopted bloomers. Though Amelia Bloomer's introduction of Turkish trousers failed miserably in the 1850s, it now became apparent that the garment nicknamed after her was the only practical

garment for cycling. Though the press routinely made rude jokes about ladies in pants, women were not willing to give up the freedom bicycles gave them for the sake of fashion.

Other forms of sportsclothes remained relatively the same. Bathing suits still consisted of bloomers and an overskirt—though some daring women rid themselves of their skirts and wore only a one-piece top and bloomer outfit. Riding habits also remained traditional—though long trains were now discarded by all practical women. Tennis, another popular sport among women of the Nineties, still had no particular costume; shirtwaists with ankle-length plain skirts were most favored.

Other Important Garments

Teagowns remained important to the women of the Nineties—though they may not have been as comfortable. While still soft and flowing on the outside, unlike teagowns of previous decades, the new teagown was snug and boned on the inside—helping to create an hourglass figure, even when ladies weren't wearing their corsets.

Capes reached their pinnacle of popularity in the Nineties, often heavily decorated with lace and beading and reaching the floor. Similarly, bolero jackets re–appeared and were especially popular from 1898 to 1899. Like capes, they were frequently and heavily trimmed with lace, braid, and beading (especially jet).

The Nineties saw the end of bonnets as fashionable headwear. Having been worn by ladies for over eight decades, bonnets were now considered "old ladyish. Instead, straw hats, heavily decorated, became the mode. One English fashion magazine wrote: "Some 20 to 30 million dead birds are imported to this country annually to supply the demand of murderous millinery." Birds and feathers were often accompanied by flowers, fruits, laces, and other intriguing creations.

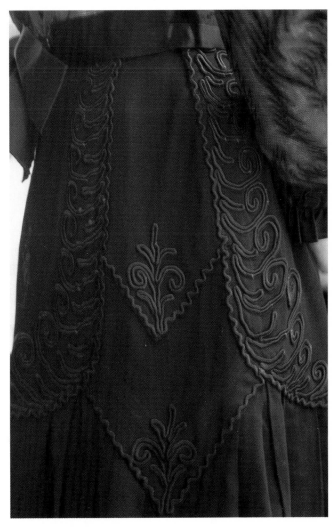

A circa 1898 skirt, featuring arrow tucks. *Courtesy of The Very Little Theatre.*

Braid trim is featured on this circa 1897 skirt. *Courtesy of The Very Little Theatre.*

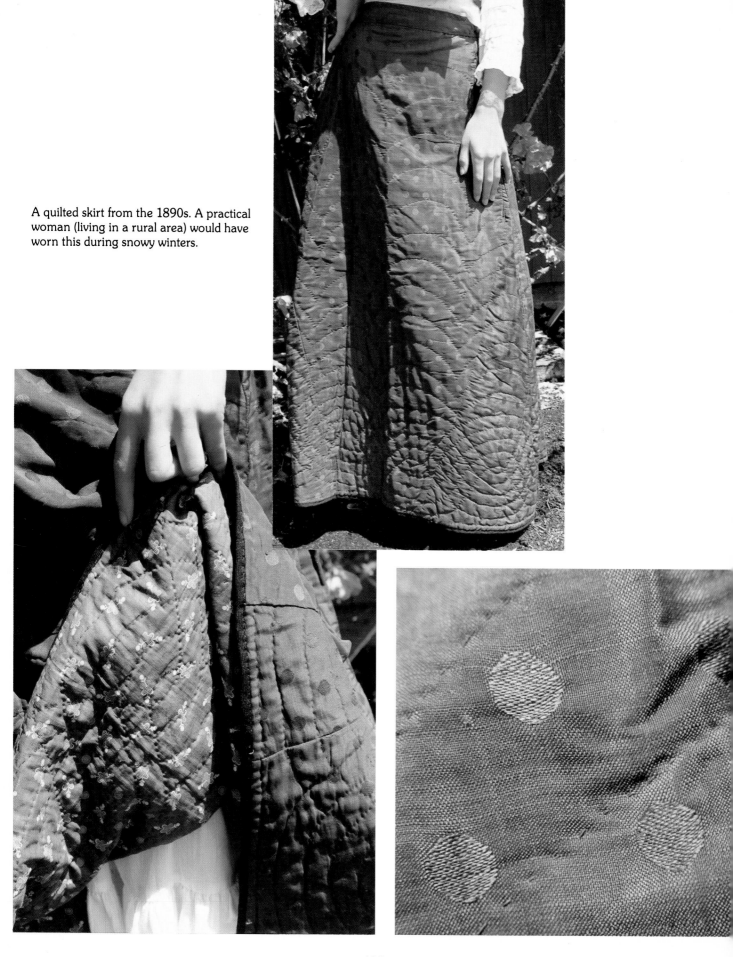

A quilted skirt from the 1890s. A practical woman (living in a rural area) would have worn this during snowy winters.

A rose and ecru printed silk skirt, circa 1899. The hem of this slightly trained skirt is lined with about four inches of crinoline, then bound with velveteen.

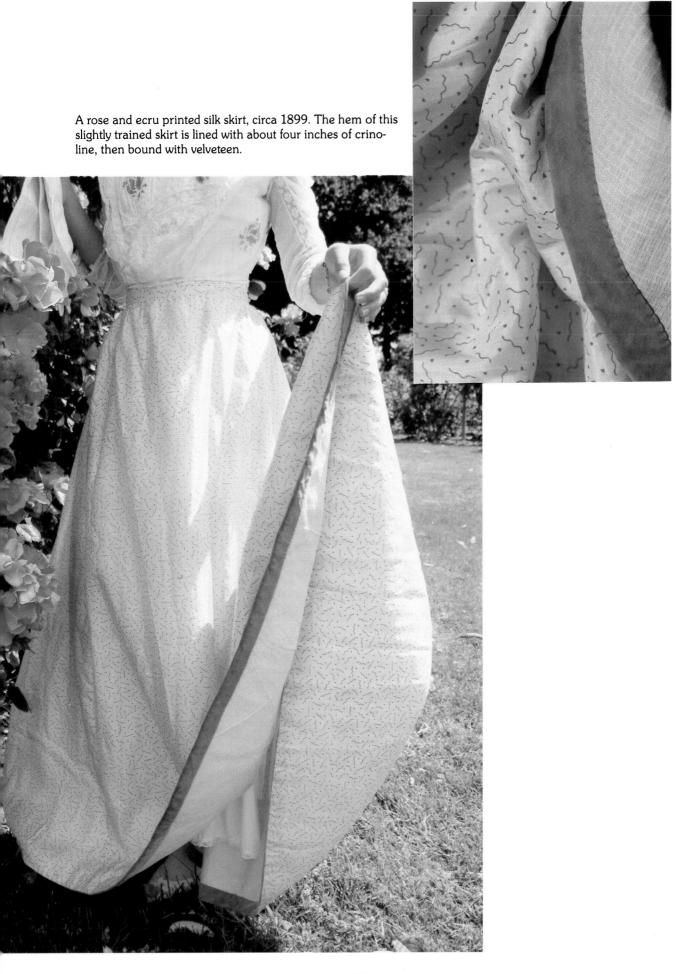

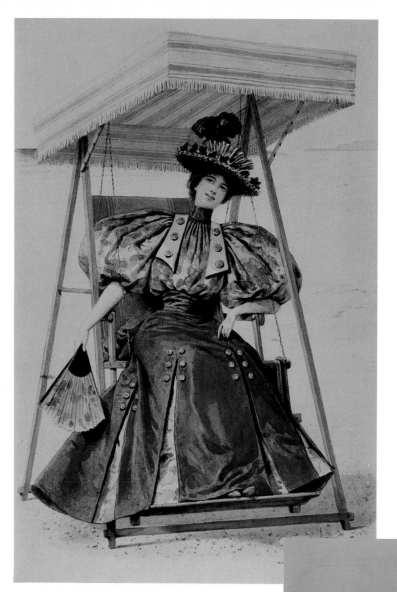

A French fashion plate from 1895.

A photograph taken about 1899, featuring a home-made dress with a slight pigeon-front.

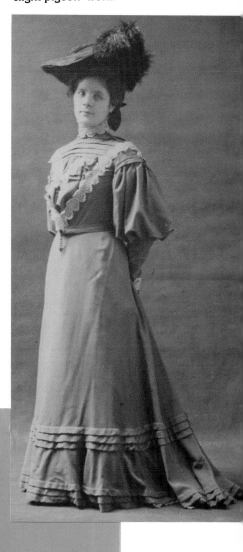

A fashionable woman wearing typically huge sleeves. Circa 1896.

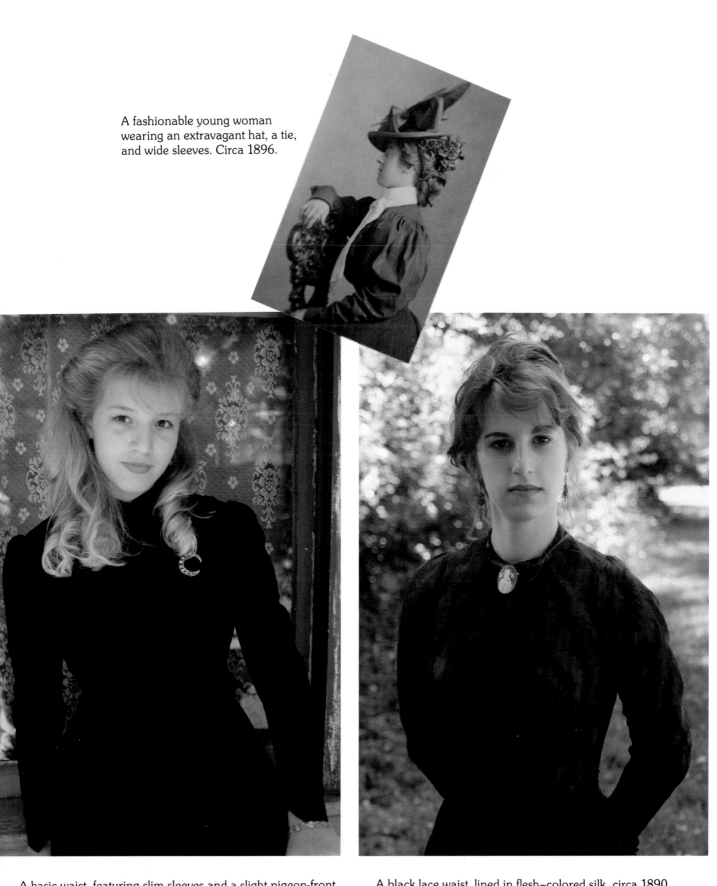

A fashionable young woman wearing an extravagant hat, a tie, and wide sleeves. Circa 1896.

A basic waist, featuring slim sleeves and a slight pigeon-front, circa 1899. *Courtesy of The Very Little Theatre.*

A black lace waist, lined in flesh–colored silk, circa 1890. *Courtesy of The Very Little Theatre.*

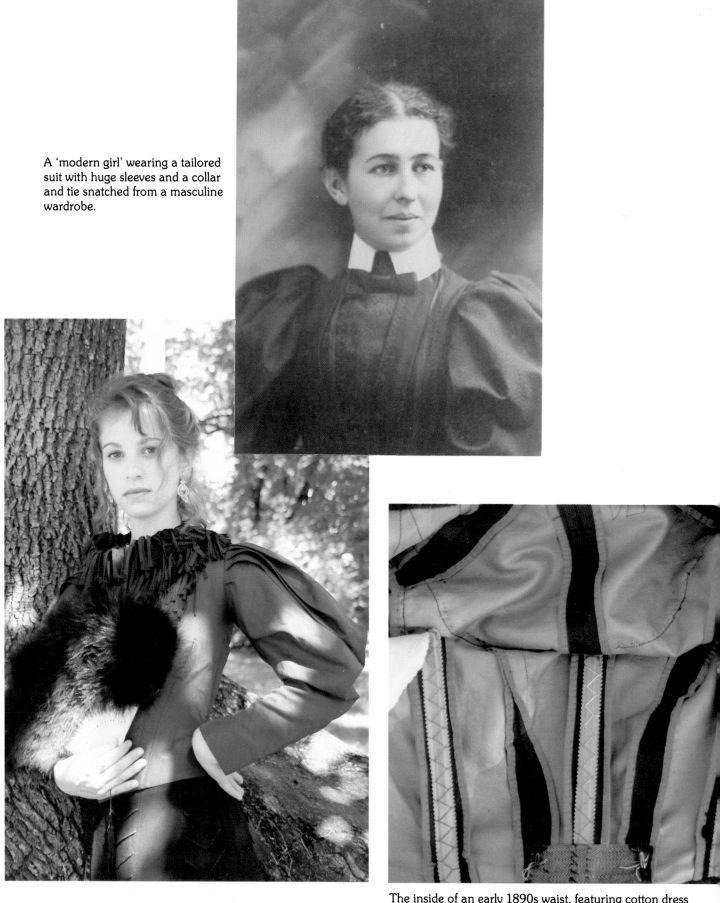

A 'modern girl' wearing a tailored suit with huge sleeves and a collar and tie snatched from a masculine wardrobe.

A circa 1894 waist featuring fringe created from strips of grosgrain ribbon. *Courtesy of The Very Little Theatre.*

The inside of an early 1890s waist, featuring cotton dress shields, six bones, and (bottom center) hooks which attached to the skirt. *Courtesy of The Very Little Theatre.*

An 1899 waist trimmed with jet. *Courtesy of The Very Little Theatre.*

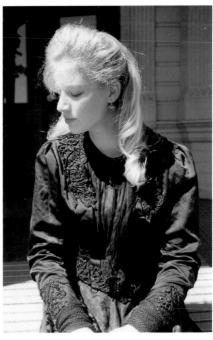

An unusual waist, circa 1899. With ruched sleeves, black knotwork, lace insets, pintucks, and handpainted roses, little more could have been done to decorate this blouse!

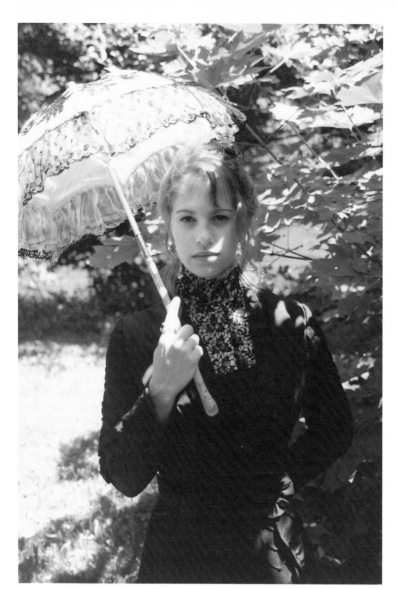

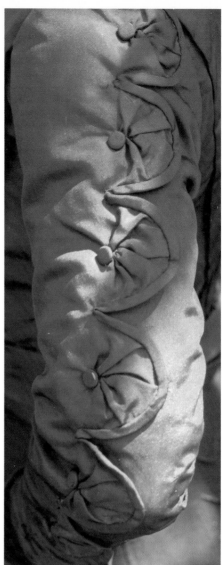

A circa 1891 waist, featuring a lace yoke and a scalloped sleeve. *Courtesy of The Very Little Theatre.*

Detail of a circa 1899 sleeve. The undersleeve is ruched along the inner seam, and the small, cap-like oversleeve is lightly gathered into the shoulder. *Courtesy of The Very little Theatre.*

Detail of a circa 1893 waist with a standing collar and a slimming sleeve. *Courtesy of The Very Little Theatre.*

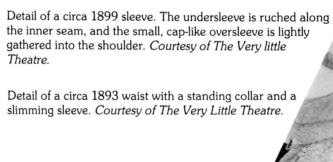

A woman wearing an unusual vest-bodice over a white lingerie dress. Circa 1898.

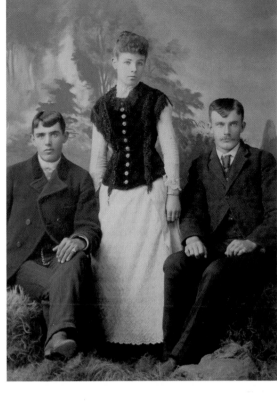

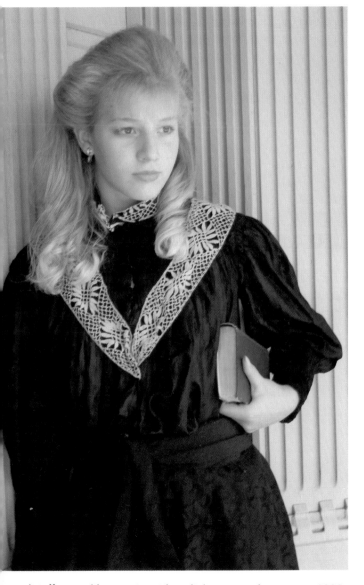

A taffeta and lace waist with a slight pigeon-front, circa 1899.
Courtesy of The Very Little Theatre.

A circa 1899 silk blouse, featuring elaborate braid trim.
Courtesy of The Very Little Theatre.

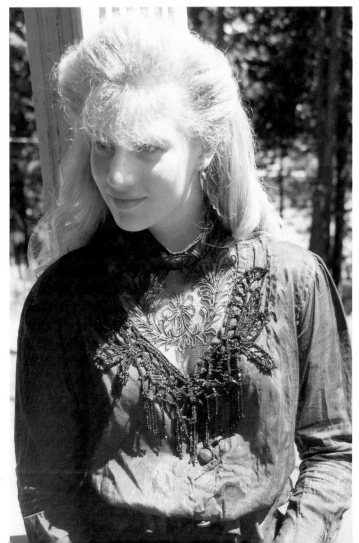

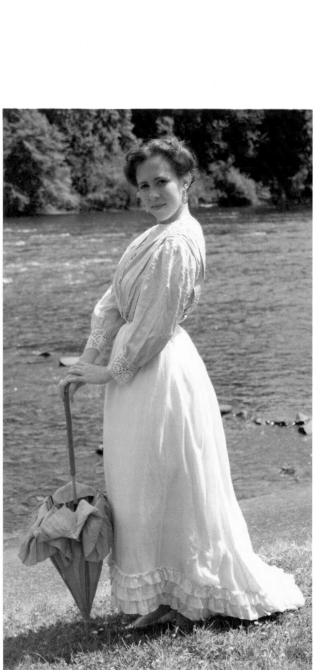

A linen waist trimmed with braid and lace, worn with a slightly trained silk skirt and a cotton parasol. Circa 1899. *Parasol courtesy of The Very Little Theatre.*

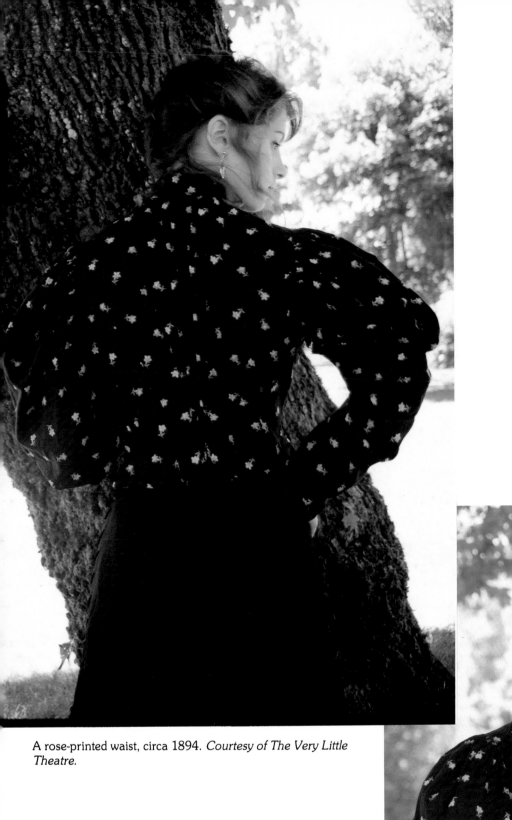

A rose-printed waist, circa 1894. *Courtesy of The Very Little Theatre.*

An unusual waist, circa 1898, featuring a great deal of ready–made trim.

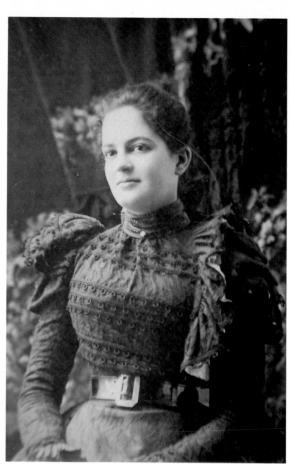

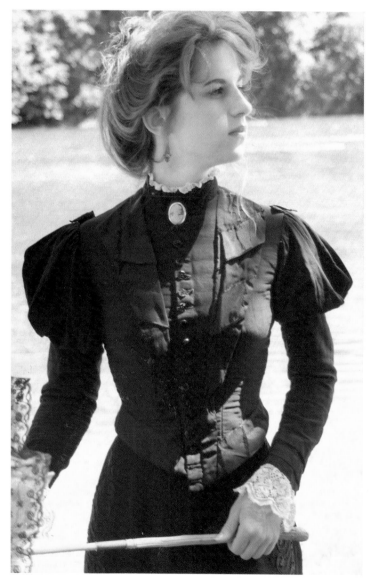

A black waist with pouffed and fitted sleeves, circa 1897. *Courtesy of The Very Little Theatre.*

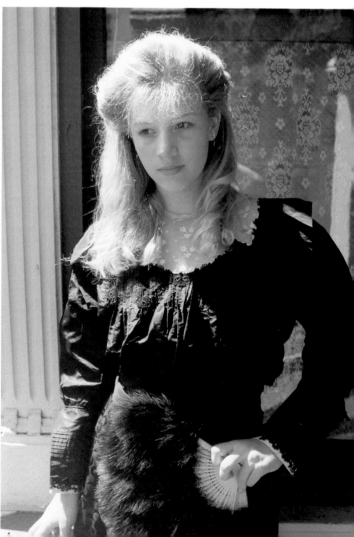

A lace-trimmed waist, circa 1898. *Courtesy of The Very Little Theatre.*

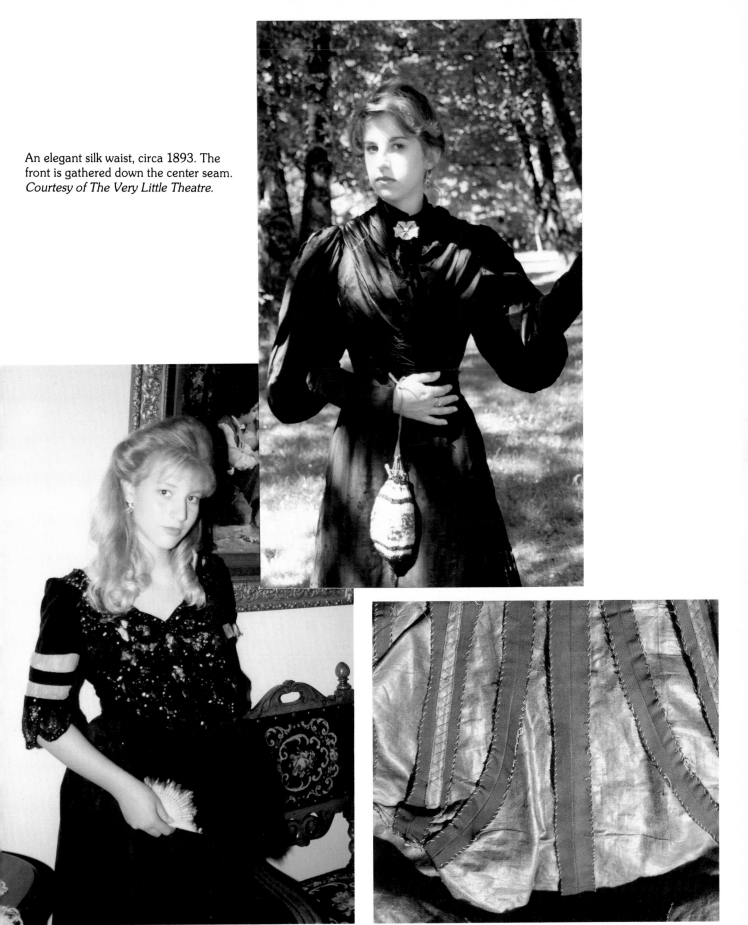

An elegant silk waist, circa 1893. The front is gathered down the center seam. *Courtesy of The Very Little Theatre.*

An evening bodice, circa 1899, made up of midnight blue velvet, netting, and iridescent beading. *Courtesy of The Very Little Theatre.*

The inside of a late 1898 waist, featuring four bones.

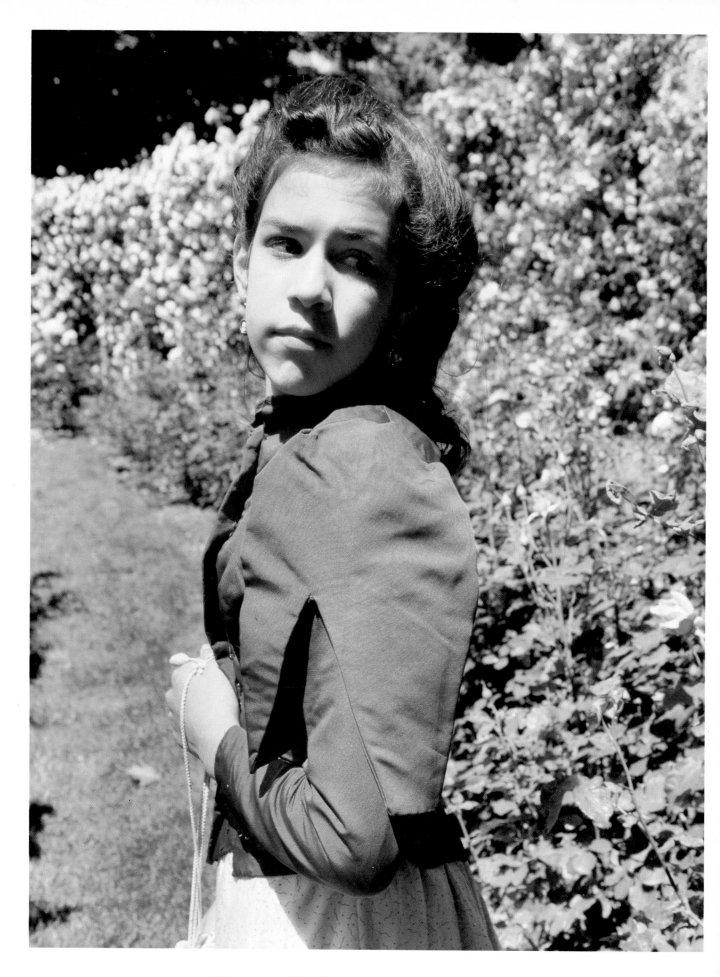

A blouse, circa 1898, featuring tulip-shaped oversleeves.

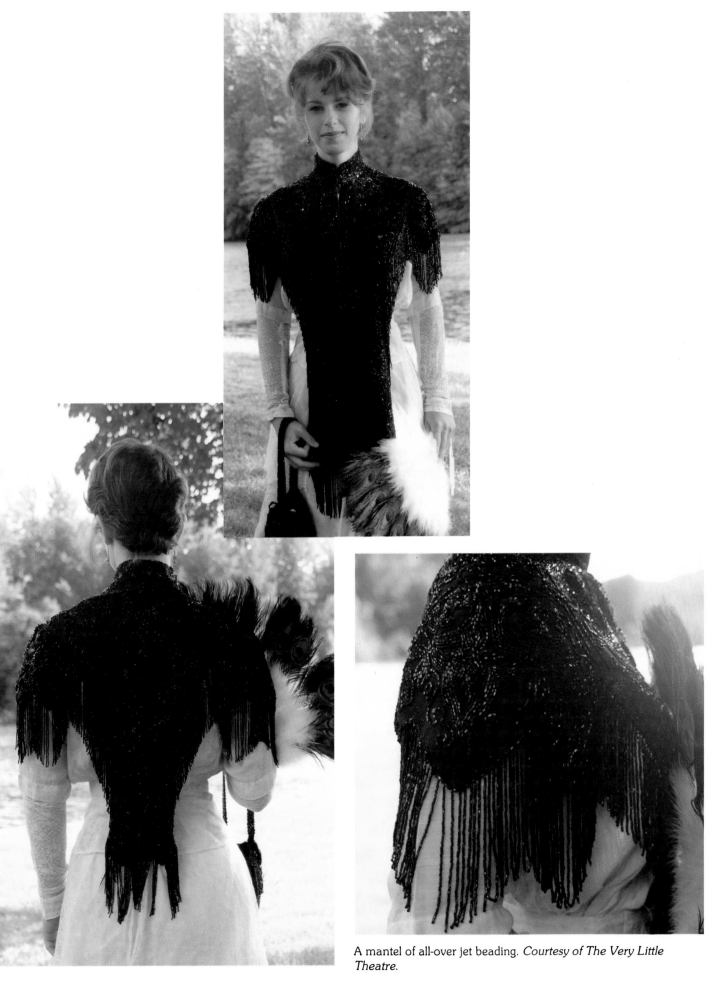

A mantel of all-over jet beading. *Courtesy of The Very Little Theatre.*

A circa 1895 French fashion plate featuring the new huge sleeve, and a profusion of bows.

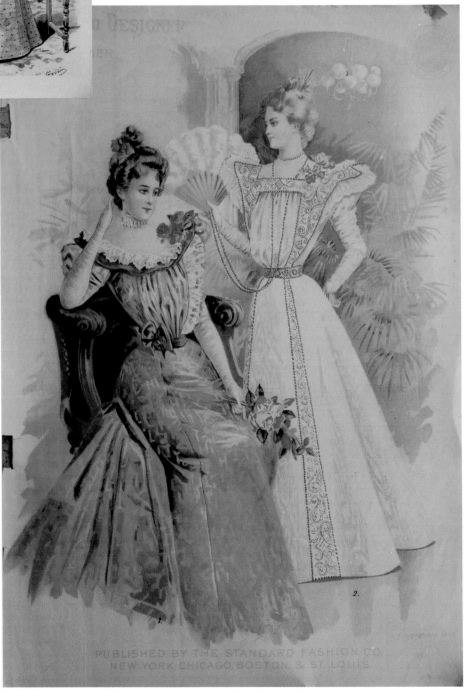

An 1897 fashion plate, featuring two evening dresses.

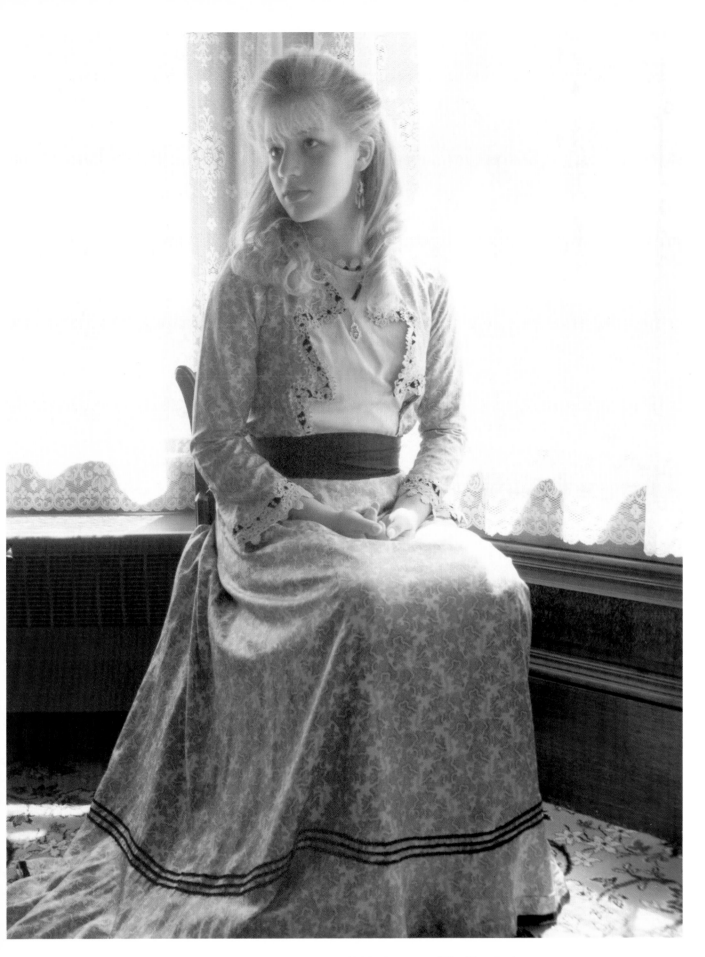

A practical day dress, circa 1890. *Courtesy of The Very Little Theatre.*

A two-piece dress of wool serge, featuring a multitude of lavender bows. Dress and parasol, circa 1892. *Courtesy of The Very Little Theatre.*

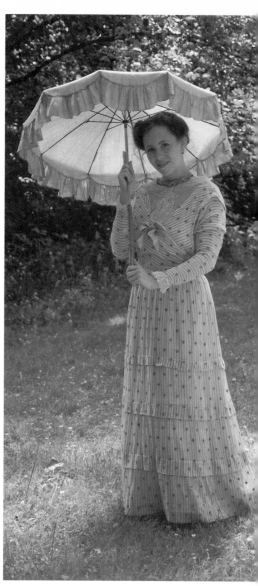

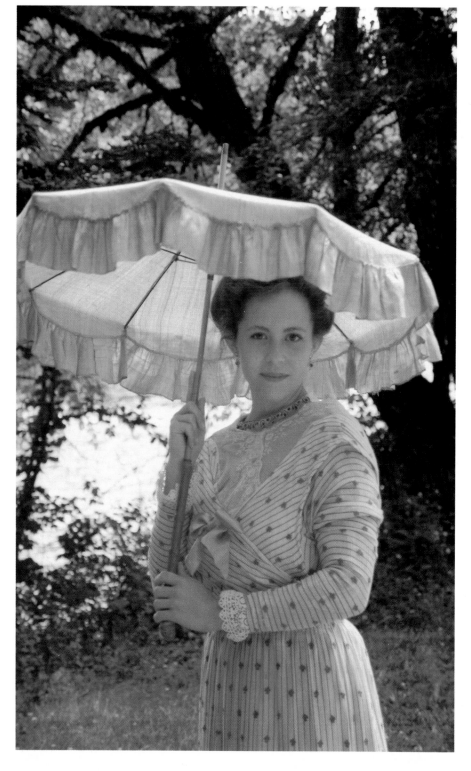

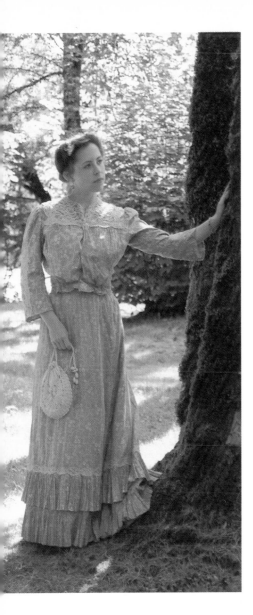

A simple two-piece dress, circa 1890. *Courtesy of The Very Little Theatre.*

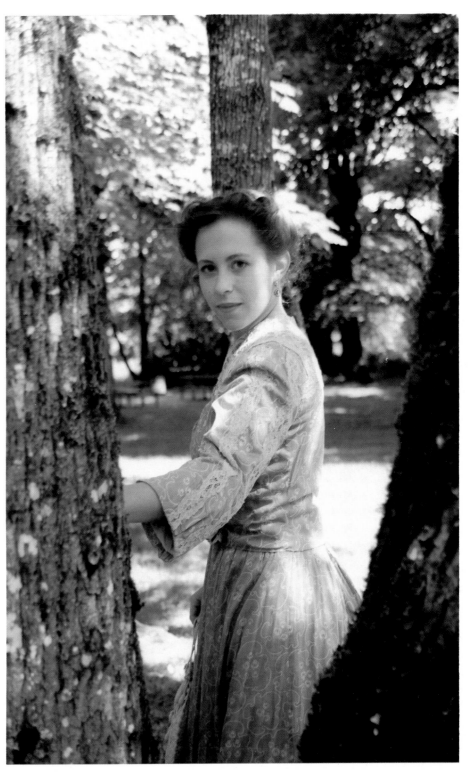

A black taffeta ensemble, circa 1899. *Courtesy of The Very Little Theatre.*

A homemade suit, circa 1891, featuring a wide corset-like waistband.

A two-piece dress with black lace trim, circa 1894. *Courtesy of The Very Little Theatre.*

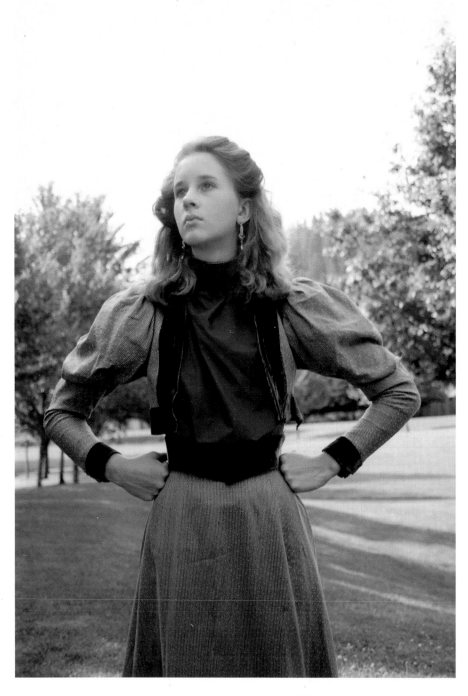

A velvet trimmed suit, circa 1891. *Courtesy of The Victorian Lady.*

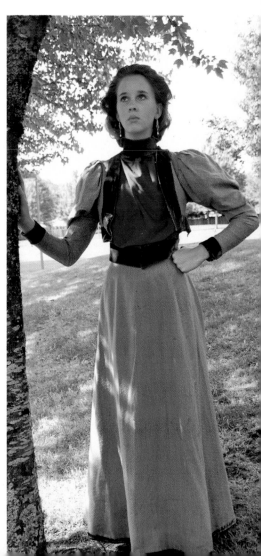

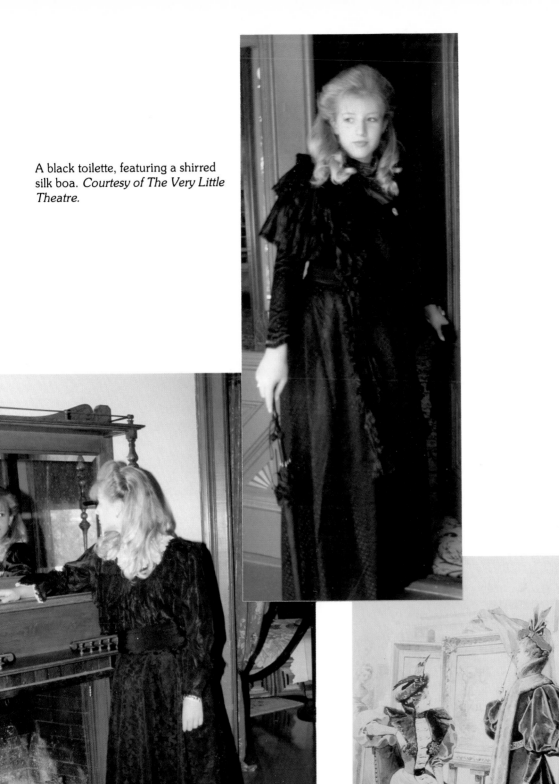

A black toilette, featuring a shirred silk boa. *Courtesy of The Very Little Theatre.*

A taffeta ensemble, circa 1899. *Courtesy of The Very Little Theatre.*

An 1895 fashion plate featuring dresses with excessively pouffed sleeves.

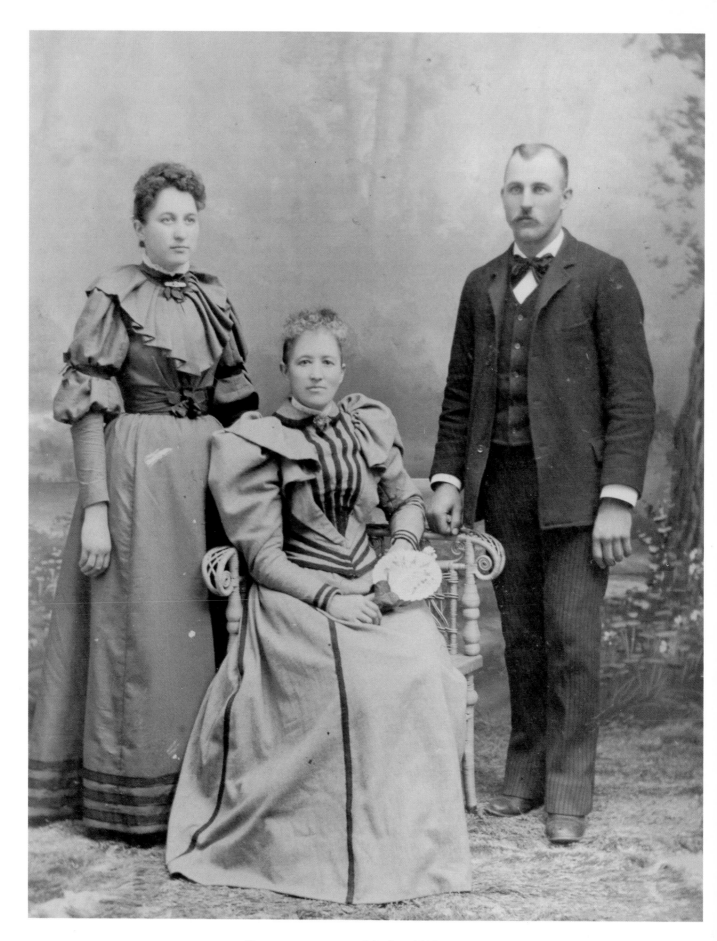

Two average women of the late 1890s.

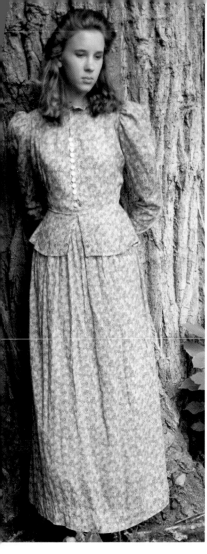

A 'prairie' dress, circa 1890.

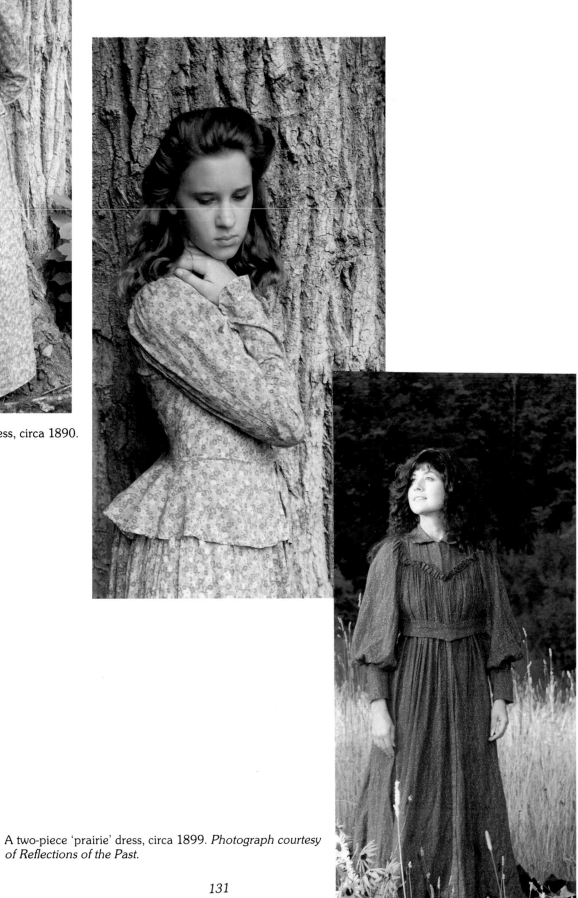

A two-piece 'prairie' dress, circa 1899. *Photograph courtesy of Reflections of the Past.*

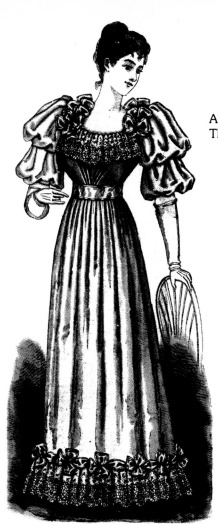

All through the Ninties, fashion flirted with Empire gowns.
This one dates to 1893.

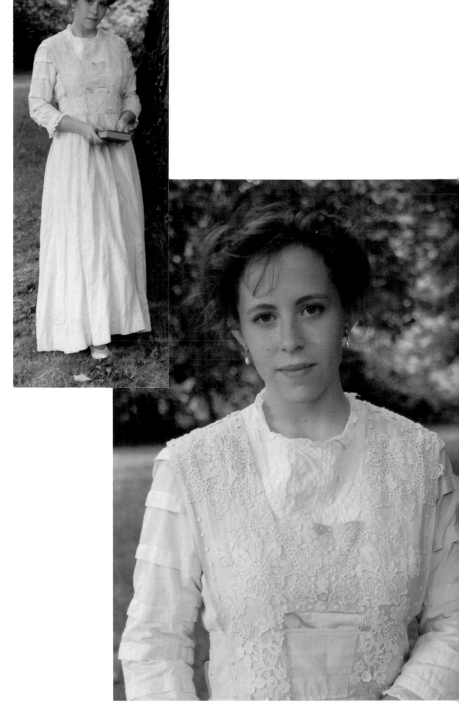

A cotton jumper trimmed with lace, circa 1898. *Courtesy of The Very Little Theatre.*

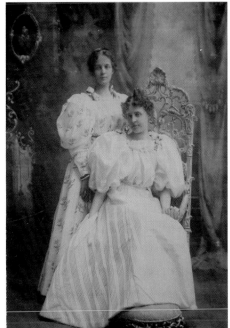

Two young ladies photographed circa 1893.

An 1897 *Standard Designer* fashion plate of winter suits.

An 1894 French fashion plate depicting novel sleeves.

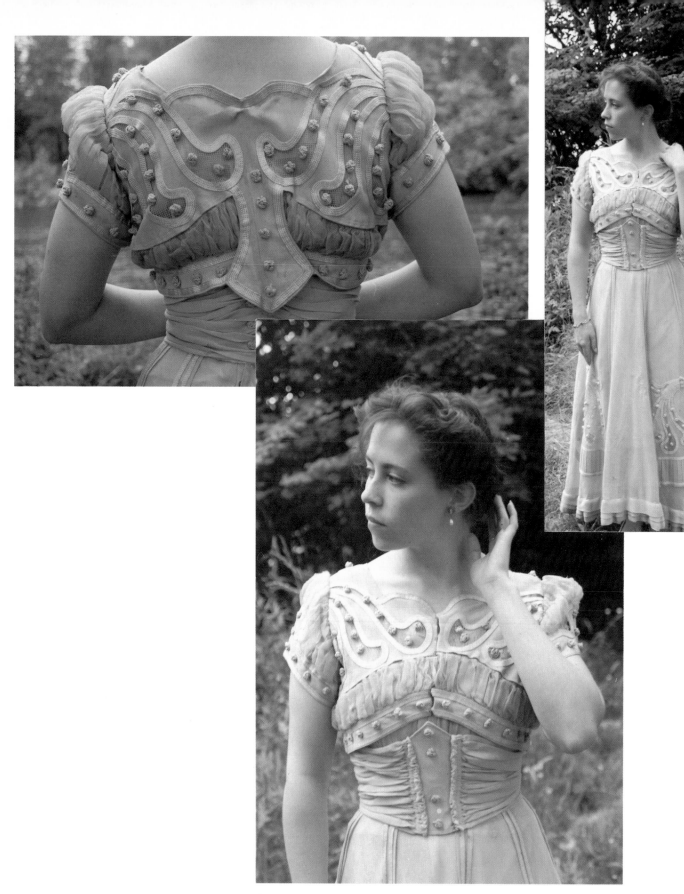

A two-piece dress featuring a wide shaped waistband and
profuse ruching, knotwork, and braid trim. Circa 1899.
Courtesy of The Very Little Theatre.

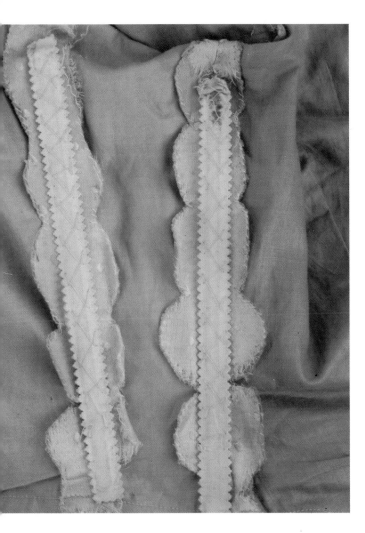

Detail of the inside of a circa 1899 waist.

Two types of combinations, from an 1893 *Standard Designer*. The garment on the left combines corset cover and petticoat, while the garment on the right combines drawers and corset cover.

Detail of a metal bone from an 1899 waist.

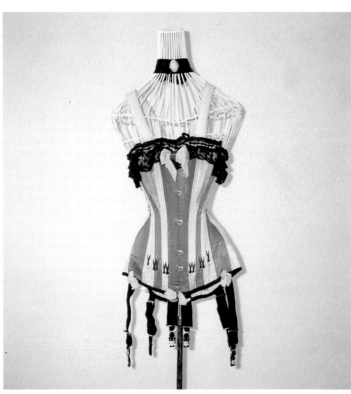

A brilliantly colored corset from the 1890s. *Photograph courtesy of Reflections of the Past.*

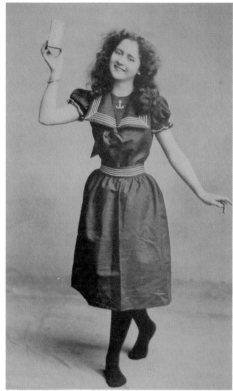

A typical 1890s bathing suit, as depicted in a period advertisement.

THE ETIQUETTE OF CYCLING

In the early 1890s, women simply wore shirtwaists and skirts while bicycling; it was not until the last few years of the Nineties that bloomer suits were widely adopted for this new pastime.

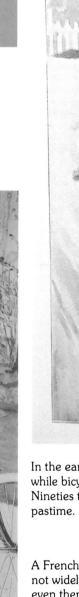

A French velveteen bicycling costume. American women did not widely adopt such cycling outfits until around 1897—and even then, few women were brave enough to wear such costumes without a skirt (usually knee-length) over their legs.

136

A fur cape. *Courtesy of The Very Little Theatre.*

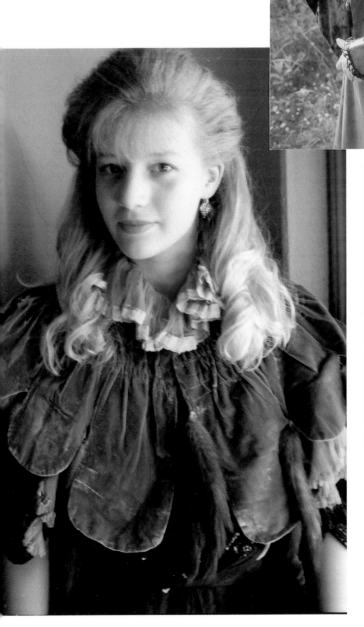

A velvet and fur cape, labeled "Mme. Pouyanna, Paix, Paris." *Courtesy of The Very Little Theatre.*

A lace and jet caplet. *Courtesy of The Very Little Theatre.*

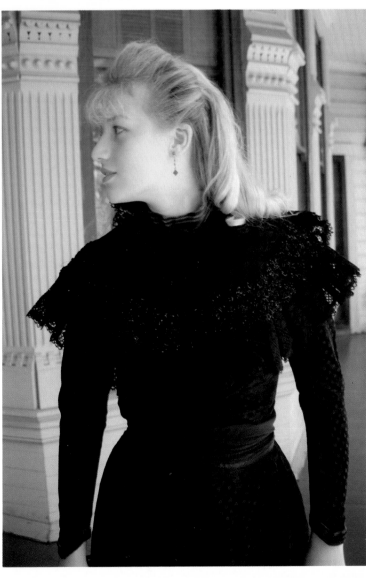

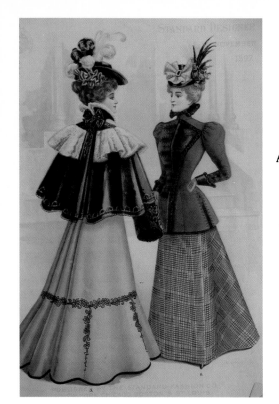

An 1897 fashion plate, featuring winter cape and coat styles.

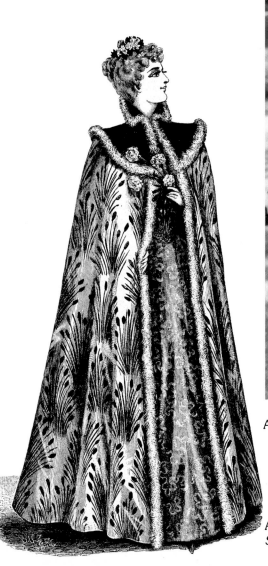

A velvet cape with a jet and braid design.

A rich silk, velvet, and maribou feather cape, from an 1897 *Standard Designer*.

A late 1890s jacket. *Courtesy of The Very Little Theatre.*

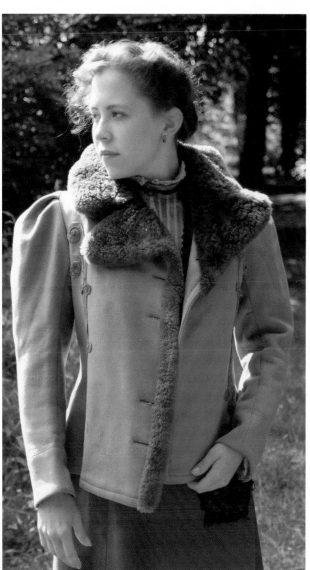

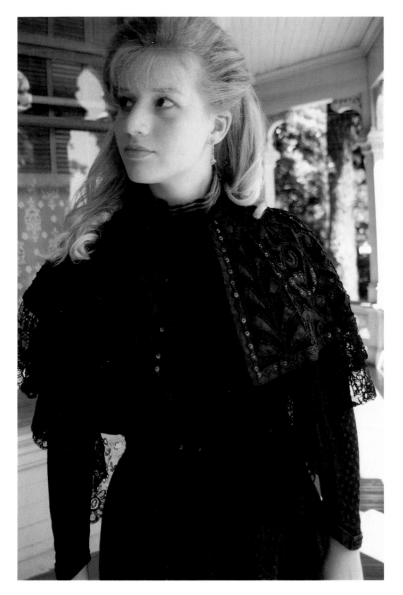

A capelet of lace, braid, and beading. *Courtesy of The Very Little Theatre.*

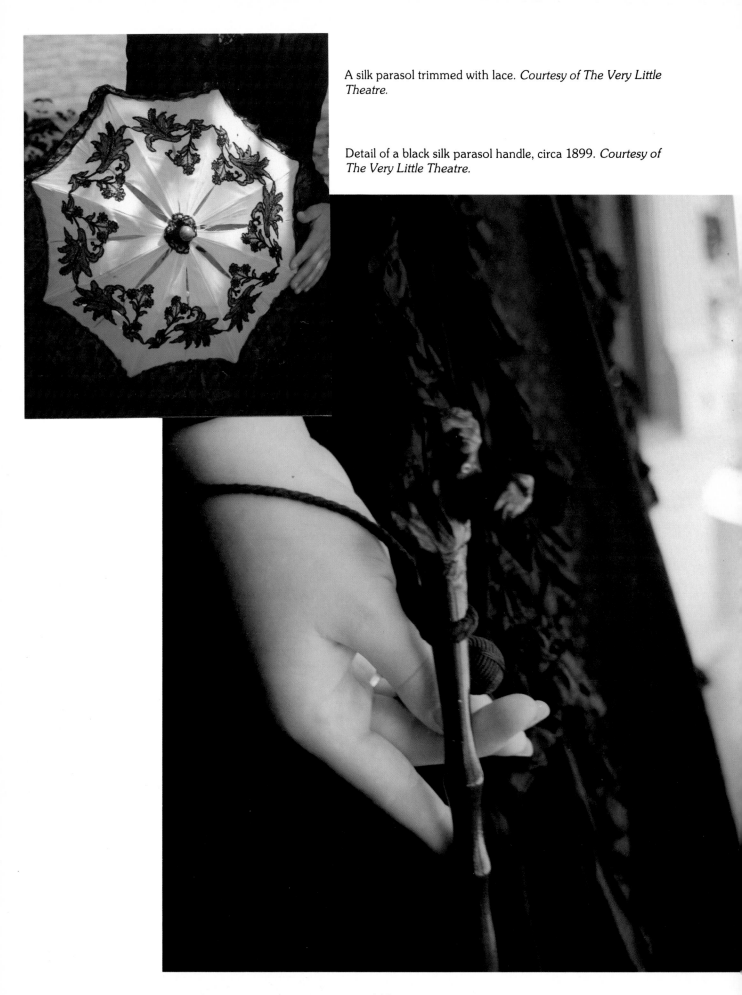

A silk parasol trimmed with lace. *Courtesy of The Very Little Theatre.*

Detail of a black silk parasol handle, circa 1899. *Courtesy of The Very Little Theatre.*

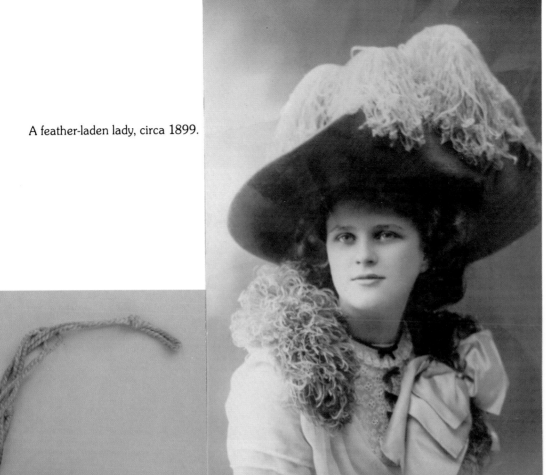

A feather-laden lady, circa 1899.

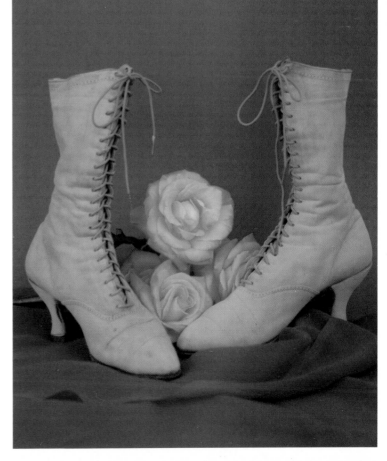

A glass-beaded purse from the late 1890s.

A pair of soft leather hightop boots. *Courtesy of Reflections of the Past.*

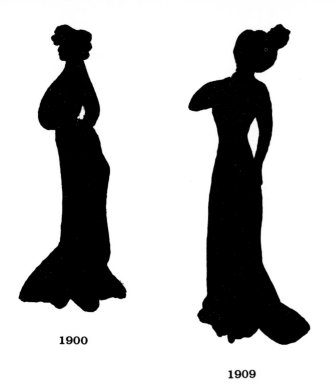

1900

1909

Chapter *Nine*

Early 1900s: Woman Matured

Now, however, they were readily available to nearly every woman, and the white and lacy lingerie dress that had become fashionable at the end of the nineteenth century became the staple of every woman's wardrobe.

A new style of corset also gave a new look to the 'New Woman', thrusting her bosom forward and throwing her hips back. A large, shelf-like bosom was favored, and the hourglass figure was considered a woman's most important asset. It was a very womanly look—and a far cry from the fashions of the beginning of the Victorian era. Women were growing up. Working to clean up poverty and alcohol abuse, and fighting for the right to vote, women were no longer the drooping, pale and thin wildflowers they once were.

"Why certain kinds of clothes are associated in the public mind with certain kinds of women is to me an amusing mystery," author Lilian Bell wrote in her book *From A Girl's Point Of View*, disparaging at society's typically turn-of-the-century way of creating hard–fast fashion and social rules. "Why are old maids always supposed to wear black silks?...[and] why are literary women always supposed to be frayed at the edges? And why, if they keep up with the fashions and wear patent–leathers, do people say, in an exasperating astonished tone, 'Can that woman write books?'...Little as some of you men may think it, literary women have souls, and a woman with a soul must, of necessity, love laces and ruffled petticoats, and high heels, and rosettes..." These attitudes all typify the early years of King Edward's reign in England. All women (even if only in their souls) were supposed to adore frilly, ultra-feminine styles—and, for the most part, all women of the early 1900s indulged in them.

The availability of machine-made laces, embroideries, eyelets, and cutworks had once only been within the budget of wealthy women—but had always been in the fashion dreams of the 'common' woman.

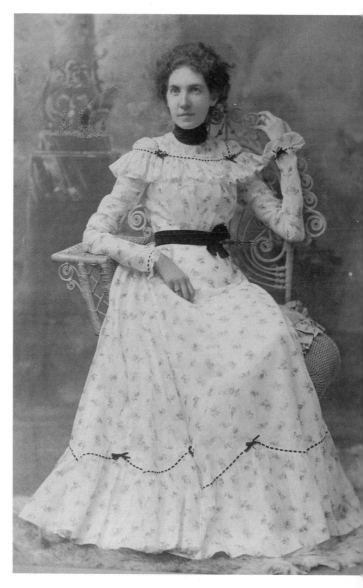

A lovely be-ribboned gown, circa 1900.

Skirts

"One thing is certain," *The Queen* dictated in late 1899, "the skirt must fit like wax at the top, and fall in full, graceful folds at the foot." Indeed, skirts from the early twentieth century were as slim as could be at the hips, but, with the help of gores, flowed with fullness at the hem. Light gathering or pleating still accentuated the derrière, as did trains in a variety of lengths. Skirts with very long trains usually also featured attached string loops at one edge near the hem, which allowed the train to be lifted gracefully by hand while walking.

Skirts were rarely lined—the light, flowing affect was now preferred. Instead, to help keep skirt hems from fraying and wearing out quickly, bands of velvet or velveteen were often sewn to hem edges. To help keep skirts full and away from the legs, many dressmakers sewed canvas or crinoline into the hems before adding this velvet binding.

Wide waistbands (which were often almost entirely hidden because women's bodices pouched so much), grew increasingly popular. Skirts made with narrow waistbands were usually worn with wide, shaped (and often boned) 'girdles' or belts. By 1907, however, the trend was banished by yet another revival of the Empire-style high waistline.

For day, skirts were usually very simple, with little or no decoration—but even walking skirts had trains. By evening, however, every tuck, trim, and frill was taken advantage of—usually at the skirt's hem.

Around 1909, skirts began changing drastically. Since about 1906, walking skirts were as short as four inches from the floor, and now this trend was beginning to show a bit in skirts worn everyday. Such skirts (increasingly tubular in shape) also grew slimmer at the hem and now had little or no fullness in the back.

Bodices

Collars reached an all time high in the early 1900s; boned and often reaching the earlobes, women were forced to carry their heads high, and sometimes looked as though their noses were in the air. Collars were sometimes detachable—which made for greater versatility in wardrobe, in addition to making collars more practical and accessible for frequent cleaning. It wasn't until 1908 that necklines for day wear could sometimes be worn at the base of the neck. Around 1909, a new style of collar appeared: the Dutch Collar, which was similar in shape to a Peter Pan Collar.

Bodices, though usually appearing very loose on the outside, were most frequently lined and fully boned on the inside, further adding to the rigidity of ladies. Inner-waistbands were also still used frequently—though by 1909, they were nearly obsolete. Bodice closures were the most versatile they had been in years, closing in the front, back, side, or a combination of the three. Often closures—especially those in the front—were concealed with ribbons and other trims.

Two delicate gowns, circa 1901.

The shirtwaist was still in high favor, as were bodices decorated with rows of tucks. But the biggest variance in bodices of the early 1900s was sleeve styles. In 1900, sleeves frequently had small cuffs. An especially popular style (that continued until about 1908), was sleeves gathered along the under, upper, or both seams. Some sleeves from the era were given an extra puffy affect by making the sleeves about twice as long as the arm. Though a bodice created in this manner looks ridiculous off the figure, once put on, the extra length is attractively pushed up the arm.

Around 1908, women's clothes took on a decidedly less frilly look. Tailored garments were much in vogue and a favorite trim was buttons—functional or otherwise. One-piece dresses from this time often had a draped, Grecian appearance, with the waist often left unbelted (though fitted). The Empire line once more became trendy, always with a well-boned inner bodice.

Two gowns, circa 1900. *Courtesy of The Very Little Theatre.*

Around 1902, though sleeves were still slender, they usually had a ruffle at the wrist, rather than a cuff. About 1903, sleeves gained extra fullness from elbow to wrist, and by 1904, sleeve styles were in the true Bishop shape. By 1906, sleeves were full at the top, as well as at the bottom. Around 1908, when Oriental influence was strong in American design, kimono-style sleeves were also sometimes worn.

Dresses

For the first time in perhaps all of fashion history, competition between designer houses created experimentation and some diversity in the style-lines of women's clothes. While fashions were by no means distant from one another, dress styles reflected some diversity—and would increasingly do so through the next decade.

Women often followed the footsteps of Charles Dana's Gibson Girl and wore separate blouses and skirts—though one and two-piece dresses were still important. Hems were often only two inches from the floor, and trains were frequently worn—especially in the evening. Though by day women were extremely well covered, by night, sleeveless styles revealing décolletage were most fashionable.

The princess dress was a staple in the early 1900s, revealing every curve of the body. Lingerie dresses were equally important, usually made up in white or off-white, but also sometimes found in delicate shades of blue, pink, lavender, peach, and other pastels. Usually these dresses were sheer and meant to be worn with a separate slip; the practical woman had a variety of basic slips in white and various pastel colors, which greatly extended her wardrobe. Tailored suits were also favored, especially in shades of grey and trimmed with lace.

After a few years of focusing on impractical laces and sheers, around 1905, American fashion magazines began to focus their attention—at least partially—on washable fabrics. The search was also on for practical clothing designs. By 1907, jumpers were filling this void. Some jumpers consisted of only skirts with wide straps and a partial bodice, and were worn over a separate blouse. Others were only a sleeveless top, created to be worn over a separate dress or blouse and skirt. Worn even in the evening, jumpers continued to be an important fashion element until about 1911.

In 1909, the tailored look became increasingly popular, and skirts grew more slender at the hem. Tunic-style skirts were the newest style, giving the appearance of two separate skirts: one worn long and tubular under a shorter, slightly fuller over-skirt. The most fashionable evening dresses were still created in the Empire style and usually were heavily beaded.

"Not only are the fabrics of exquisite texture," *The Lady* praised in 1902, "but they are embellished with miraculously fine hand embroidery, applique, lace insertions, and trimmings of many kinds." Indeed, these were the choice fabrics for most of the early 1900s. Velvet crepe de Chine, moire, voile, silk, net, and lawn were also popular. Later in the decade, tailored styles were created primarily in linens and wools.

All pastel shades were fashionable—especially within the first few years of the 1900s. In complete contrast, royal shades of purple, blue, deep red, and emerald green were also fashionable.

Undergarments

The introduction of the straight-fronted corset had a tremendous impact upon early twentieth century fashions. Originally created with the intention of putting less force on women's bodies (and therefore, being more healthful), the corset's creators must not have understood turn-of-the-century women very well. In order to work as designed, the corset had to be fitted only lightly to the figure—but after decades of tight-lacing, women naturally cinched their new corsets as tight as ever. The healthy intentions of the corset were thus ruined and a peculiar S-shape silhouette became *the* look of the early 1900s. Reaching well past the tummy and contorting the back into a curve, corsets were as uncomfortable as ever. A woman's only relief was a corset created with elastic gussets, or the so-called 'ribbon corset', made shorter and more flexible and intended for housework and sportswear.

Around 1908, a forerunner of the bra could be purchased and worn instead of a corset—but it was by no means worn by the masses. These so-called 'bust supporters' were actually nothing more than boned corset covers.

Corset covers themselves were more important than ever in the early twentieth century, since sheer fabrics were popular and many corsets now left the bosom free. Women who were blessed with a much-admired ample bosom could purchase very snug-fitting, lace-up corset covers, designed to help support the bosom. Since a very large bosom was much to be desired, many corset covers of the early 1900s were layered with ruffles and frills. When even ruffles didn't produce the bosom desired, false bosoms were favored. Unlike the 'falsies' of previous decades, however, these bosoms usually were not made of stiff rubber, but of soft fabric pads or inflatable rubber.

Fabric pads were also sometimes worn on the hips to help achieve an hourglass figure, and while the large, cumbersome bustle had long since been out of fashion, small fabric pads were worn until about 1908 by some women. To add to this alarming array of 'falsies', *Harper's Bazar* recommended placing a small flat pad at the center front of the bodice in order to achieve as straight-fronted a look as possible.

Two afternoon gowns, as featured in a 1902 issue of *The Delineator* magazine.

Combinations continued in their newly-found popularity, and new styles were often toyed with. One of the most popular alternative styles was a combination corset cover and petticoat, which was worn by some until 1908.

The rustle of silk and taffeta petticoats was of great appeal to early twentieth century women, though by 1908, petticoats abandoned their frills and furbelows and became quite simple. For the first time in decades, the wearing of only *one* petticoat became the norm.

From about 1900 to 1907, full-length slips were widely worn—mostly because of the popularity of sheer lingerie dresses. Usually made up in the close-fitting Princess style, these slips looked like very simple, sleeveless dresses, usually with a few flounces at the hem.

Sportswear

After great strides in women's sportswear in the 1890s, the genre came to a virtual standstill until the Edwardian period ended.

Bloomer costumes were worn by some turn-of-the-century women for nearly all forms of exercise. Consisting of a blouse (usually loose-fitting) and pleated or gathered bloomers, many women thought them ridiculous–looking and choose instead to wear traditional long skirts and snug bodices.

Swimwear also remained much the same—though now, occasionally, separate 'underbodies' consisting of a plain (usually sleeveless) top attached to bloomers were worn under a skirt or dress–like overbody.

Other Important Garments

Boas—though enjoying some popularity in the late 1890s—became truly fashionable in the early 1900s. Used as trim on dresses or as wide, fluffy stoles, nearly every fashionable woman tried her hand at them; but their popularity didn't last much past 1908. Huge hats decorated with every imaginable flower, fruit, and bird were worn by the most fashionable women, and from about 1908 forward, shoes decorated with rhinestones, beads, and sometimes flowers, were especially favored for evening wear.

Housegowns became a more acknowledged garment in the twentieth century. Designed to be worn for housework, they were carefully created with a snug-fitting inner bodice which could be laced up tightly, in case a corset was not worn. Teagowns (now fashionably called 'negligees') were still worn, but 'dressing saques' were quickly replacing them. Actually, the two were virtually the same, except saques only reached the thigh, whereas teagowns usually touched the floor.

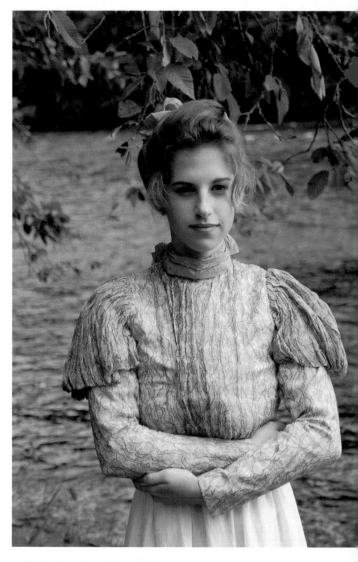

A girlish, pleated waist, featuring silk bows. *Courtesy of The Very Little Theatre.*

A lace waist lined with robin's-egg-blue silk, circa 1900.

Two waists, circa 1905. On the left, a heavy crocheted collar is featured, while the waist on the right features insets of lace. *Courtesy of The Very Little Theatre.*

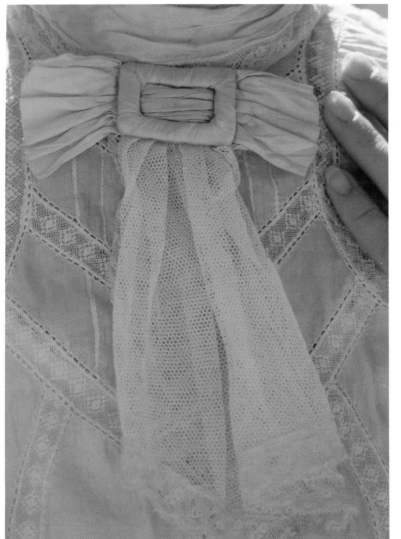

An eyelet blouse, circa 1909.

A detachable silk jabot, circa 1903. *Courtesy of The Very Little Theatre.*

A striped silk waist, circa 1902. *Courtesy of The Very Little Theatre.*

A typically pigeon-fronted waist, circa 1903. *Courtesy of The Very Little Theatre.*

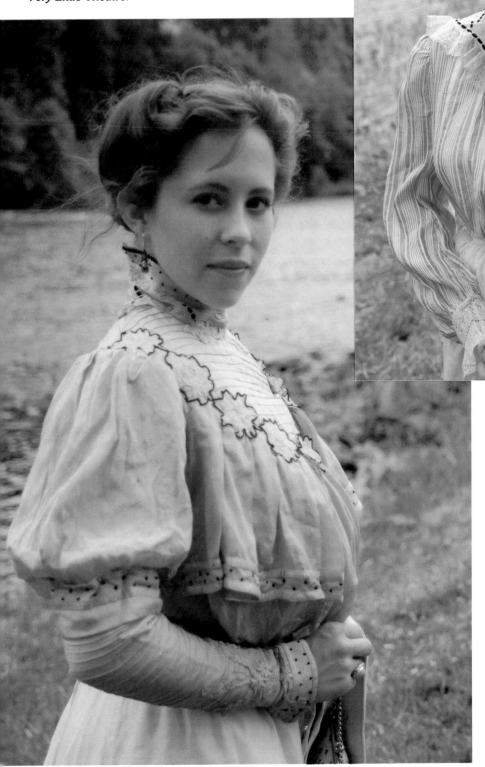

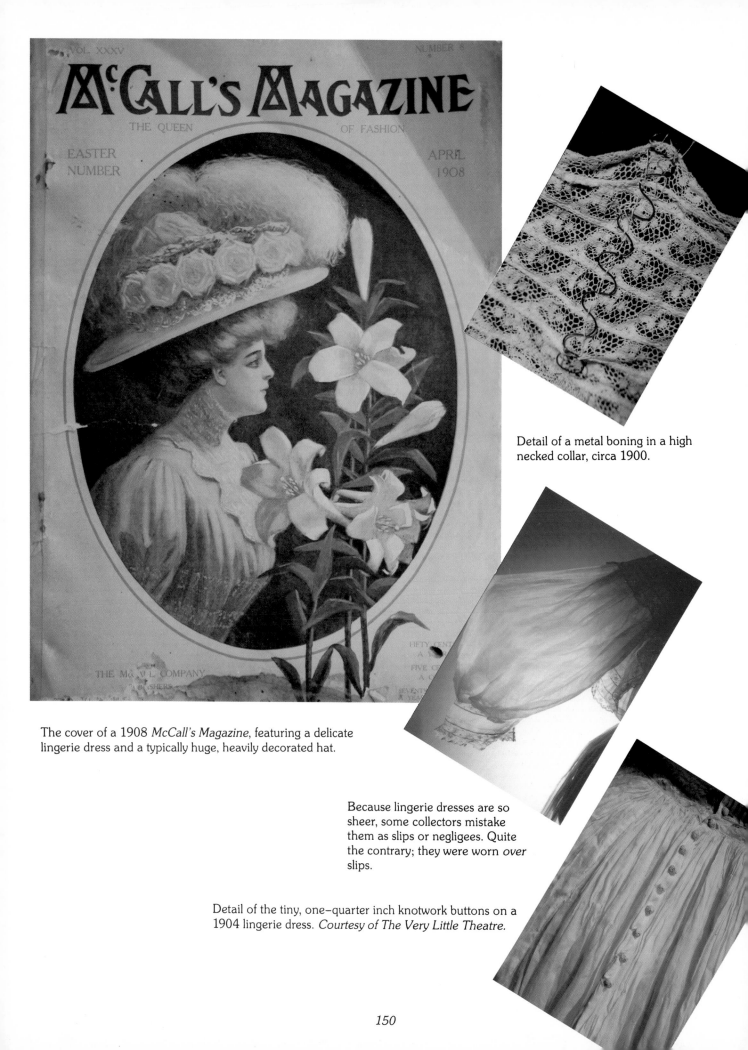

Detail of a metal boning in a high necked collar, circa 1900.

The cover of a 1908 *McCall's Magazine*, featuring a delicate lingerie dress and a typically huge, heavily decorated hat.

Because lingerie dresses are so sheer, some collectors mistake them as slips or negligees. Quite the contrary; they were worn *over* slips.

Detail of the tiny, one–quarter inch knotwork buttons on a 1904 lingerie dress. *Courtesy of The Very Little Theatre.*

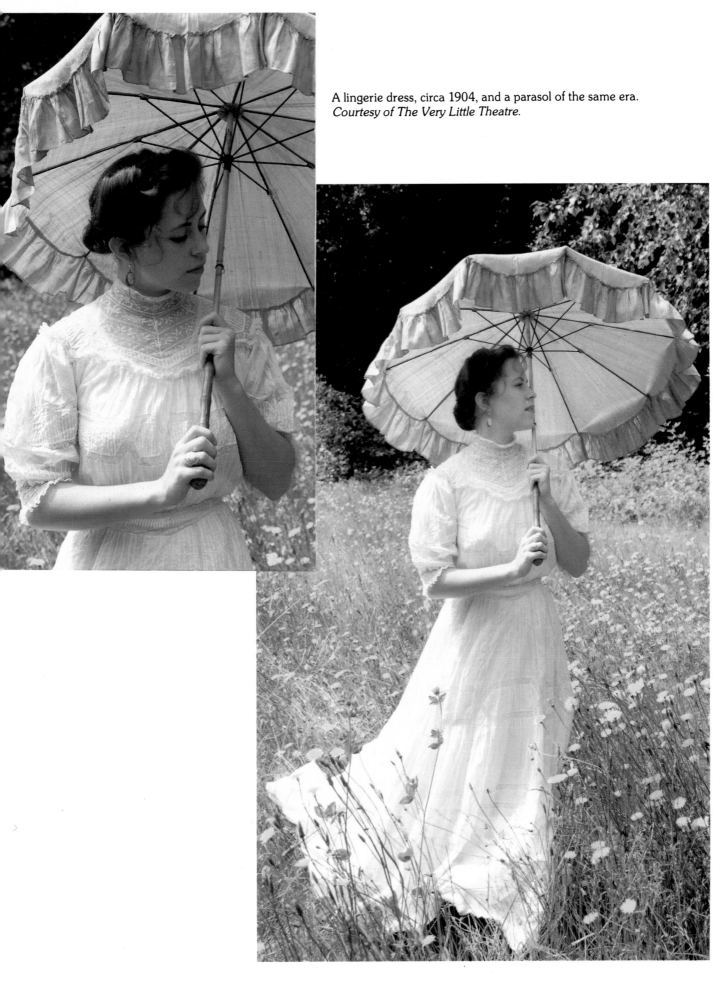

A lingerie dress, circa 1904, and a parasol of the same era. *Courtesy of The Very Little Theatre.*

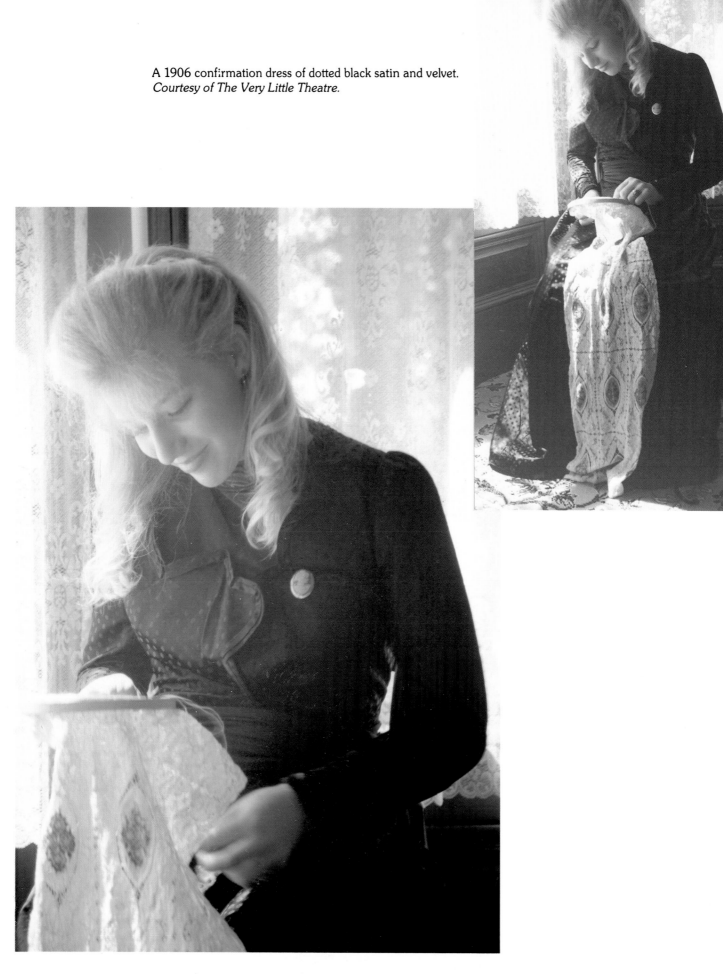

A 1906 confirmation dress of dotted black satin and velvet.
Courtesy of The Very Little Theatre.

Blissfully domestic, this Edwardian lady is dressed in a fashionable lingerie dress.

A lingerie dress, circa 1904. *Courtesy of The Very Little Theatre.*

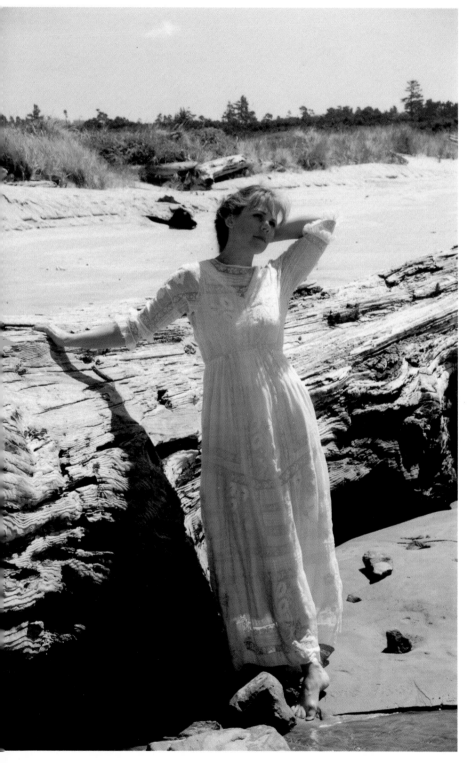

The cover of a 1906 French fashion magazine, featuring a tailored suit.

Vol. LXVI OCTOBER, 1905 No. 4

THE DELINEATOR

PUBLISHED MONTHLY BY THE BUTTERICK PUBLISHING CO. (LTD.) PARIS-LONDON-NEW YORK-TORONTO
$1.00 A YEAR ENTERED AT THE POST OFFICE, NEW YORK, AS SECOND CLASS MAIL MATTER 15 CENTS A COPY

The cover of a 1905 magazine, featuring tailored, but soft and well trimmed, dresses.

Detail of a circa 1903 lace-trimmed dress train. *Courtesy of The Very Little Theatre.*

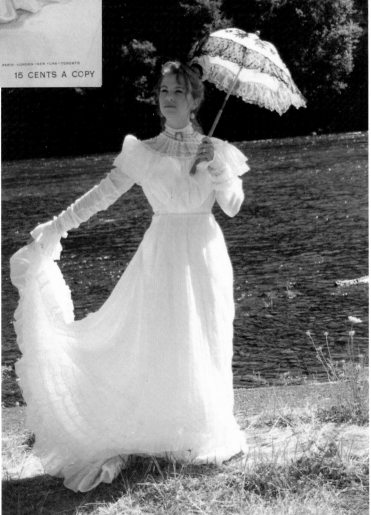

A two-piece dress, circa 1903. The bodice has very long sleeves, which are pushed up the arm for a gathered affect. *Courtesy of The Very Little Theatre.*

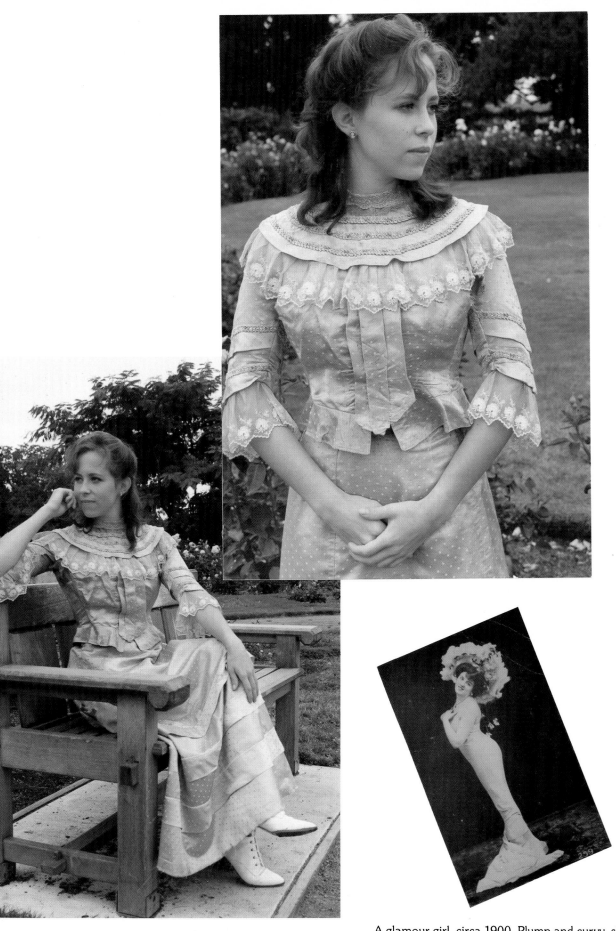

A silk two-piece dress trimmed with lace, tucks, and braid, circa 1900.

A glamour girl, circa 1900. Plump and curvy, she wears a princess-cut dress, with the long train wrapped about her ankles.

Detail of the lace-shaping, whitework, and tucks of two lingerie dresses. *Courtesy of The Very Little Theatre.*

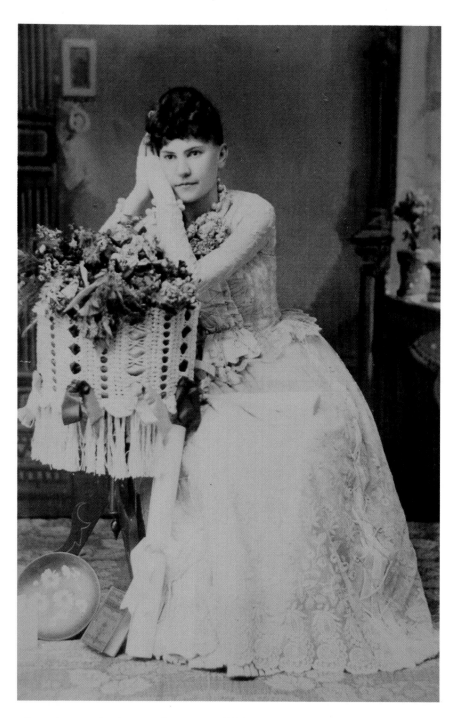

A graduation-day lingerie dress, circa 1900. Though white dresses were fashionable for every woman's wardrobe, they were considered absolutely essential for graduation day.

A tailored suit or a dress of frills and furbelows—two quintessential early 1900 styles.

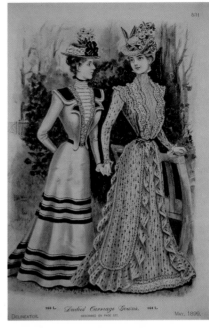

A lingerie dress with a wide, shaped belt, circa 1908.

A lingerie dress, circa 1903. *Courtesy of The Very Little Theatre.*

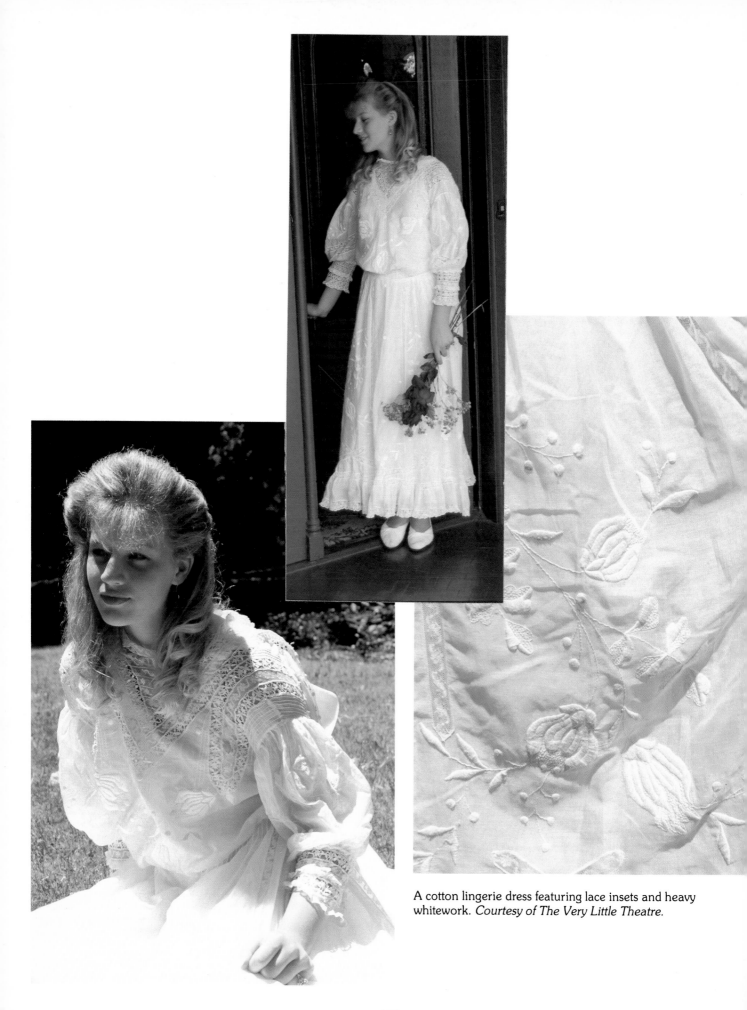

A cotton lingerie dress featuring lace insets and heavy whitework. *Courtesy of The Very Little Theatre.*

A lingerie dress featuring the more tubular lines of 1910.

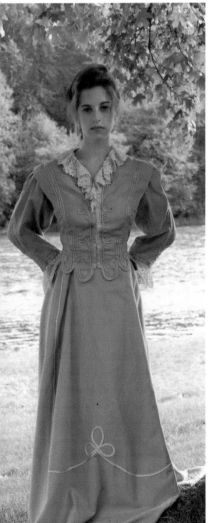

Grey suits dripping with lace were eminently popular in the early 1900s. This one dates to about 1905. *Courtesy of The Very Little Theatre.*

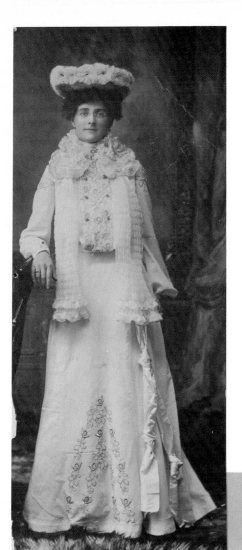

An atypical Edwardian lady, wearing a shirred boa and a white dress trimmed with lace, ribbon, and embroidery.

Two 'stylish toilettes' from a 1908 *McCall's Magazine*.

A tastefully dressed woman, circa 1906.

A delicate dress, circa 1903, trimmed with profuse 'drippery'. *Courtesy of The Very Little Theatre.*

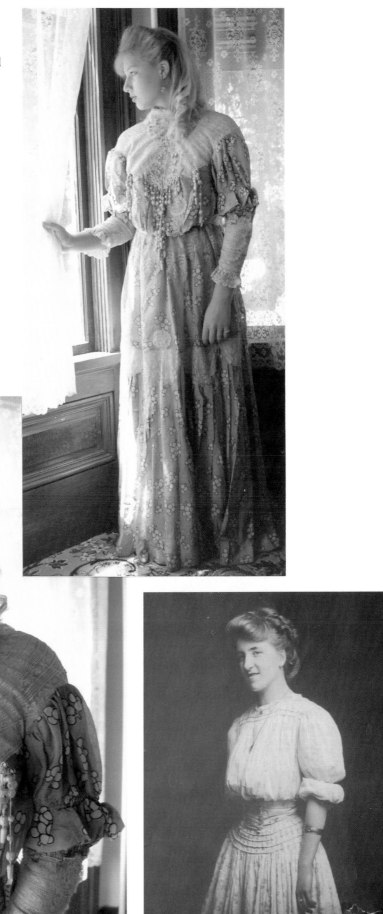

A young lady in a casual print dress, circa 1909.

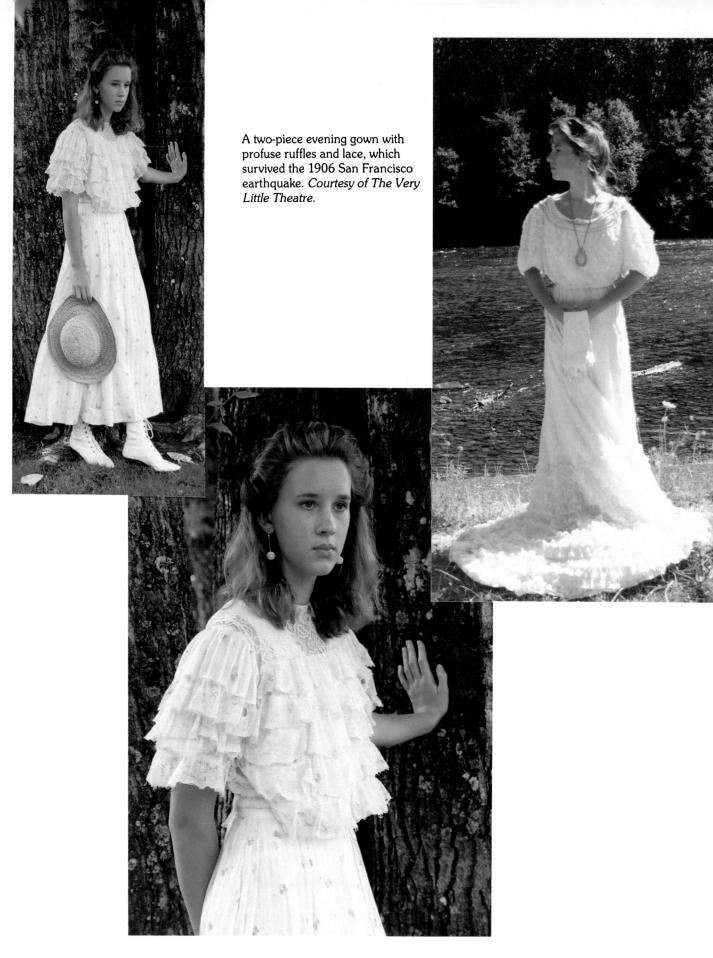

A two-piece evening gown with profuse ruffles and lace, which survived the 1906 San Francisco earthquake. *Courtesy of The Very Little Theatre.*

A two-piece rose-printed dress, circa 1905. *Courtesy of The Victorian Lady.*

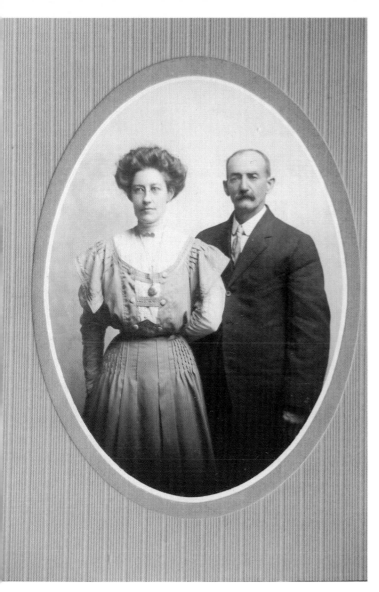

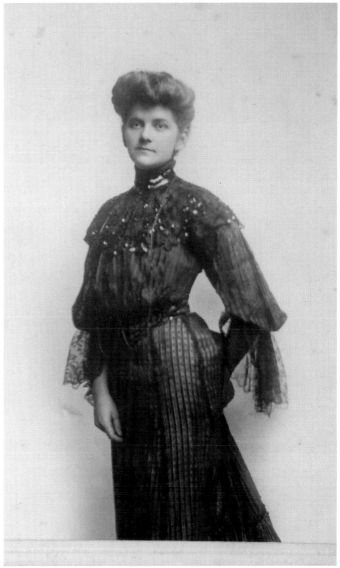

A woman wearing the more tailored suffragette look, circa 1904.

A wealthy Edwardian lady dressed in a lace and net dress, trimmed with beading. Circa 1901.

A 1908 fashion plate illustrating functional and practical jumpers.

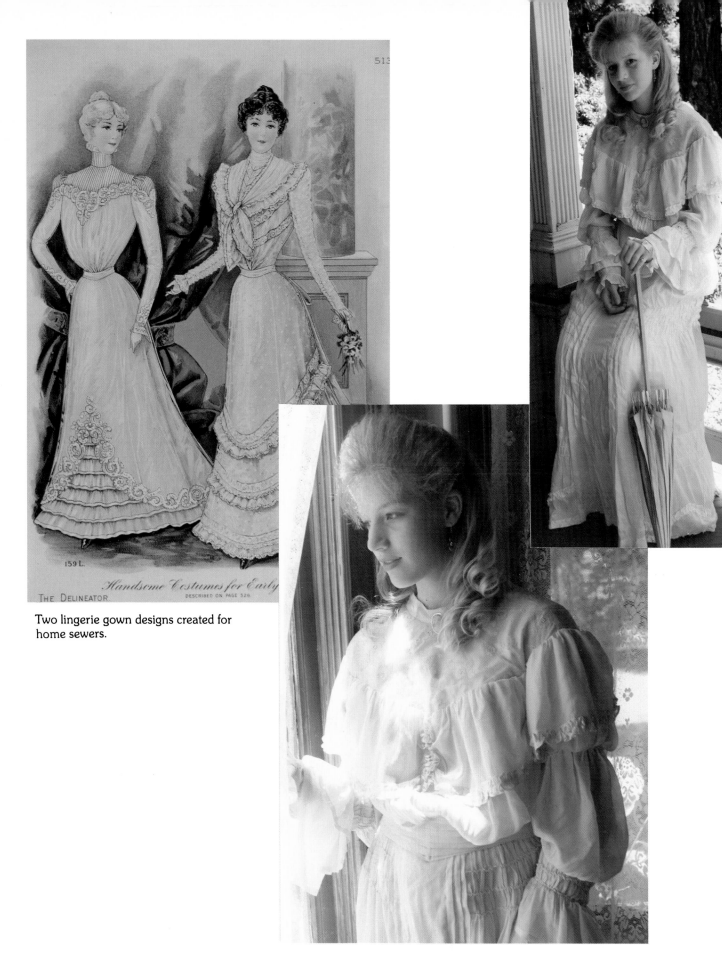

Two lingerie gown designs created for home sewers.

A soft, poufy, two-piece dress with a matching shaped belt, circa 1903. *Courtesy of The Very Little Theatre.*

Two jumpers from a 1908 *McCall's Magazine.*

A working girl, circa 1909.

A 1908 fashion plate featuring tailored suits and large, feathered hats.

A suffragette suited in a sleek, minimalist toilette, resembling her husband's three-piece suit. Circa 1910.

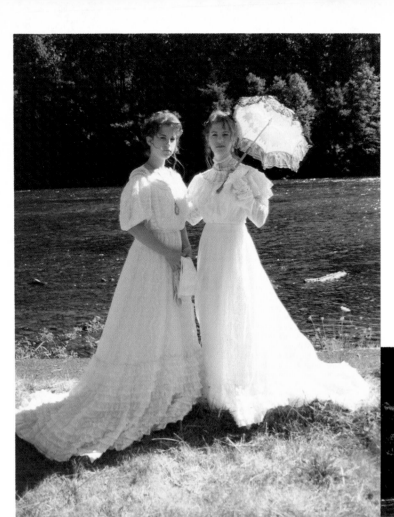

Two dresses, circa 1905. On the left, flounces predominate, while on the right, tucks and ruching were favored. *Courtesy of The Very Little Theatre.*

A small, quilted bustle, circa 1900. *Courtesy of The Very Little Theatre.*

Sweep Length

Round Length

Two negligees from a 1908 fashion magazine. The gown at left is a traditional teagown, while the garment at right is in the shorter style

Bathing suits remained much the same as they had been in the previous decade, except now they were a bit more revealing.

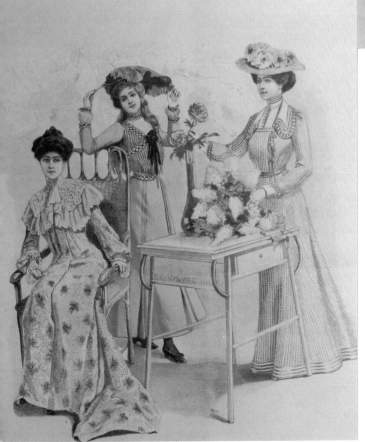

A 1901 fashion plate, featuring (on the far left) a teagown. *Courtesy of Reincarnation.*

A 'naughty' postcard, circa 1900, showing a ribbon corset and combinations.

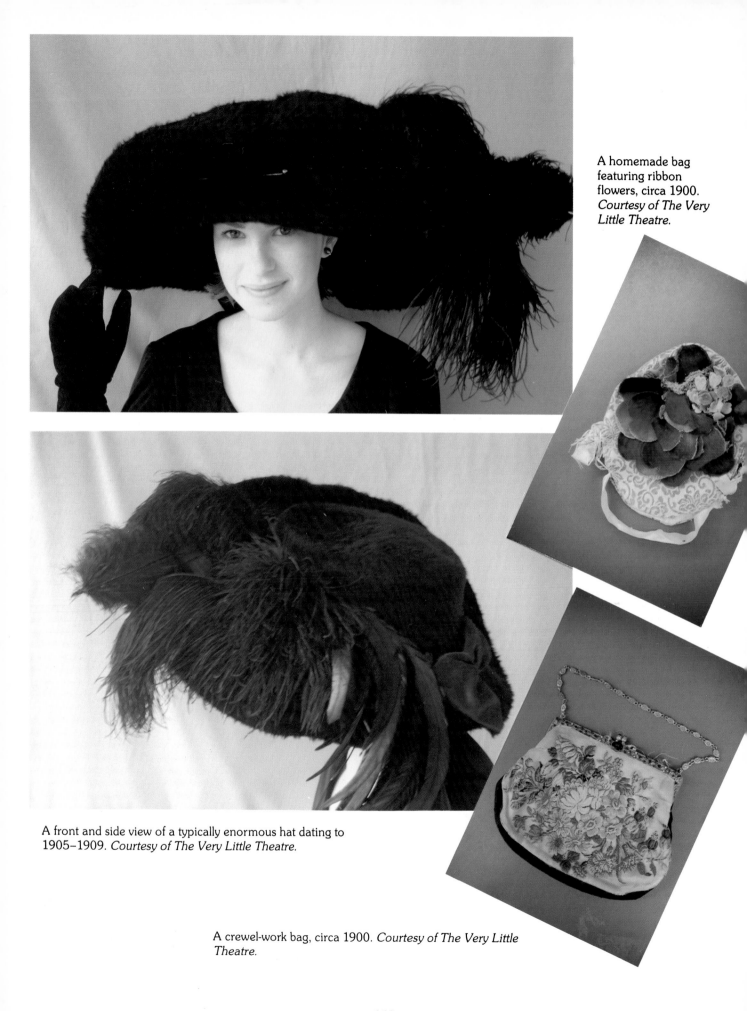

A homemade bag featuring ribbon flowers, circa 1900. *Courtesy of The Very Little Theatre.*

A front and side view of a typically enormous hat dating to 1905–1909. *Courtesy of The Very Little Theatre.*

A crewel-work bag, circa 1900. *Courtesy of The Very Little Theatre.*

Camille Clifford, striking a modern woman's defiant pose,
circa 1905.

A humourous postcard, circa 1900, poking fun at fashion's
latest invention.

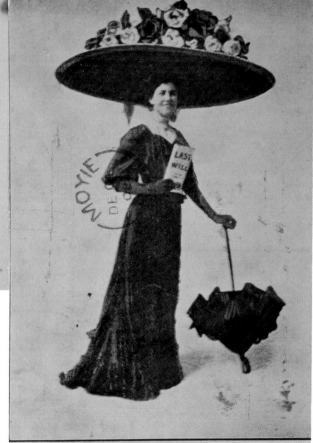

I've all the cash that I can use,
 This will of Hubby's fixes that,
There's none to growl next time I choose
 To get a MERRY WIDOW HAT.

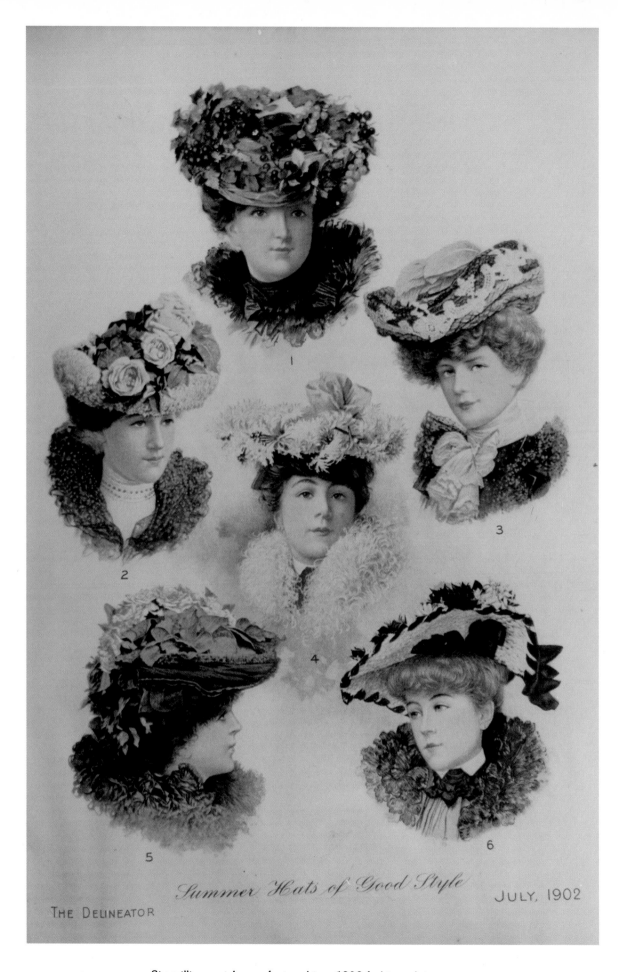

Six millinery styles, as featured in a 1902 fashion plate.

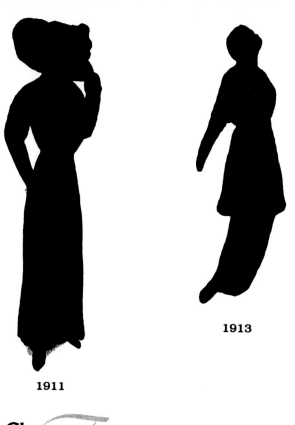

1913

1915

1919

1911

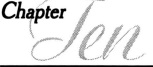

'Teens: Hodge–Podge Years

A parade of ever–changing styles, the 'teens have but one common denominator: though apparently 'modern' and more comfortable on the outside, on the insid, they were as uncomfortable and confining as ever.

"Anyone who wishes to look really smart and up-to-date must 'take heed to their corsets,' and see that they...are long—very, *very* long...It is quite *le dernier cri* to have the bodice 'floppy'...*but* under all that seeming freedom, there is a well cut, tight-fitting, and *boned* bodice lining," demanded *The Young Ladies Journal* in 1911. Indeed, though suffragettes were well on their way to political and social freedom, their clothes still kept them bound: long and tight corsets, hairpins and huge hats, and slim and snug skirts.

In 1913, *The Young Ladies Journal* complained about the restrictive fashions: "A human being's limbs...experience considerable difficulty in making an energetic stride, owing to the confining line in the region of the knees. It is, in fact, quite necessary nowadays to 'rehearse' an elaborately draped skirt before appearing in it in public, to realize the precise length of each pace to be taken, and calculate exactly how far it is possible to turn without the necessity of having to free ones ankles from the entanglement of the narrow tail-like train which most...gowns are now encumbered."

Coming closer to the vote, the women of 1913 preferred more sophisticated gowns.

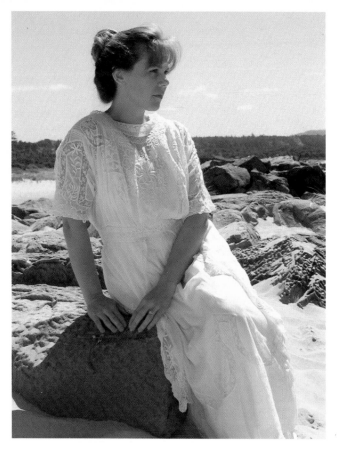

A lingerie dress, circa 1910. *Courtesy of The Very Little Theatre.*

Skirts

From 1910 to about 1914, skirts were slim through the hips—and if and when they were worn full, all fullness was below the knee. For evening, trains both slight and excessive were worn. By day, skirts were most often instep length. So-called 'hobble' skirts were at the cutting edge of fashion in 1910, though the excessively slim and crippling skirt was mocked by most. "Hobble, hobble little skirt," was the press's cry for the new style, often a mere thirty–two inches wide at hem. Around 1912, skirts began to feature side slits or wide pleats, which made walking considerably easier. Such slits were always worn with colored slips, however, so as not to reveal too much of the lady's limbs.

By 1913, all skirts featured Empire-style, high waistlines. In this same year, the 'barrel' or 'peg-top' skirt became fashionable. This new, draped style looked much like a wrap-around skirt, but featured full pleats, gathers, or open-ended darts at the waistline—which emphasized and exaggerated the hips. This emphasis on the hips took over completely in 1914. Puffs, panniers, peplums, tiers, and many other creative affects predominated.

In 1915, skirts took on an entirely new look. Circular and A-line styles offered greater freedom to their wearer's and were enthusiastically adopted. Skirts were also shorter, often three to five inches from the floor. This new freedom was short lived, however. As early as 1918, full skirts were going out of fashion, and by 1919, they were obsolete—though, thankfully, skirts did retain a length of five to seven inches from the floor.

Blouses

In the early 'teens, most bodices—now called 'blouses' or 'shirtwaists'—were cut low on the neck and were designed to be worn with a high-necked 'guimpe', or dickey. Occasionally necklines were also worn at the base of the neck. Tailored, tucked, and pleated shirtwaists were still worn frequently, as were net, embroidered, cutwork, eyelet, and sheer blouses.

By 1911, blouses started to take on new style. First, short peplums were added, then apron-like panels came into fashion. By 1912, raglan sleeves were sometimes worn, and by 1913, V-shaped necklines were becoming acceptable. Around this time, blouses also often featured a wrap-around look.

In 1914, raglan sleeves became extremely vogue, as were men's-shirtwaist-style collars. By 1916, blouses took on a structured, asymmetrical look. Long, tunic style blouses were sometimes worn outside the skirt, as were lightly gathered peplums.

In the years 1917 to 1919, blouses grew continually longer and were frequently worn outside of the skirt. By 1919, most blouses were quite simple and had a draped affect with wrap–around peplums, flounces, and long, loose sleeves.

Dresses

In 1910, dresses remained very similar to dresses worn in the past few years, with the exception that their skirts were slightly more slender. Most dresses were still two-piece, and most one-piece dresses were high-waisted. This new Empire style was slightly different than previous Empire styles, however; it was a few inches higher in the back than in the front.

In the evening, the fashion was still for light, gauzy fabrics, but necklines were more modest and did not feature décolletage. The most fashionable evening dresses still had trains, though now they frequently came to a sharp point in the back. Such trains were

also weighed down, usually with small, round, flat pieces of lead, which made humorous noises when their wearer walked across wooden floors or down staircases.

The 'lingerie' and tailored looks prevailed in the 'teens, and dresses followed all the trends of skirts and blouses, including the wrap-around look from 1912 to 1914, the peg-top look in 1913 and 1914, the A-line style from 1915 to 1917, and the draped, tubular look from 1918 to 1919.

Materials and colors varied as widely as the fashions of the 'teens, but in general, gauzes, eyelets, serge, velvet, silk, and satin (often delicately printed) were favored from 1910 to 1915, and light to medium weight cottons, georgettes, silk, satin, and wools in checks, stripes, and solids were favored from 1916 to 1919.

Undergarments

Perhaps it was the overwhelming popularity of the Tango and similar 'sinful' dances that prompted designers to create a new corset. Though still long and largely restrictive, corsets now featured insets of elastic that allowed for greater freedom of movement. By 1913, the corset had evolved even further; no longer was the corset designed to emphasize the waist, bust, and hips. Instead, it neglected them. The new look was straight, square, and curveless, and corsets controlled the hips to achieve this affect. Though still containing some boning, these corsets were largely made up of strong cottons, rubber webbings, and elastic. Because they often reached the knees, corsets were now laced instead of hooked up, in order to make movement easier.

In the 'teens corsets were gradually evolving into girdles, and by 1917, corsets were made almost entirely of elastic. Though now much more comfortable in nearly every respect, they had at least one major flaw: every time a lady sat, her corset rolled up her legs.

After decades of wearing impractical, immodest open-crotched drawers, by 1910, most ladies had discovered that closed–crotched knickerbockers or bloomers were preferable by far. Normally they were cut slim, sometimes featuring a hip yoke so more fullness could be allowed at the knees. By 1913, when the 'peg–top' look was fashionable, bloomers were often worn without petticoats in order to ensure a smooth, slender appearance; this trend continued into the next decade.

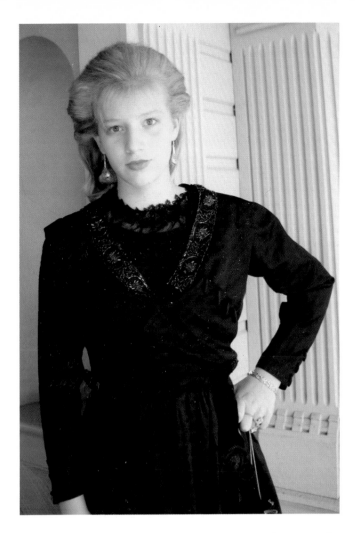

A circa 1910 bodice, trimmed with jet and lace. *Courtesy of The Very Little Theatre.*

'Bust supporters' were still being advertised in fashion magazines. Forerunners of the bra, the new-style supporters looked much like short corset covers, except that they were lightly boned, ended just below the bust, and often had fabric cups to hold the breasts. By 1913, the term 'brassiere' was being used to describe these supporters—but they hardly resembled modern bras.

Sportswear

Bathing suits, increasingly important to a world that was beginning to envy the suntans of the leisure class, looked more like everyday dresses than ever before. Box-like and loose-fitting, they always covered the knees. Around 1915, it at last became acceptable to wear a wider variety of colors and fabrics in bathing wear; checks, stripes, and polka-dots were favored by the most fashionable ladies. By 1917, knees were sometimes being seen on the beaches—a disclosure that rapidly led to more and more revealing styles.

Sportsclothes remained much the same, otherwise, until about 1917, when many women began choosing full trousers for activities such as fishing, golfing, and housework.

Other Important Garments

Capes continued in their popularity, and like many fashionable clothes of the 'teens, turned sophisticated and exotic. Wrapped around the body like a cocoon, draped, and created in opulent fabrics and trims, the new style in capes was definitely *couture*.

Shoes also took on a new face, now being created in a wide variety of shapes, and trimmed with everything from rhinestones to boa feathers (two trims that adorned *every* possible fashion accessory in the 'teens).

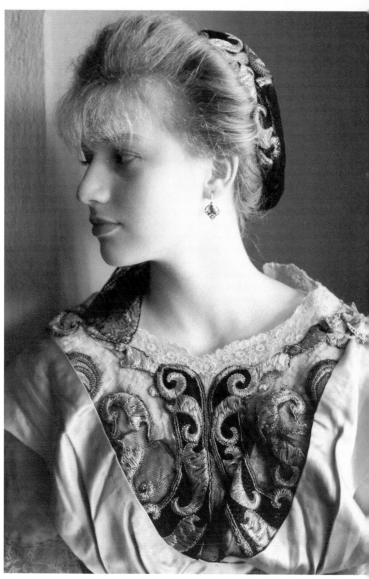

A satin embroidered evening gown with a matching embroidered net hat, circa 1913. The train, which comes to a point in back, is weighted. *Courtesy of The Very Little Theatre.*

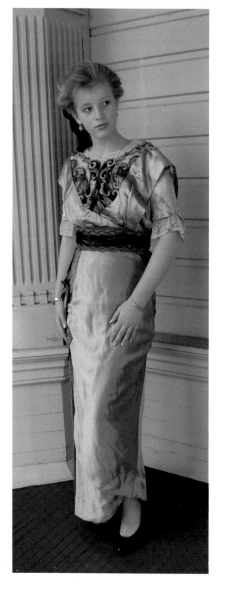

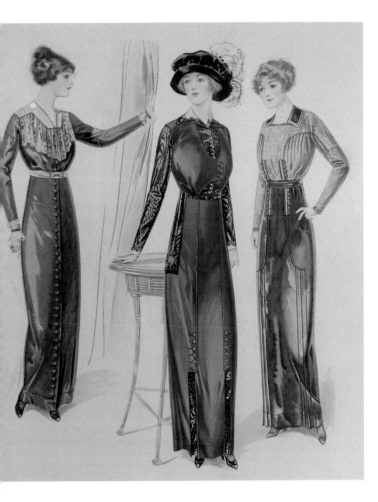

Three long, slim dresses from a 1914 fashion plate.

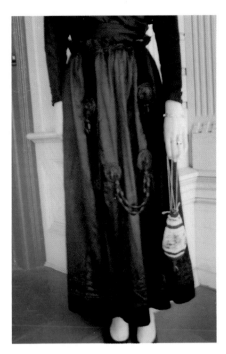

A circa 1910 skirt, trimmed with velvet and braided passementerie. *Courtesy of The Very Little Theatre.*

The cover of a 1911 magazine, showing the new sleek and sophisticated style in evening gowns.

Detail of a celluloid bone inside a 'teens blouse collar.

Two *toilettes* from a 1910 fashion magazine. The tailored ensemble, at left, features a snug-fitting skirt and a typically huge hat. The day dress, at right, also fits the lower figure snugly, but it is made up in a more traditional style.

A simple day dress as illustrated in a 1913 issue of *The Young Ladies' Journal.*

Three fashion plates from a 1913 issue of *The Young Ladies' Journal* illustrating evening and special occasion gowns.

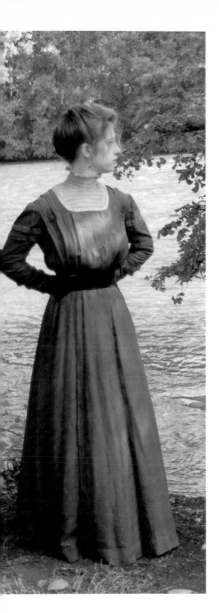

A tucked dress with a separate velvet belt, circa 1910. *Courtesy of The Very Little Theatre.*

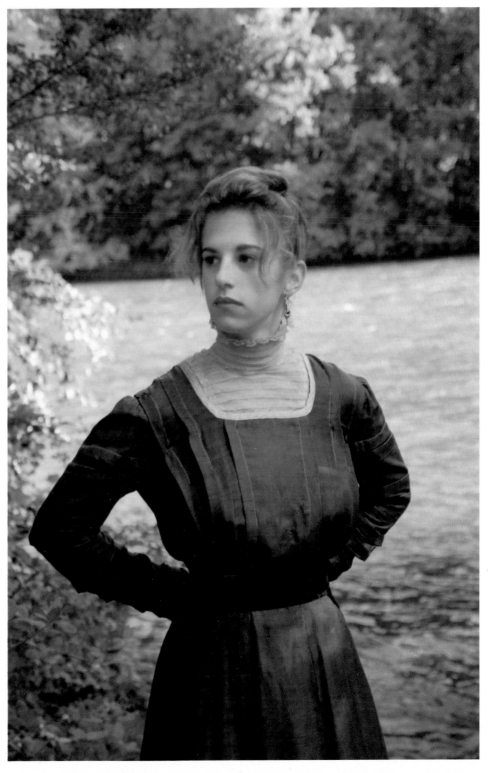

This tucked dress with large buttons is typical of the suffrag-
ette look prevalent at the end of the previous decade and the
beginning of the 'teens. The tucked and flowered belt was
from Chicago's Marshal Field and Company. *Courtesy of The
Very Little Theatre.*

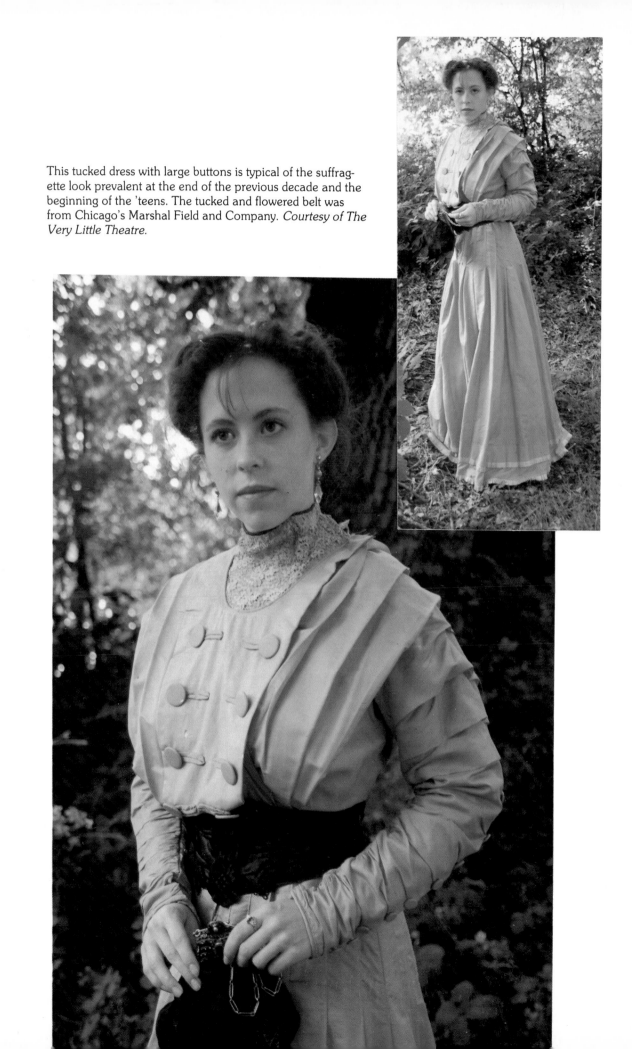

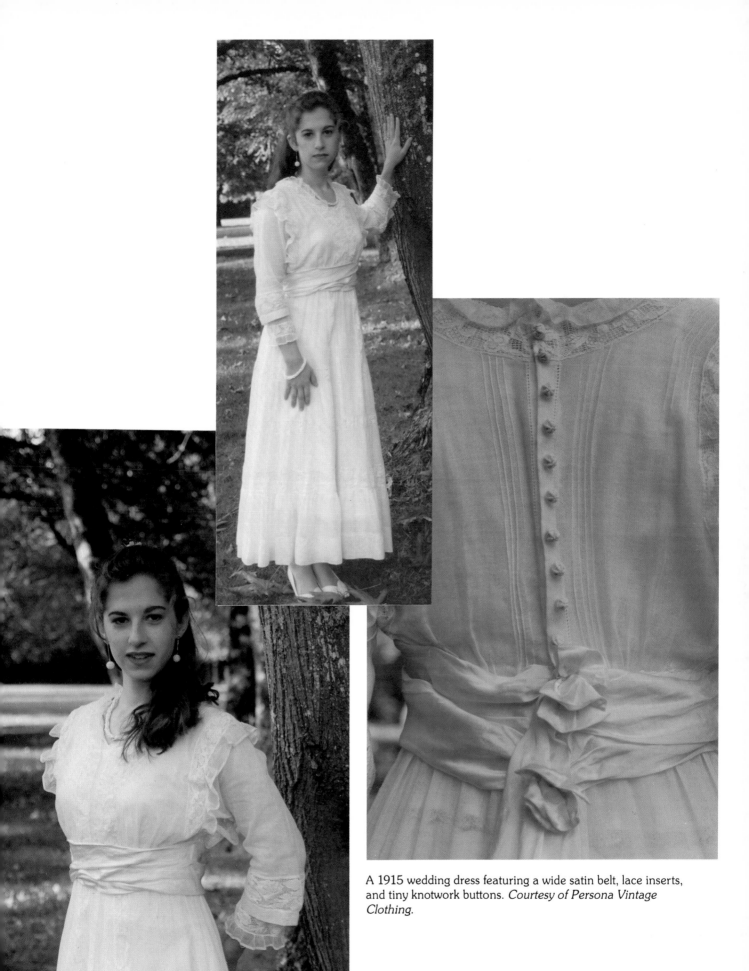

A 1915 wedding dress featuring a wide satin belt, lace inserts, and tiny knotwork buttons. *Courtesy of Persona Vintage Clothing.*

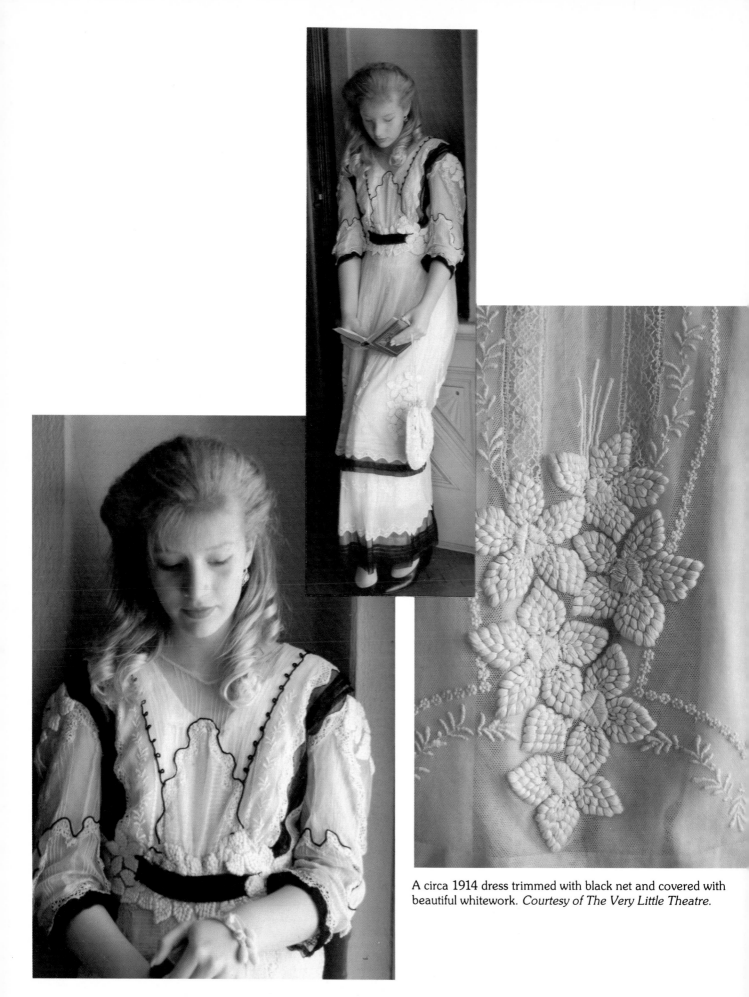

A circa 1914 dress trimmed with black net and covered with beautiful whitework. *Courtesy of The Very Little Theatre.*

A dramatic dress with a silk and velvet skirt, a wide velvet belt, and a bodice made up of chiffon, velvet, and lace. Circa 1916. *Courtesy of The Very Little Theatre.*

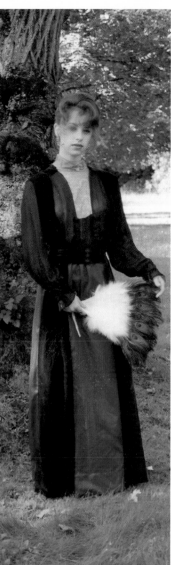

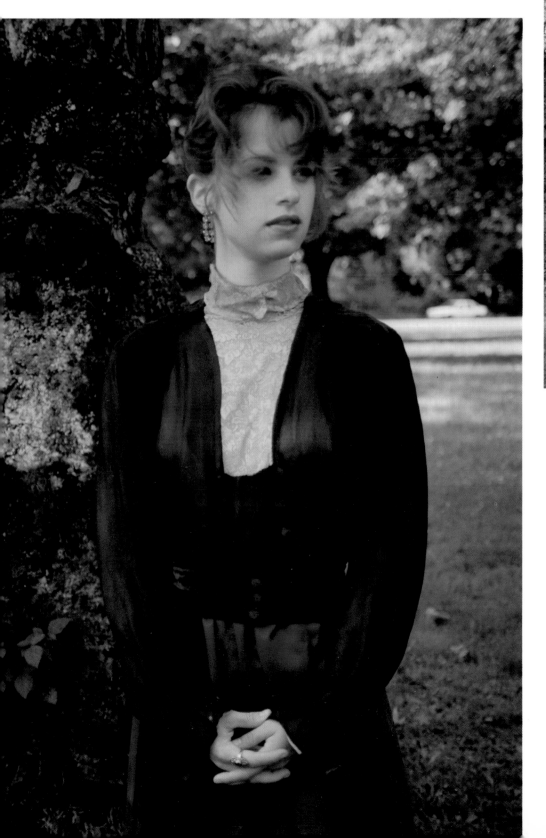

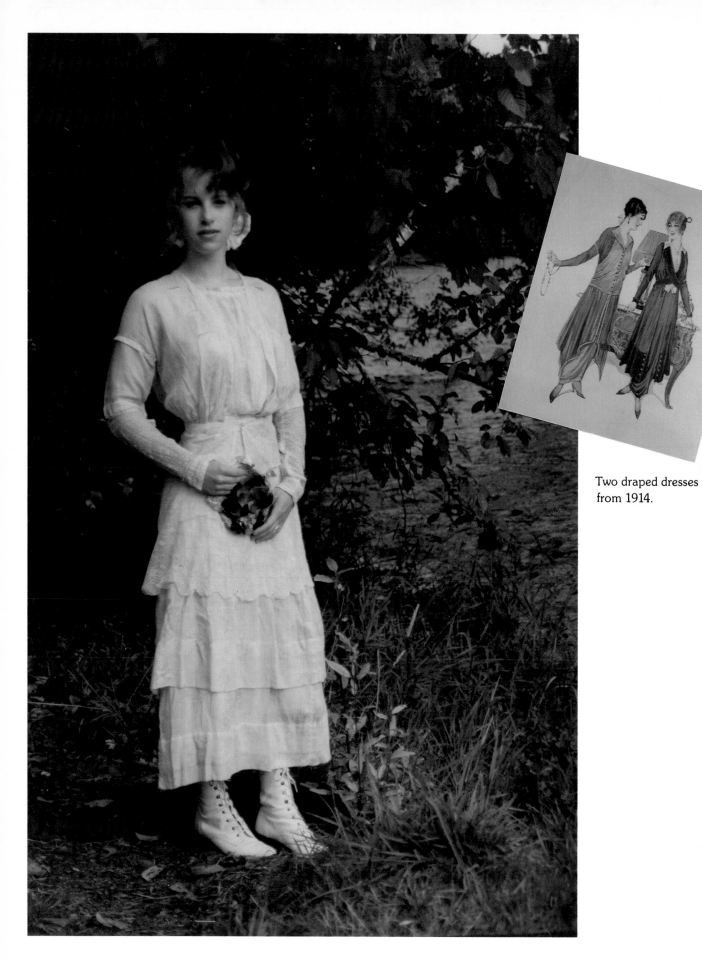

Two draped dresses
from 1914.

A cotton two-piece dress, circa 1918, *Courtesy of The Very
Little Theatre.*

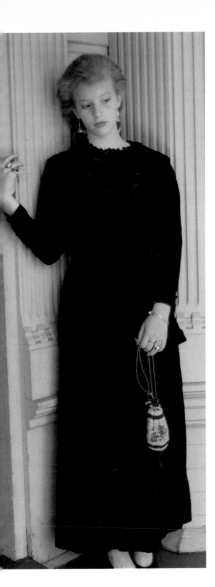

A two-piece dress, circa 1910. *Courtesy of The Very Little Theatre.*

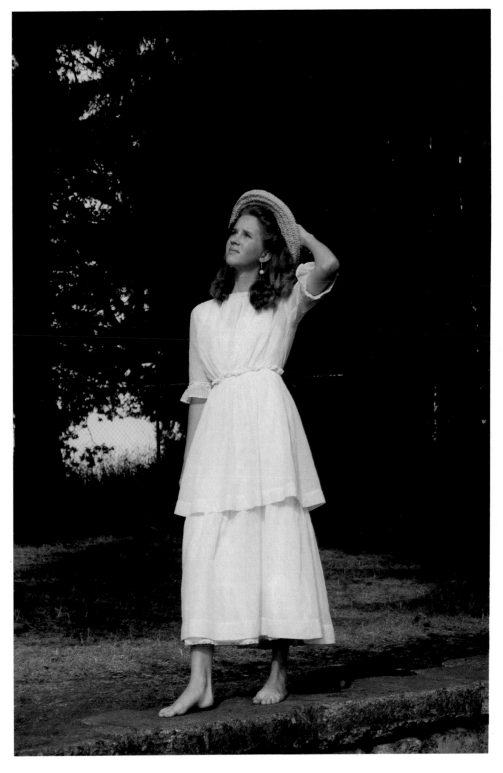

A two-tiered lawn dress, circa 1918.

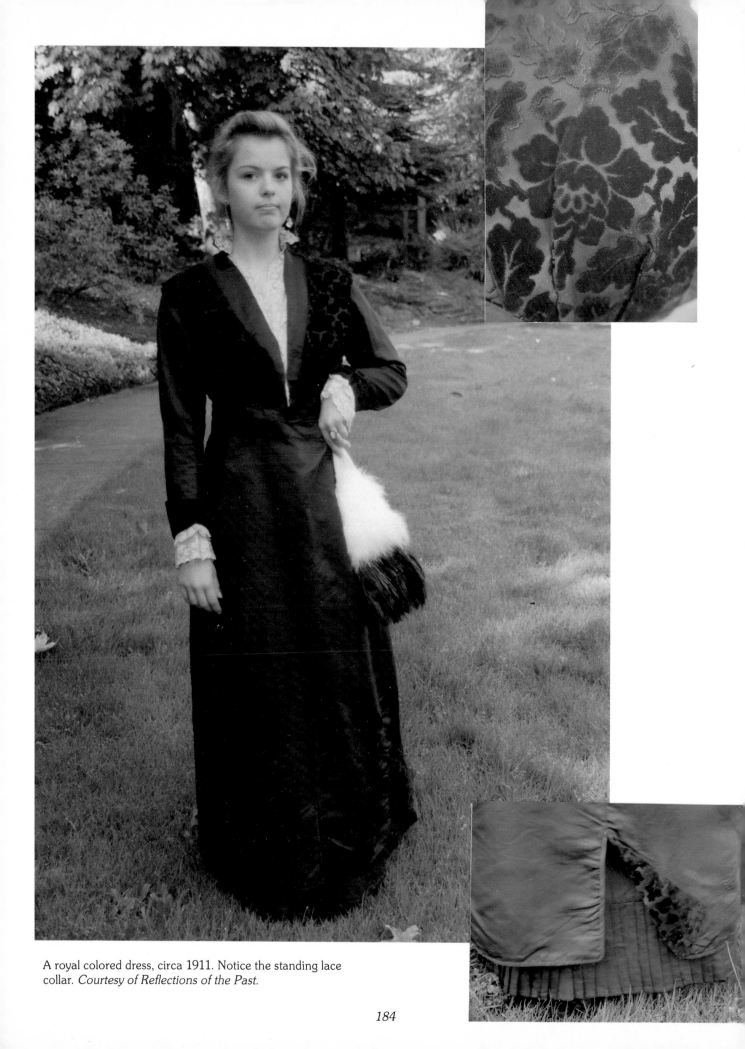

A royal colored dress, circa 1911. Notice the standing lace collar. *Courtesy of Reflections of the Past.*

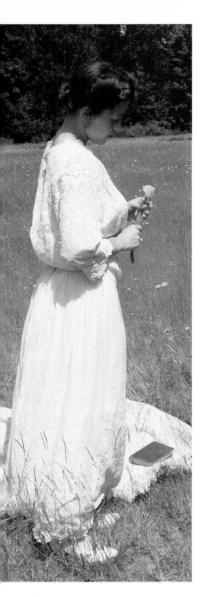

A lingerie dress with a wide, slightly dropped waist, circa 1918. *Courtesy of The Very Little Theatre*

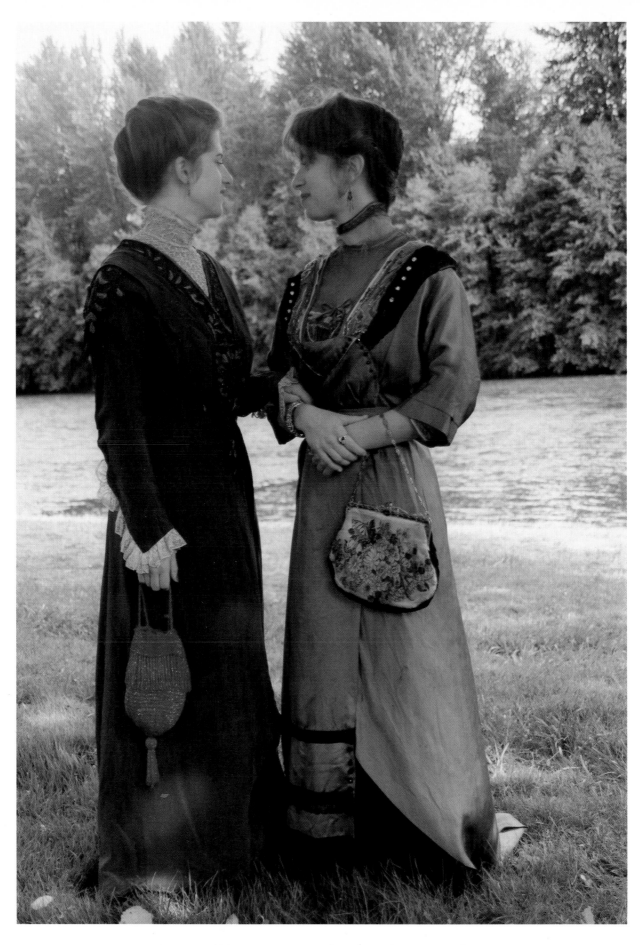

Two circa 1913 evening gowns. *Gown on right courtesy of
The Very Little Theatre.*

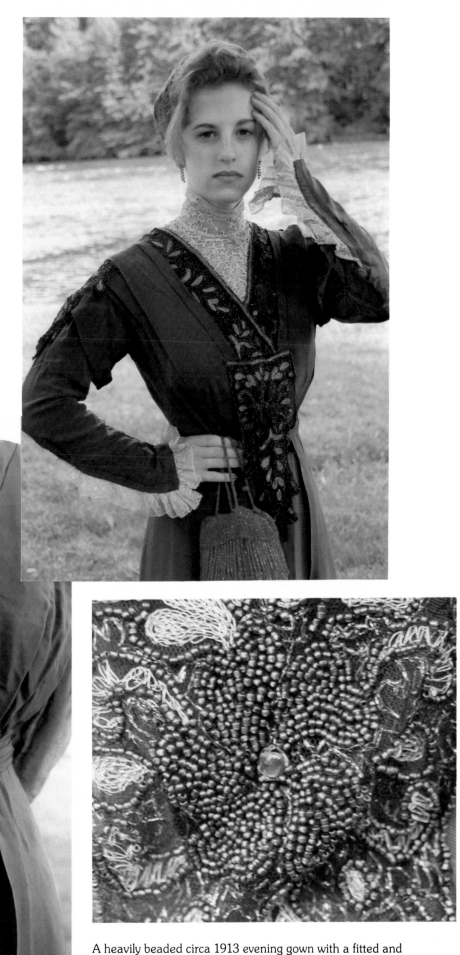

A heavily beaded circa 1913 evening gown with a fitted and boned bodice, boned high collar, and lace-trimmed sleeves.

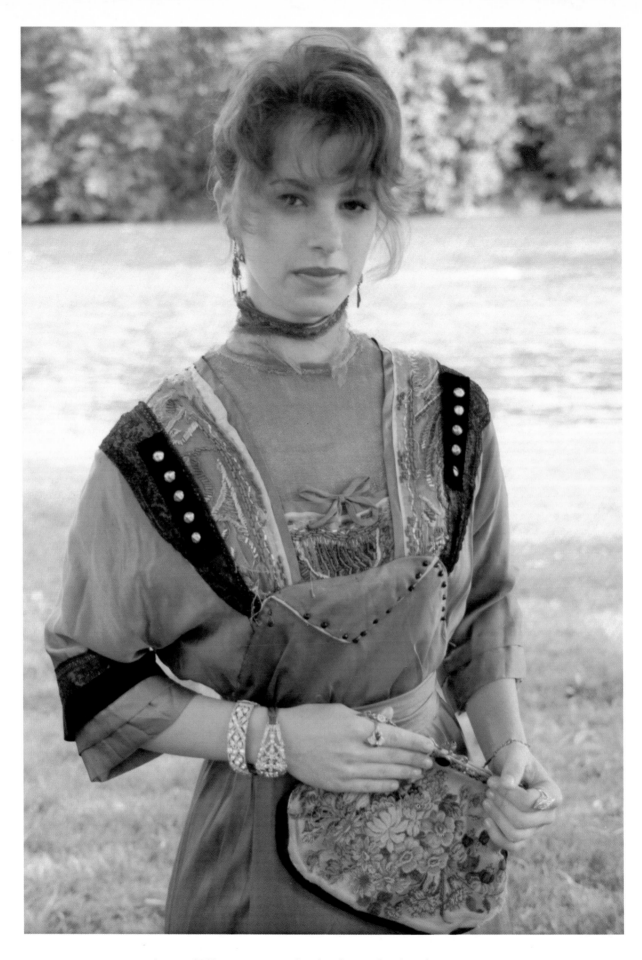

A circa 1913 gown, trimmed with velvet and embroidery.
Courtesy of The Very Little Theatre.

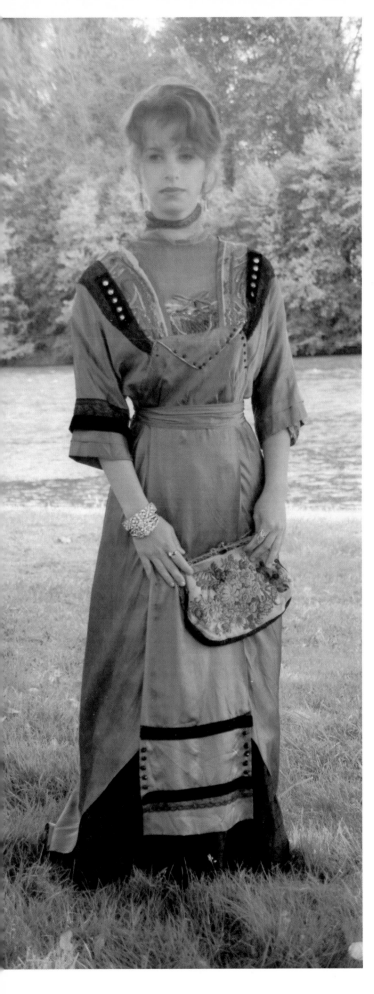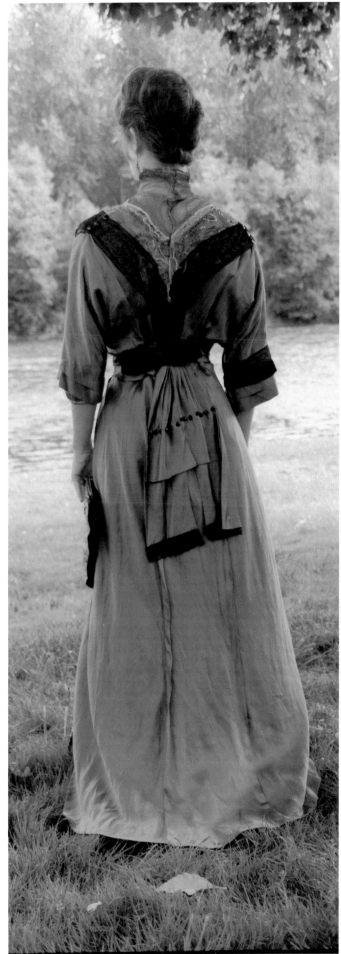

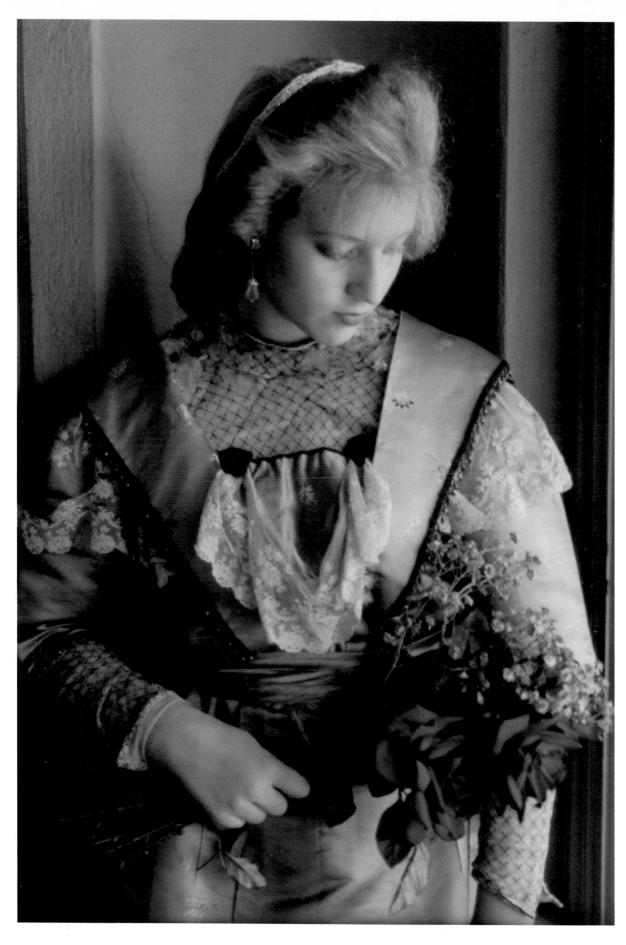

A heavy silk dress with a clear Oriental influence, circa 1913.
Courtesy of The Very Little Theatre.

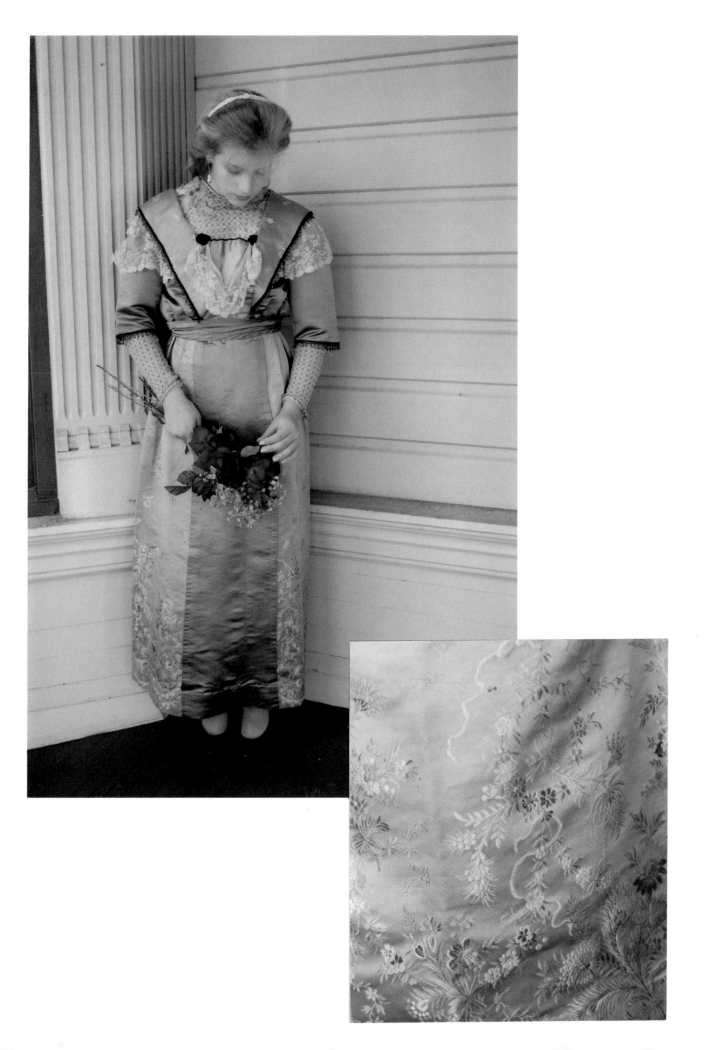

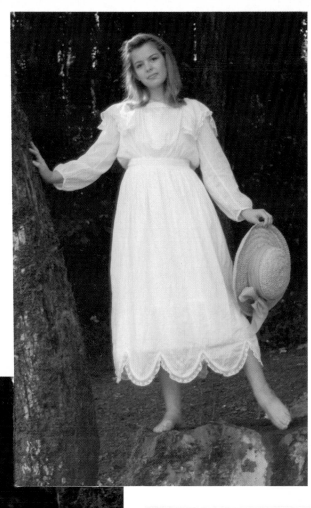

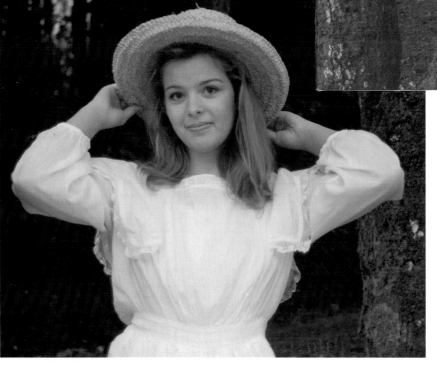

A circa 1919 cotton day dress with a small sailor collar and scalloped hemline.

A circa 1919 silk dress with a V-shaped lace insertion. The beginnings of the 1920s look is evident. *Courtesy of Persona Vintage Clothing.*

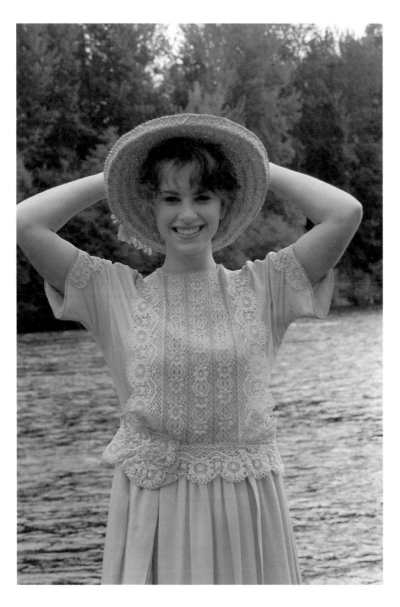

A day dress, circa 1919, nearly shaped in the 1920s tubular style. *Courtesy of The Very Little Theatre.*

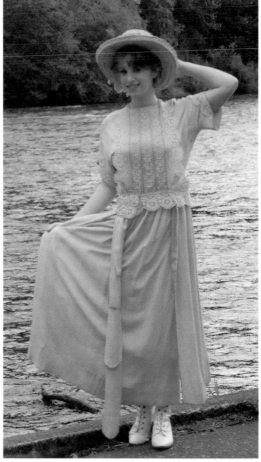

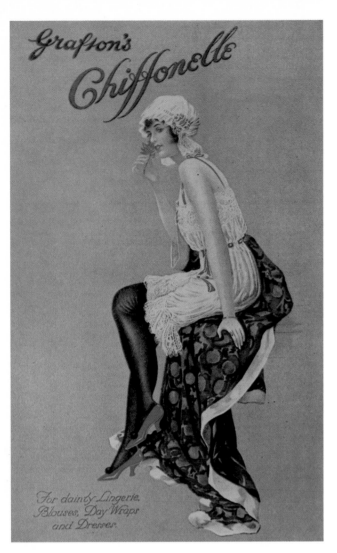

A 1918 advertisement featuring a pair of 'dainty' combinations and a nightcap.

The 'modern' style bathing suit worn by only the most daring women in the early 'teens, but almost universally adopted by 1920.

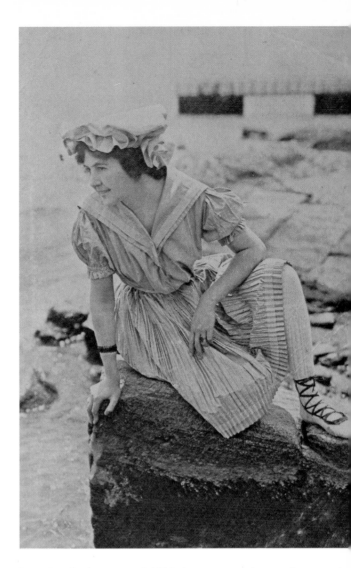

A modest bathing suit of 1910, featuring stockings, shoes, and a cap.

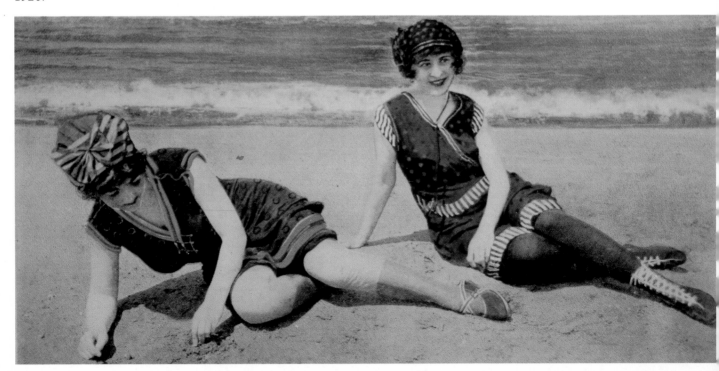

A 'teens corset with elastic garters. *Courtesy of Reflections of the Past.*

Two bathing suits in the style the majority of women wore in during the 'teens. These date to 1911.

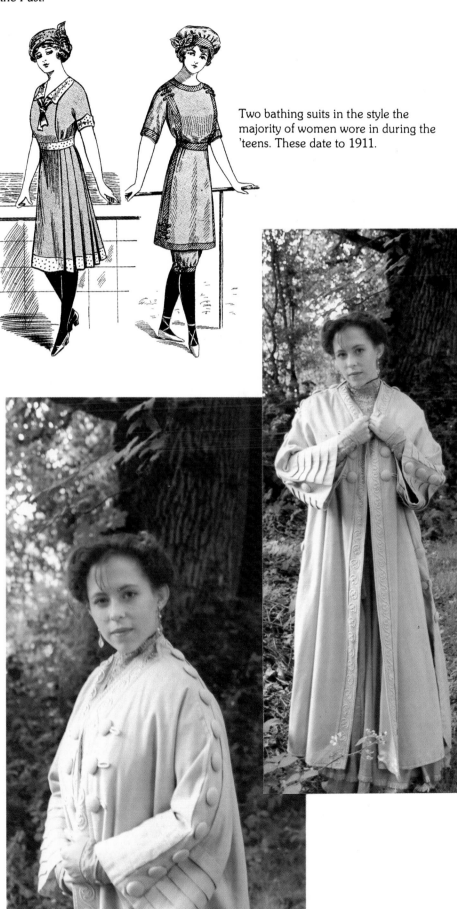

A tucked coat from Boston's Jordan Marsh Company, circa 1910. *Courtesy of The Very Little Theatre.*

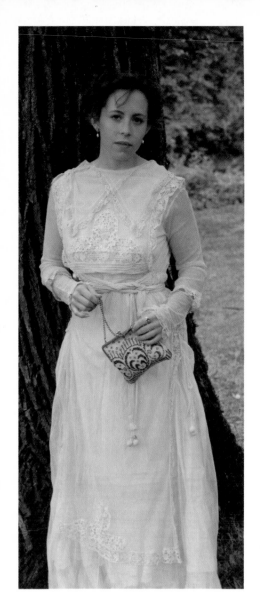

A lingerie dress in the draped style of 1914. *Courtesy of The Very Little Theatre.*

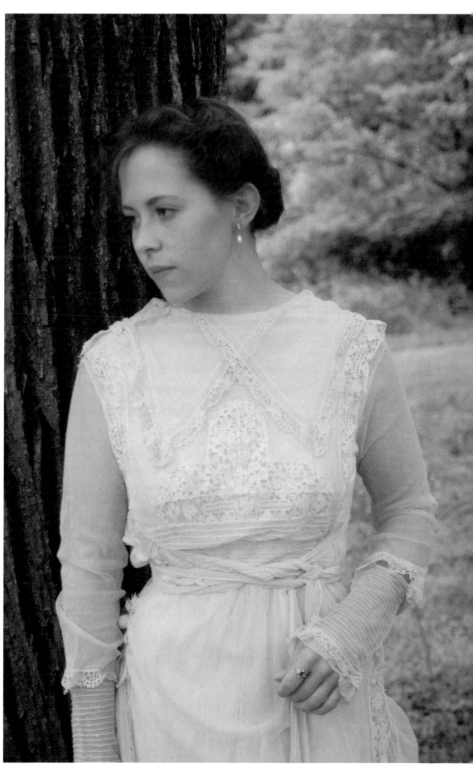

"Short evening frocks the rage—" a 1914 fashion plate proclaims.

A circa 1918 net dress with a handkerchief hemline and satin sash. *Courtesy of Persona Vintage Clothing.*

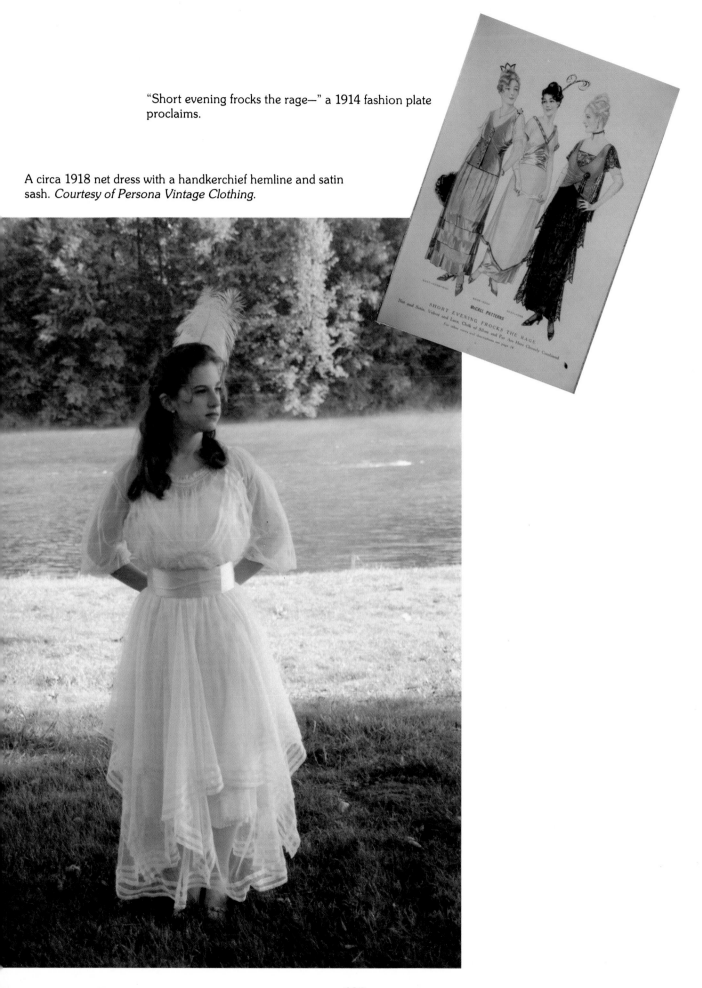

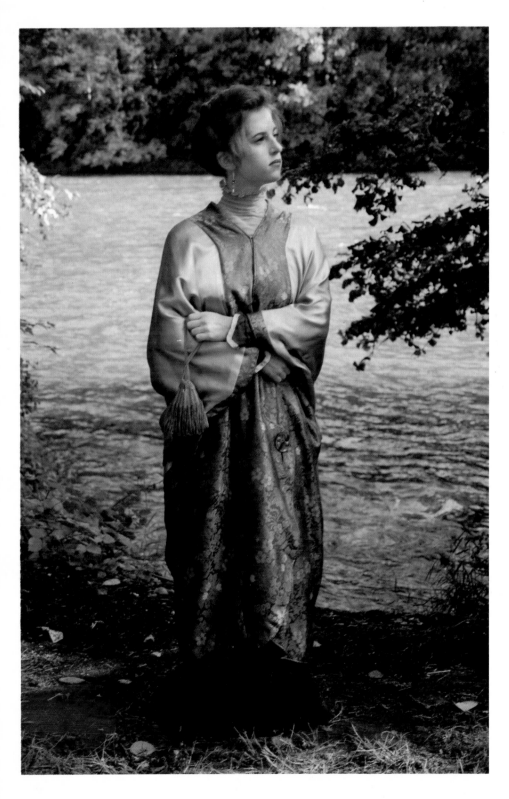

A magnificent, draped cape, circa 1913. Made up of satin, brocade, and tassels, this look was very modern. *Courtesy of The Very Little Theatre.*

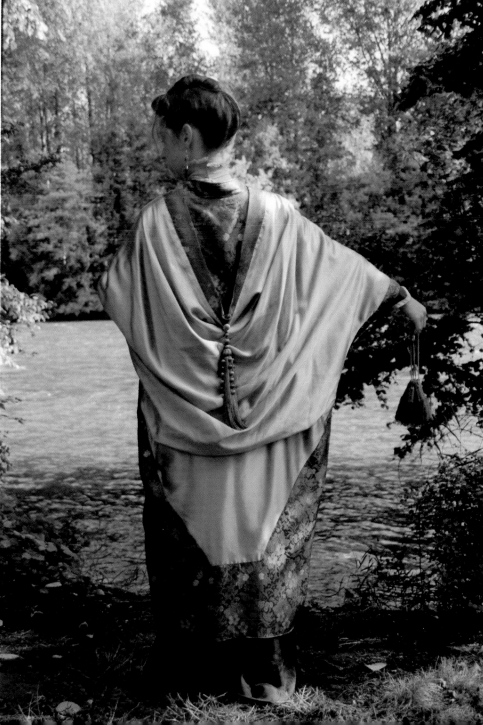

A pair of silk shoes with silver buckles, in their original box: "Costume Bootery of O'Connor & Goldberg at 23 Madison, East Chicago." Circa 1912. *Courtesy of The Very Little Theatre.*

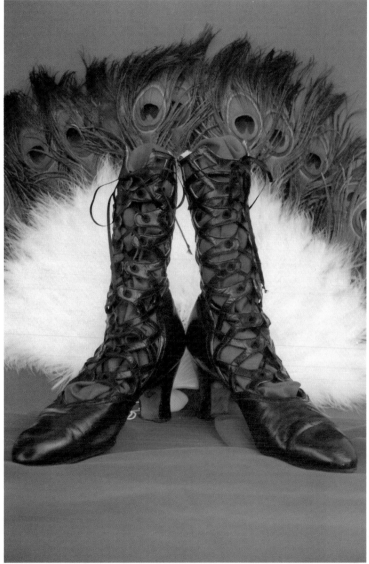

A striking pair of cutwork leather shoes. *Courtesy of Reflections of the Past.*

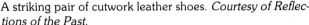

A dramatic evening ensemble featuring a royal purple velvet cape. *Courtesy of The Very Little Theatre.*

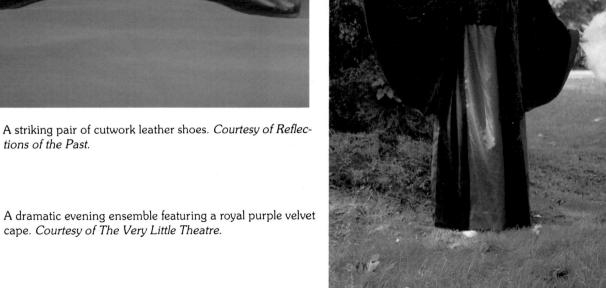

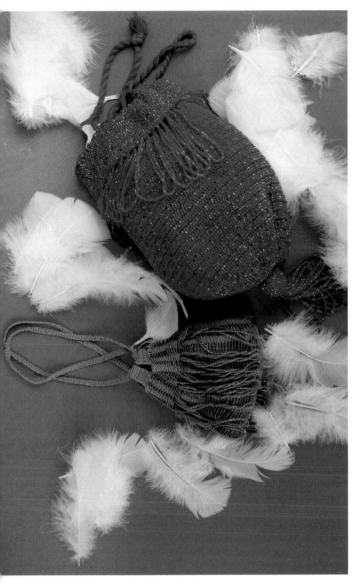

Two glass-beaded drawstring bags. *Courtesy of The Very Little Theatre.*

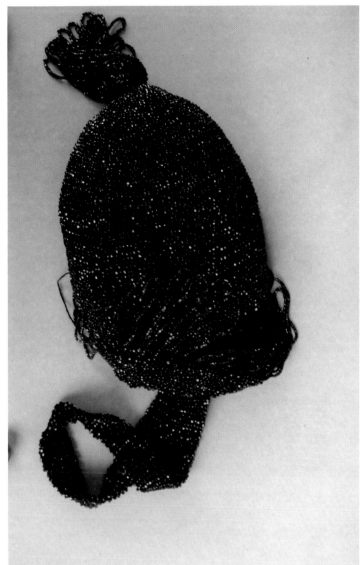

An iridescent beaded bag from the 'teens. *Courtesy of The Very Little Theatre.*

A ruched silk bag trimmed with faux gems. *Courtesy of The Very Little Theatre.*

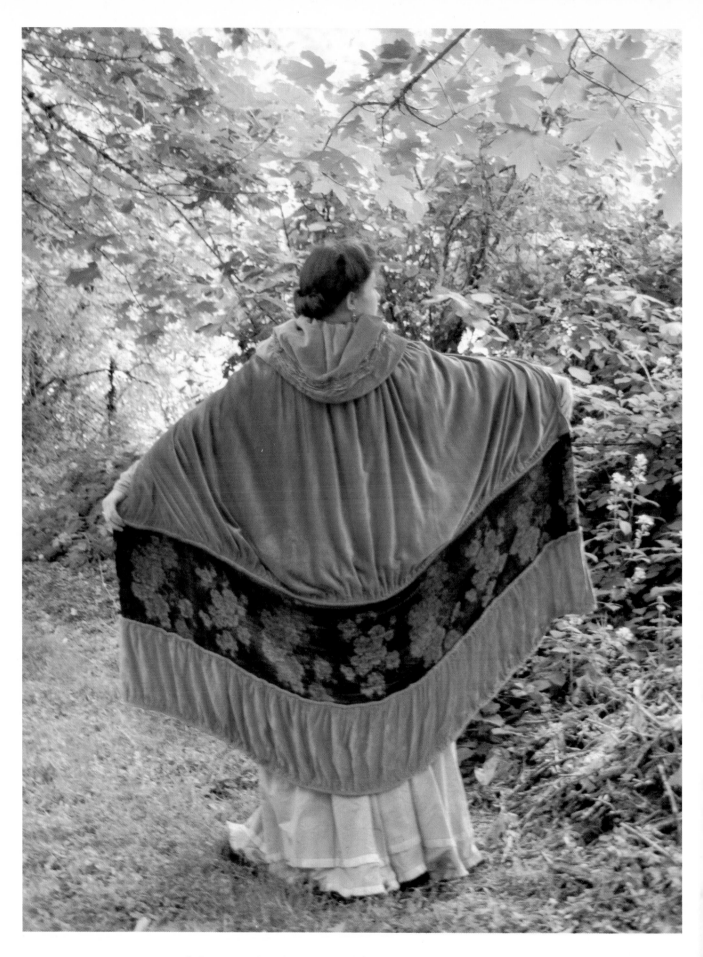

A dramatic velvet cloak, circa 1912. *Courtesy of The Very Little Theatre.*

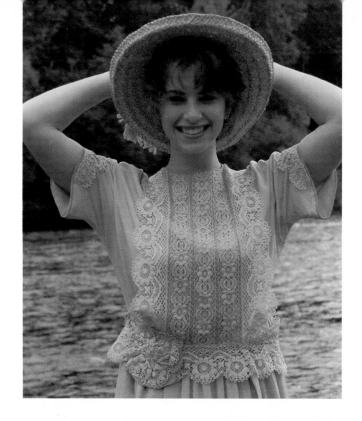

Epilogue

The Victorian and Edwardian eras were years of great change. After the wild abandon of the Neopolian I years, the 1840s began with clothing and thought that was modest and moralistic. Change away from modesty may not have been easily discernible, but by 1919, women were well on their way to the radical attitude and attire of the 1920s flapper. True Victorian and Edwardian styles were but a brief (though glorious) spurt in time, never to be fully revived. Let us fully enjoy them, then, carefully conserving them for future generations to appreciate, learn from, and love. They are unique artifacts with wonderful tales to tell about our ancestors—how they lived, what their skills were, what they thought...Besides, as Dorothy Parker once astutely said, "Where's the man could ease a heart like a satin gown?"

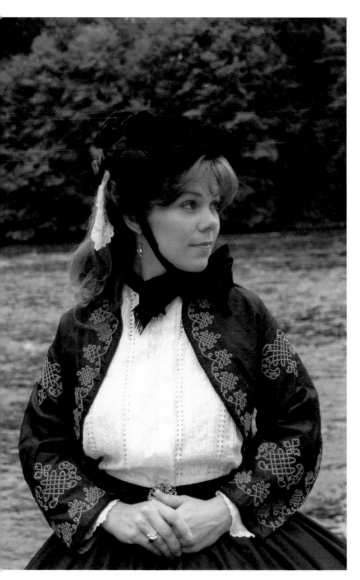

Selected Bibliography

To cite every book or periodical that has influenced me in the writing of this book is an impossible feat; everything I have ever read on the subject of historical fashions has no doubt had a great impact on my work. Therefore, I list here only a few books and periodicals which I consider exceptional and particularly useful to me in writing this book.

Books

Bell, Lilian. *From A Girl's Point Of View*, Harper & Brothers, New York, NY 1897.

Blum, Stella. *Victorian Fashions and Costumes From Harper's Bazar*, Dover Publications, Inc. Mineola, NY 1974.

———— and Louise Hamer. *Fabulous Fashion*, The Metropolitan Museum Of Art, New York, NY (nd)

Black, Alexander. *Modern Daughters*, Charles Scribner's Sons, New York, NY 1899.

Bradfield, Nancy. *Costume In Detail: 1730–1930*, Plays, Inc., Boston, MA 1968.

Burgess, Janet. *Clothing Guidelines For The Civil War Era*, Amazon Dry Goods, Davenport, IA 1985.

Coleman, Elizabeth Ann. *The Opulent Era*, Thames and Hudson, New York, NY 1989.

Cunnington, C. Willett. *English Women's Clothing in the Nineteenth Century*, Dover Publications, Inc., Mineola, NY 1990.

————————. *The History of Underclothes*, Dover Publications Inc., Mineola, NY 1992.

Ewing, Elizabeth. *Dress and Undress*, B.T. Batsford, Ltd., London, England 1978.

Ginsburg, Madeleine, Avril Hart, Valerie D. Mendes. *Four Hundred Years Of Fashion*, Victoria And Albert Museum, London, 1984.

Hall, Carrie A. *From Hoopskirts to Nudity*, Caxton Printers, Ltd., Caldwell, ID 1946.

LaBarre, Kathleen and Kay. *Reference Book of Women's Vintage Clothing: 1900–1919*, LaBarre Books, Portland, OR 1990.

Tarrant, Naomi. *The Rise And Fall Of The Sleeve*, Royal Scottish Museum, 1983.

Thieme, Charles Otto, Elizabeth Ann Coleman, Michelle Oberly, and Patricia Cunningham. *With Grace and Favour*, Cincinnati Art Museum, Cincinnati, OH 1993.

Waugh, Nora. *Corsets and Crinolines*, Routeledge, New York, NY, 1993.

————————. *The Cut Of Women's Clothes*, Routeledge, New York, NY 1993.

Periodicals

Delineator, The
Dress
Englishwomen's Domestic Magazine, The
Godey's Lady's Book
Graham's Magazine
Harper's Bazar
Home Book Of Fashions, The
Lady, The
Ladies Cabinet, The
Ladies Home Journal, The
McCall's Magazine
Miss Leslie's Magazine
Peterson's Magazine
Queen, The
Standard Designer, The
Young Ladies Journal, The

Value Guide

The following is intended to be a general reference for collectors and dealers who want to know what they can expect to pay for various items in the antique clothing field or what they can sell them for. The actual prices listed come directly from antique fashion dealers throughout the United States. All values listed presume the item is in mint or excellent condition. When trying to evaluate items, every bit of damage and every flaw must be taken into consideration, and the items must be depreciated accordingly. There is no such thing as a garment in "good condition for its age"; either it is in good condition or it is not. Mint and excellent condition items from 1840s do exist, as do terribly torn-up garments from the 'teens. Bear in mind that prices vary from state to state and region to region. Demand in your own area and current collecting trends also affect values.

Page	Item	Value
20	Fashion Plate	$45
21	Fashion Plate	$29
23	Fashion Plate (right)	$30
23	Fashion Plate (left)	$25
24	Bodice	$180
25	Bodice	$150
25	Embroidered Picture	$50
25	Fashion Plate	$30
26	Dress	$395
27	Fasion Plate (top)	$20
27	Fashion Plate (bottom center)	$35
27	Fashion Plate (right)	$19
28	Fashion Plate (top left, right, & bottom)	$30 ea.
29	Dress	$695
30	Embroidered Picture	$45
30	Fashion Plate	$60
31	Fashion Plate (top)	$15
31	Fashion Plate (bottom)	$20
32	Capelet	$175
33	Fashion Plate	$33
34	Fashion Plate	$41
34	Bodice	$120
35	Bodice	$67
37	Fashion Plate	$15
37	Dress	$495
38	Dress	$295
39	Dress	$575
39	Fashion Plate	$30
40 &12	Hoopskirt, cotton	$170
40 &12	Hoopskirt, child's	$75
40	Fashion Plate	$40
41	Fashion Plate	$45
41	Shoes	$225
42	Shoulder Cape	$195
42	Stockings	$115
43	Fashion Plate (top)	$20
43	Fashion Plate (bottom)	$29
44	Bonnet & Cape set	$325
44	Hat, man's	$160
46	Fashion Plate	$42
47	Bodice	$95
47 &15	Hat	$100
47	Headdress	$27
49	Dress	$650
49	Fashion Plate	$30
50	Fashion Plate	$15
50	Shirtwaist	$60
51	Vest	$180
51	Bodice	$85
52	Bodice	$90
52	Blouse, Vest, and Belt ensemble	$230
53	Paletot	$67
54	Dress	$200
54	Fashion Plate	$39
55	Dress	$295
56	Dress	$150
56	Fashion Plate (top)	$20
56	Fashion Plate (bottom)	$30
57	Dress	$575
58	Fashion Plate	$22
58	Dress (left)	$475
58	Dress (right)	$210
59	Dress	$395
60 & 12	Hoopskirt	$80
61	Stockings	$95
61	Fashion Plate	$35
63	Bodice	$69
64	Jacket	$125
66	Bodice	$150
67	Dress	$145
67	Fashion Plate	$27
68	Dress	$350
69	Suit	$295
70	Dress	$650
71 & 15	Wedding Gown	$195
72	Fashion Plate	$45
73	Dress	$295
74	Dress	$650
77	Dress	$110
78	Fashion Plate	$65
79	Dress	$170
81	Robe	$1,110
82	Negligee	$475
83	Stockings	$110
84	Shoes	$65
84	Gloves	$25
84	Mantel	$1,000
86	Fashion Plate	$30
88	Bodice	$180
89	Bodice	$37
91	Chemisette	$210
92	Fashion Plate	$25
93	Dress	$398
93	Parasol	$160
94	Dress	$310
95	Fashion Plate	$15
96	Dress	$190
98	Suit	$210
98	Fashion Plate (left)	$60
98	Fashion Plate (right)	$56
99	Corset, black	$230
99	Corset, white	$184
99	Bustle	$50
100	Petticoat	$70
101	Cape	$115
103	Bodice (left)	$125
103	Bodice (right)	$55
105	Fashion Plate	$12
107	Skirt (right)	$115
107	Skirt (left)	$120
108	Skirt	$125
109	Skirt	$96
110	Fashion Plate	$45
111	Bodice (left)	$34
111	Bodice (right)	$90
112	Bodice	$89
113	Bodice (top)	$90
113	Bodice (bottom)	$145
114	Bodice (top)	$170
114	Bodice (bottom left)	$30
114	Bodice (bottom right)	$56
115	Bodice (top)	$29
115	Bodice (bottom)	$45
116	Bodice	$50
116	Parasol	$90
117	Bodice	$70
118	Bodice (right)	$40
118	Bodice (left)	$35
119	Bodice (top)	$50
119	Bodice (bottom)	$130
120	Bodice	$60
121	Mantel	$300
122	Fashion Plate (top)	$40
122	Fashion Plate (bottom)	$35
123	Dress	$60
124	Dress	$280
124	Parasol	$80
125	Dress	$70
126	Dress	$120
127	Dress	$100
128	Suit	$299
129	Boa	$39
129	Ensemble (top)	$100
129	Ensemble (bottom)	$83
129	Fashion Plate	$30
131	Dress (top)	$90
131	Dress (bottom)	$195
132	Jumper	$60
133	Fashion Plate (top)	423
133	Fashion Plate (bottom)	$30
134	Dress	$515
135	Corset	$1,700
137	Cape, fur (top)	$90
137	Cape, fur (bottom)	$70
137	Cape, lace	$50
138	Fashion Plate	$15
138	Cape	$69
139	Jacket	$110
139	Capelet	$85
140	Parasol (top)	$200
140	Parasol (bottom)	$180
141	Purse	$160
141	Shoes	$150
143	Fashion Plate	$21
144	Dress (right)	$290
144	Dress (left)	$260
145	Fashion Plate	$12
146	Bodice	$45
147	Bodice	$109
148	Bodice (left)	$40
148	Bodice (right)	$30
148	Jabot	$30
149	Bodice (top)	$50
149	Bodice (bottom)	$66
150	Magazine	$15
151	Dress	$400
151	Parasol	$185
152	Dress	$225
153	Dress	$130
153	Magazine	$30
154	Dress	$430
154	Magazine	$10
155	Dress	$290
157	Fashion Plate	$10
157	Dress	$100
158	Dress	$90
159	Dress	$85
159	Suit	$280
160	Fashion Plate	$12
161	Dress	$510
162	Dress (left)	$325
162	Dress (right)	$620
163	Fashion Plate	$13
164	Dress	$149
165	Fashion Plate (left & right)	$10 ea
166	Dress (right)	$430
166	Dress (left)	$620
166	Bustle	$20
168	Hat	$135
168	Purse(top)	$25
168	Purse (bottom)	$69
170	Fashion Plate	$10
171	Magazine	$10
172	Dress	$70
173	Bodice	$35
174	Dress & Cap set	$515
175	Skirt	$45
175	Magazine	$12
177	Dress	$82
178	Dress	$89
178	Belt	$30
179	Wedding Dress	$160
180	Dress	$135
181	Dress	$365
182	Dress	$115
182	Fashion Plate	$10
183	Dress (top)	$89
183	Dress (bottom)	$65
184	Dress	$300
185	Dress	$70
186 &187	Dress (left)	$115
188 & 18	Dress	$125
190 &191	Dress	$525
192	Dress (top)	$65
192	Dress (bottom)	$95
193	Dress	$67
195	Corset	$190
195	Coat	$125
196	Dress	$165
197	Dress	$185
197	Fashion Plate	$12
198 &199	Cape	$415
200	Shoes (top)	$160
200	Shoes (bottom)	$200
200	Ensemble	$385
201	Purse, red	$160
201	Purse, small green	$70
201	Purse, iridescent	$115
201	Purse, ruched	$46
202	Cape	$370

Index